**Lidén** Klara
**Lozano-Hemmer** Rafael
**Lucas** Renata
**Lucas** Sarah

**Macchi** Jorge
**Man** Victor
**Manders** Mar
**Marclay** Chris
**Marden** Brice
**Margolles** Teresa
**Marshall** Kerry James
**McCarthy** Paul & Damon
**McKenzie** Lucy
**McQueen** Steve
**Mehretu** Julie
**Mik** Aernout
**Mirza** Haroon
**Motti** Gianni
**Mueck** Ron
**Murakami** Takashi
**Mutu** Wangechi

**Nara** Yoshitomo
**Nashat** Shahryar
**Ndiritu** Grace
**Nelson** Mike
**Neshat** Shirin
**Neto** Ernesto
**Neuenschwander** Rivane
**Nordström** Jockum

**Odita** Odili Donald
**Ofili** Chris
**Ondak** Roman
**Ono** Yoko
**Opie** Catherine
**Orozco** Gabriel
**Ortega** Damian
**Owens** Laura

**Paci** Adrian
**Pardo** Jorge
**Parker** Cornelia
**Parreno** Philippe
**Parrino** Steven
**Penone** Giuseppe
**Perry** Grayson
**Pessoli** Alessandro
**Pettibon** Raymond
**Peyton** Elizabeth
**Pfeiffer** Paul
**Pica** Amalia

**Price** Elizabeth
**Price** Seth
**Prince** Richard

**Quaytman** R. H.

**Ray** Charles
**Rehberger** Tobias
**Reyle** Anselm
**Rhoades** Jason
**Richter** Gerhard
**Rist** Pipilotti
**Rojas** Clare E.
**Rondinone** Ugo
**Rothschild** Eva
**Ruff** Thomas
**Ryden** Mark

**Sailstorfer** Michael
**Sala** Anri
**Salcedo** Doris
**Saraceno** Tomas
**Šarčević** Bojan
**Sasnal** Wilhelm
**Schabus** Hans
**Scheibitz** Thomas
**Schneider** Gregor
**Schütte** Thomas
**Schutz** Dana
**Sehgal** Tino
**Serra** Richard
**Shahbazi** Shirana
**Shaw** Raqib
**Sherman** Cindy
**Shonibare** Yinka
**Shrigley** David
**Sierra** Santiago
**Sietsema** Paul
**Signer** Roman
**Singh** Dayanita
**Slominski** Andreas
**Song**
**Sosn**
**Stan**
**Stan**
**Stin**
**Struth** Thomas
**Sugimoto** Hiroshi
**Suh** Do Ho
**Sun** Xun

**Superflex**
**Sze** Sarah

**Tan** Fiona
**Tillmans** Wolfgang
**Tiravanija** Rirkrit
**Tobias** Gert & Uwe
**Trecartin** Ryan
**Tuazon** Oscar
**Tuymans** Luc

**Uklański** Piotr

**Vasconcelos** Joana
**Villar Rojas** Adrián
**Violette** Banks
**Vo** Danh

**Walker** Kara
**Walker** Kelley
**Wall** Jeff
**Wallinger** Mark
**Warren** Rebecca
**Weber** Klaus
**Weischer** Matthias
**Wekua** Andro
**West** Franz
**White** Pae
**Whiteread** Rachel
**Woods** Clare
**Wool** Christopher
**Wyn Evans** Cerith

**Xu** Zhen

**Yang** Haegue
**Yang** Fudong
**Yin** Xiuzhen
**Yuskavage** Lisa

**Zaatari** Akram
**Zeng** Fanzhi
**Zhang** Huan
**Zhao** Bandi
**Żmijewski** Artur

THE
TWENTY
FIRST
CENTURY
ART
BOOK

Φ

Phaidon Press Limited
Regent's Wharf
All Saints Street
London N1 9PA

Phaidon Press Inc.
65 Bleecker Street
New York
NY 10012

www.phaidon.com

First published 2014

© 2014 Phaidon Press Limited

ISBN 978 0 7148 6739 7

A CIP catalogue record of this book is available from
the British Library

**Authors**
Jonathan Griffin, Paul Harper, David Trigg and Eliza Williams

**Editors**
Lee Beard and Rebecca Morrill

**Production Controller**
Adela Cory

**Design**
Studio Philippe Apeloig

**Layout**
Géraldine Nassieu-Maupas

**Printed in Hong Kong**

**Abbreviations**
h=height
w=width
d=depth
l=length
diam=diameter
dur=duration

**The Twenty-First Century Art Book** presents a fascinating overview of what has been a hugely prolific period for the visual arts since the start of the new millennium. Easy to use, insightful and fresh, this book is a far-reaching A to Z of international artists working across a wide range of media and techniques. It features the best known names in the contemporary art world – Ai Weiwei, Matthew Barney, Jeff Koons, Christian Marclay, Gerhard Richter, Cindy Sherman and Jeff Wall – as well as introducing many of the rising stars of the next generation. Each artist is represented by an illustration of a significant artwork, accompanied by an illuminating text. The alphabetical arrangement allows a performance by Marina Abramović to be studied next to a painting by Tomma Abts, a sculpture by Subodh Gupta contrasted with a photograph by Andreas Gursky, or an intricate installation by Sarah Sze considered alongside a two-screen video projection by Fiona Tan. The entries are comprehensively cross-referenced, and a glossary of artistic and technical terms is included, together with a listing of the major art events across the globe. By avoiding traditional artistic and geographical categorizations, **The Twenty-First Century Art Book** is an invaluable visual source book that provides an exciting and compelling celebration of contemporary art.

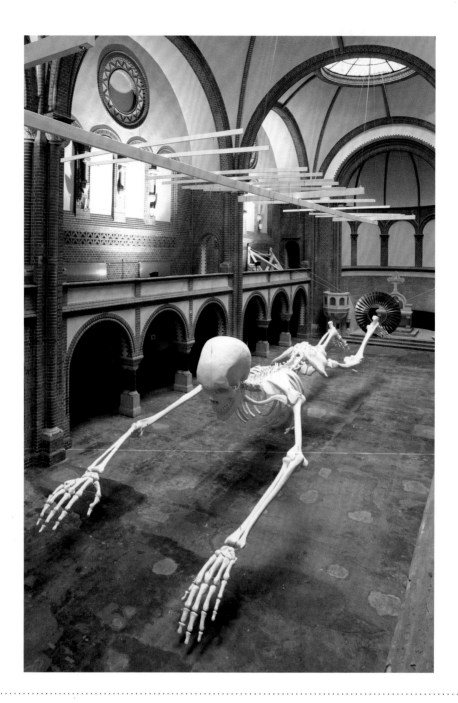

# **Abdessemed** Adel

### Habibi, 2003

An enormous human skeleton with its arms outstretched hovers horizontally above the floor as if frozen mid-flight. Behind its feet hangs a large aircraft engine turbine, seemingly propelling the flying bones (although it could equally be sucking the skeleton towards destruction). Skeletons appear as reminders of death throughout art history, but Abdessemed's oversized sculpture seems more comical than sobering. Known for his provocative works tackling racial, sexual and religious taboos, Abdessemed employs a wide range of media, refusing to limit himself to a single approach. Now based in

Paris, he fled his native Algeria as a political migrant following the violent repercussions of the military coup that toppled the country's government in 1992. Although his sculptures, videos, drawings, animations and installations can often be explicit in their shock value, many express the artist's deeper concern with the fragility of life and the violent effects that our globalized society has on the individual.

⌁ Altmejd, Hirst, Orozco

**Adel Abdessemed. b** Constantine, Algeria, 1971. **Habibi**. 2003. Resin, fibreglass, polystyrene, and aeroplane engine turbine. 121 m. 169 ft. Installation view 'Peintures/Malerei – Art France Berlin', Martin-Gropius-Bau, Berlin, Germany, 2006. Collection Mamco, Geneva, Switzerland

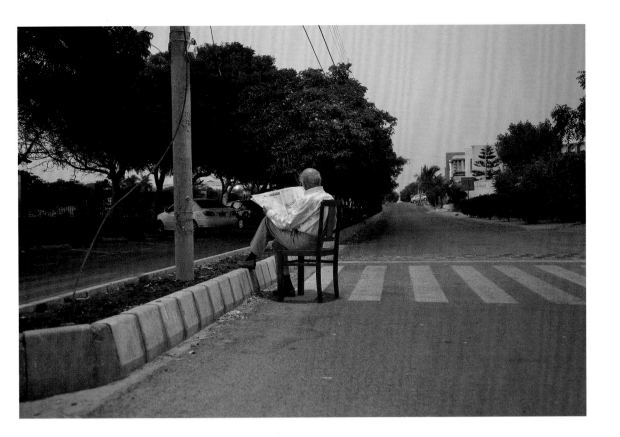

# Abidi Bani

### Jerry Fernandez, 7:45 pm, 21 August 2008, Ramadan, Karachi, 2009

At first glance, Abidi's photograph *Jerry Fernandez, 7:45 pm, 21 August 2008, Ramadan, Karachi* might look like a candid – though surprising – documentary image. While it is unclear why a man would choose to read a newspaper sitting in the middle of the road, such confounding apparitions have become almost expected within the genre of international photojournalism or via the photo sharing tools of social media. Abidi, however, is an artist and suspicions that this scene is in fact fabricated are confirmed by other photographs in the same series. In one, a woman irons clothing in the street; in another, someone arranges flowers. Though each photograph is (allegedly) taken on a different day, all are shot within the holy month of Ramadan at an hour when the city's streets are typically deserted. Abidi's work, which also encompasses video, explores the territories between the bizarre and the banal, between cultural archetypes and ironic, constructed performance.

⋯⋮⋅ Sherman, Wall, Zhao

**Bani Abidi. b** Karachi, Pakistan, 1971. **Jerry Fernandez, 7:45 pm, 21 August 2008, Ramadan, Karachi**. 2009. Duratrans lightbox. **h** 50.8 x **w** 76.2 cm. **h** 20 x **w** 30 in

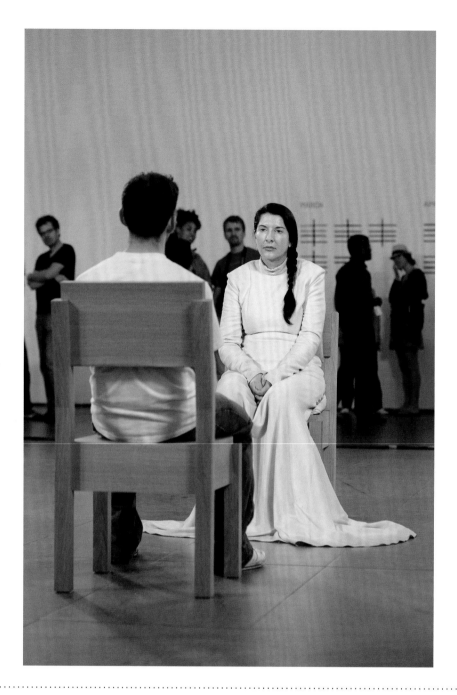

# Abramović Marina

## The Artist is Present, 2010

As part of the biggest ever exhibition of performance art in MoMA's history, Abramović sat on a chair for seven hours a day, six days a week, for nearly three months. Visitors were invited to take turns sitting opposite the artist who, dressed in a flowing gown, remained silent throughout. Viewers became participants, as much a performer as the artist. Some cried, others stared, and some even claimed to have had transcendent experiences. For Abramović, the work was a simple exhortation to contemplate the present moment. While appearing straightforward, it was, in fact, incredibly gruelling, both physically and psychologically as she tried to engage with them all on a personal level. Pushing her body to the limit has been a defining characteristic of Abramović's extreme performances since the 1970s. Her challenging works, which have seen her body stabbed with knives, exposed to ice and cut with razor blades, continue to influence new generations of artists.

⋯⋮⋗ Chopra, Kawara, Ndiritu, Zhang

**Marina Abramović. b** Belgrade, Serbia, 1946. **The Artist is Present**. 2010. Installation view, 'Marina Abramović: The Artist is Present', MoMA, New York, 2010

# **Abts** Tomma

## **Veeke, 2005**

While Abts's paintings are invariably and determinedly abstract, they have a precision that is astonishing for subjects that existed only in her mind and are painted without preparatory sketches. In this work, *trompe-l'œil* shadows make some lines leap from the canvas, while others look completely flat. The picture, convincing as it at first seems, is a physical impossibility. Seen up close, ridges in the surface of the paint reveal that Abts built up the image from different layers and shapes. The muted colour scheme in *Veeke* evokes 1960s Middle European domestic interiors or textbook covers, remembered perhaps from Abts's childhood in Germany. While many contemporary artists make deliberate aesthetic reference to historic Modernist abstraction, Abts's work refers only to itself. All her paintings are exactly the same size; as if to assert their individuality, however, she titles each one with a name taken from a dictionary of approved German forenames.

·····∴· Grotjahn, Mehretu, Shahbazi, Stingel

**Tomma Abts. b** Kiel, Germany, 1967. **Veeke**. 2005. Acrylic and oil on canvas. **h**48 x **w**38 cm. **h**18 7/8 x 14 1/2 in

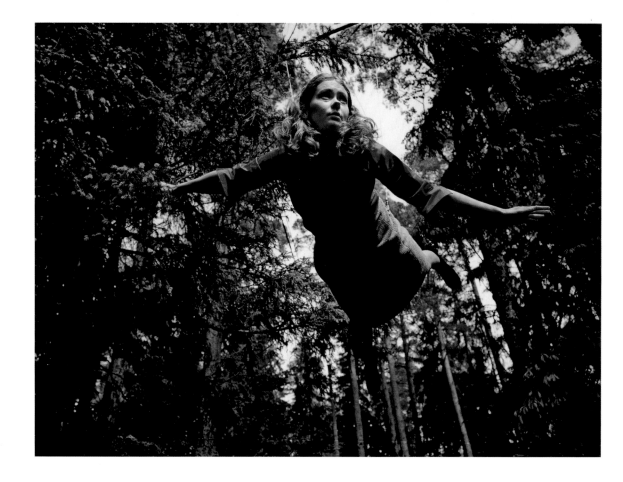

8

# **Ahtila** Eija-Liisa

## The House, 2002

After graduating as a painter, Ahtila studied filmmaking in London and Los Angeles. The work she now makes straddles both installation art and film, and although it is typically shown in art galleries it draws on the techniques and production values of cinema more than a lot of moving image art. *The House* is a three-channel film that plays across three perpendicular screens. A woman drives through a forest to her house, where she eats a sandwich at her kitchen table. Linear time and rational logic break down, however, when we see the car moving without a driver, sounds emerging without sources and the woman floating through the trees. The film evolved from conversations Ahtila had with people suffering from psychotic disorders: *The House* allows viewers to inhabit the disordered mind of the protagonist. Throughout her work, Ahtila dissolves the perceived boundaries between interior and exterior worlds, frequently focusing on women going through a traumatic experience.

⋯⋮⋅ Hiorns, Julien, Kabakov, Suh

**Eija-Liisa Ahtila. b** Hämeenlinna, Finland, 1959. **The House**. 2002. Three-channel video projection, colour, sound. **dur** 14 min

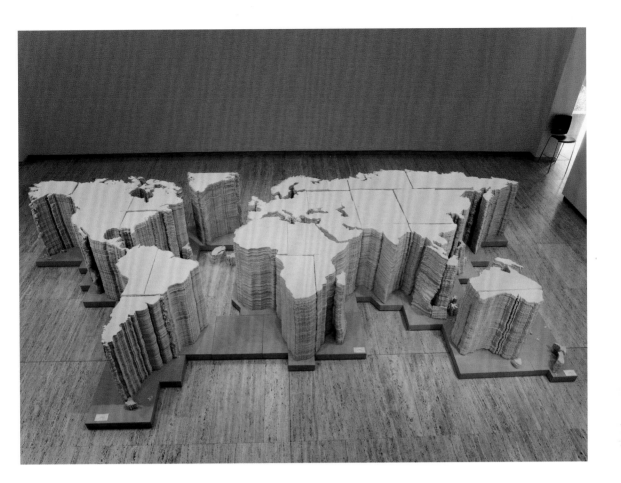

# Ai Weiwei

## World Map, 2006

Thousands of sheets of fine cotton cloth have been cut into the shape of a world map and layered precisely to create a three-dimensional sculpture. Actual geographical borders between countries are ignored in favour of the straight edges of the fabric, which divide the map. Using a familiar image, Ai has constructed a complex work that is by design very labour-intensive to install, thus evoking China's status as a source of cheap workers for the garment industry. The difficulty of placing the elements accurately also introduces issues of international relations and global trade. The historical, socio-political and economic conditions of contemporary China frequently serve as starting points for Ai's art and he has become internationally known for his critical stance. He uses a diverse range of techniques and materials, often drawing on Chinese traditions, and although politically motivated, he uses humour and metaphor, producing work that is poetic and subtle in its content, with formal aesthetic qualities.

⋯⋮ Alÿs, Anatsui, Sierra

Ai Weiwei. b Beijing, China, 1957. World Map. 2006. Cotton on wooden base. h100 x w800 x d600 cm. h39 1/2 x w315 x d236 1/4 in

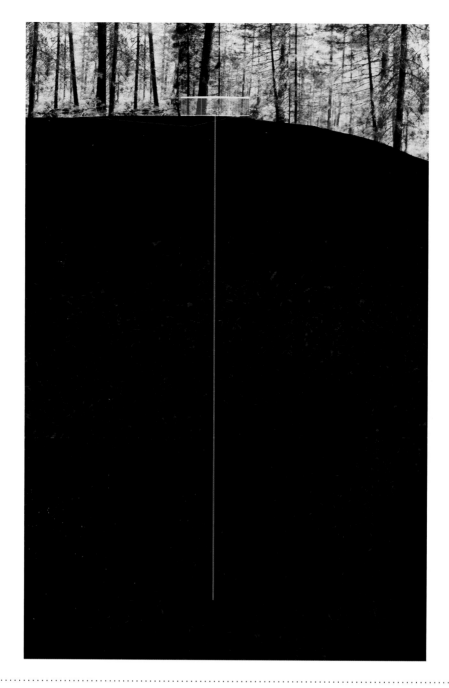

# **Aitken** Doug

## Sonic Pavilion, 2009

A unique listening experience is provided by this immersive sound installation, in which the mysterious rumblings of a subterranean realm reverberate around a glass-enclosed pavilion. Situated in the forest-covered hills of southeast Brazil, at the Inhotim sculpture park and museum, Aitken's installation amplifies low-level noises deep below the earth's surface. High-sensitivity microphones buried at a depth of 600 metres (2000 ft) capture these extraordinary geological sounds, which are then played back through the pavilion's speakers. Sometimes peaceful and mellow, at other times agitated and turbulent, the sounds change continually. As a living artwork it exists in a state of constant flux and no two visits to the pavilion are the same. The work builds on Aitken's interest in sound, which is an important aspect of his films and video installations. Working with a wide range of media, his works investigate the intersection of nature and culture, and explore connections between memory, time and space.

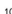 Hiorns, Mirza, Villar Rojas

**Doug Aitken. b** Redondo Beach, CA, USA, 1968. **Sonic Pavilion**. 2009. (Rendering). Concrete, steel, and glass. Site-specific outdoor installation, Inhotim Contemporary Art Center, Brumadinho, Brazil. **diam** 14 x 4.2 m above grade. **diam** 46 x 13 ft 9 1/2 in above grade

# Allora & Calzadilla

## Stop, Repair, Prepare: Variations on 'Ode to Joy' for a Prepared Piano, 2008

Emerging from a hole cut into the centre of a baby grand piano, a pianist proceeds to play – or at least attempts to play – the famous final movement of Beethoven's *Ninth Symphony*, known commonly as 'Ode to Joy'. Leaning awkwardly over the keyboard, the performer plays upside down and in reverse. With two octaves rendered unplayable by the hole, the music is disjointed and muffled. Moreover, the performer's feet propel the instrument around the room, according to a prearranged choreography. The work addresses the ambiguous politics of a melody that was a favourite of Hitler's; employed as the national anthem of apartheid state Rhodesia; praised during the Chinese Cultural Revolution; and, more recently, adopted as the anthem of the European Union. Based in Puerto Rico, Allora and Calzadilla have been collaborating since 1995. Engaging with history and the conflicts and challenges of globalization, their rich body of work covers sculpture, photography, installation and video.

······ Feng, Warren, Haegue Yang

**Jennifer Allora. b** Philadelphia, PA, USA, 1974. **Guillermo Calzadilla. b** Havana, Cuba, 1971. **Stop, Repair, Prepare: Variations on 'Ode to Joy' for a Prepared Piano.** 2008. Prepared Bechstein piano, pianist (Andrea Giehl, depicted in photo) l206 cm. l81 in

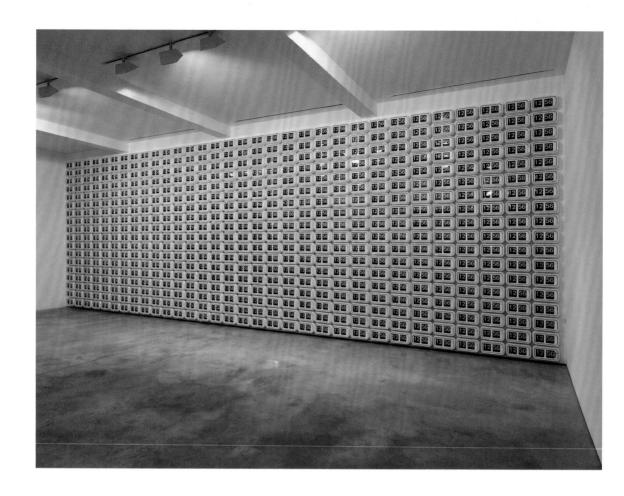

# **Almond** Darren

### Tide, 2008

This installation contains over five hundred identical digital clocks. Hung in a grid formation and filling an entire wall, they are synchronised so that each one reads the same time. Viewers wait in silence until, in unison, the clocks all flip over with a loud clack as another minute passes. For Almond the work is an attempt to isolate and encapsulate time within the tangible form of a sculpture. Clocks are a recurring motif in the work of the British artist, whose films, installations and sculptures have, since the mid 1990s, focused on the unrelenting passage of time and its effects. Scientific methods of measuring time are often pitted against the subjective perception of temporal events; indeed, waiting for the minutes to pass in this installation can feel like a very long time. In this way Almond challenges viewers to contemplate their relationship with time and its influence upon the world.

⋯⋮⋅ Barba, Macchi, Marclay, Wyn Evans

**Darren Almond. b** Wigan, UK, 1971. **Tide**. 2008. 576 digital wall clocks. Perspex, electro-mechanics, steel, vinyl, computerized electronic control system and components. Each clock: **h** 31.2 x **w** 18.2 x **d** 14.2 cm. **h** 12 1/4 x **w** 7 1/4 x **d** 5 1/2 in. Installation view, 'Darren Almond: Fire Under Snow', Parasol unit foundation for contemporary art, London, 2008

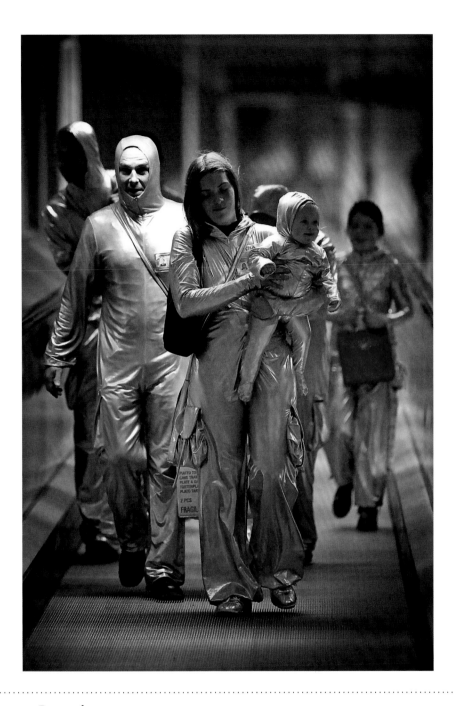

# Althamer Pawel

## Common Task, 2009

In the ongoing work *Common Task*, Althamer uses the framework of a science-fiction story to devise a series of journeys, which have so far taken place in Warsaw, Brazil, Belgium, the UK and Mali. In the course of these journeys Althamer's friends and neighbours from his hometown in Poland improvise actions and events in the role of visiting aliens, dressed in futuristic gold lamé jumpsuits, which are documented in films and photographs. These extraterrestrial travellers bring fresh perspectives to everyday reality, drawing attention to the mysterious potential of the world. Althamer's work, which embraces

sculpture, performance, film and public actions, often takes the form of orchestrated events involving communities of people in collective acts of creation. Central to his work is a belief in the transformative possibilities of art. For many years he has taught a pottery evening class for adults with learning and physical disabilities.

⋯⋮ Avery, Cantor, Deller

**Pawel Althamer. b** Warsaw, Poland, 1967. **Common Task**. 2009. Arrival at Heathrow Airport, destination Modern Art Oxford, UK, 2009

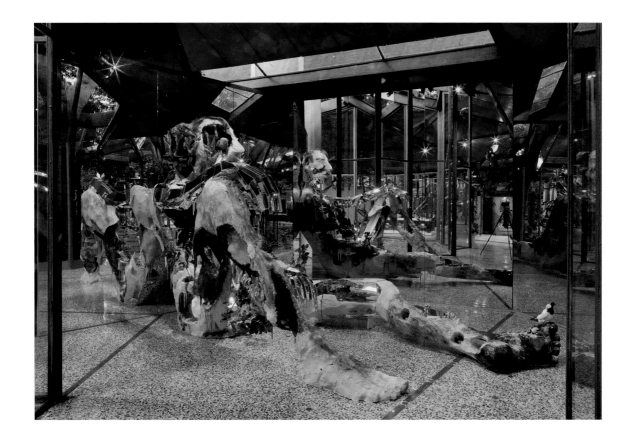

# Altmejd David

### The Giant 2, 2007

In Altmejd's fantastical sculptures and installations, one element seems constantly to be melting into the next. With *The Giant 2*, a sculpture that Altmejd made as part of his installation for the Canadian Pavilion at the *52nd Venice Biennale*, the enormous reclining figure appears to be dissolving from within. While his hairy skin is viscerally real, holes in his legs and torso reveal his insides to be made from shards of mirror. A handcrafted sculpture of an owl has taken up residence in his face. Altmejd expresses the metaphorical qualities of his humanoid sculptures by confusing physical distinctions between inside and out.

Faces might sprout crystals, or fruit, or miniature hands, for example, while their skin cracks apart and threatens to slough off entirely. Other sculptures by the New York-based artist, are predominantly abstract, such as *The Orbit* (2012), an ethereal Plexiglas vitrine containing intricate systems of shimmering chain, cracked mirrors, cast hands and a shower of cherries.

⋯⋰ Bhabha, Villar Rojas, Weber

**David Altmejd. b** Montreal, Canada, 1974. **The Giant 2**. 2007. Foam, wood, glass, mirror, Plexiglas, resin, silicone, taxidermy birds and animals, synthetic plants, paint, pinecones, horse hair, burlap, chains, wire, feathers, quartz, pyrite, other minerals, jewellery, beads, glitter. **h**254 x **w**427 x **d**234 cm. **h**100 x **w**168 x **d**92 in

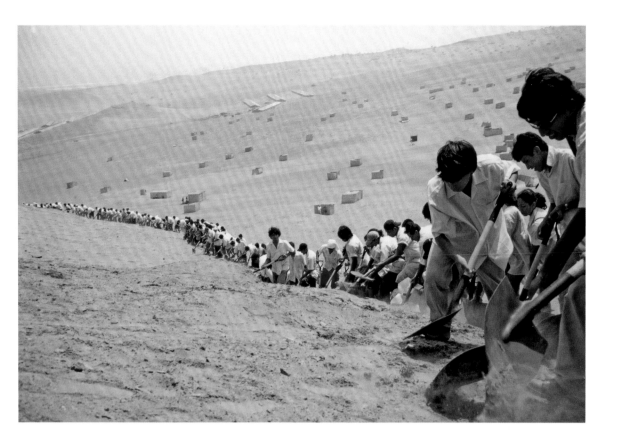

# Alÿs Francis

## When Faith Moves Mountains, 2002

This video work captures the occasion when 500 volunteers armed with spades attempted to move an immense sand dune near Lima, Peru. People shuffle across the sand in a long, snaking line, shovelling as they go, but in the end only a small amount of sand is displaced. The substantial disproportion between effort and outcome typifies Alÿs's projects, which often function as social allegories; in this case the effectiveness of collective effort and the actual power of faith is called into question. Alÿs first became known for his simple yet poignant performances, many of which took place on the streets of Mexico City where the Belgian-born artist has lived since the mid-1980s. More recently he has explored the relationship between poetic and political acts. The potential for his actions to become fables or urban myths is an important factor for the artist, who only considers his works to be complete once their stories have been shared.

·····⫶ Barba, Gelitin, Sierra

**Francis Alÿs. b** Antwerp, Belgium, 1959. **When Faith Moves Mountains**. 2002. Video installation with one projection and two monitors. Dimensions variable

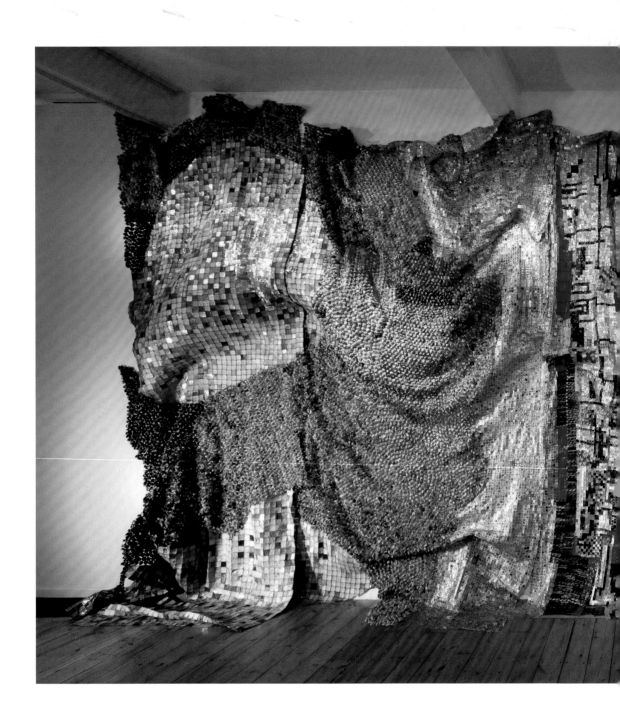

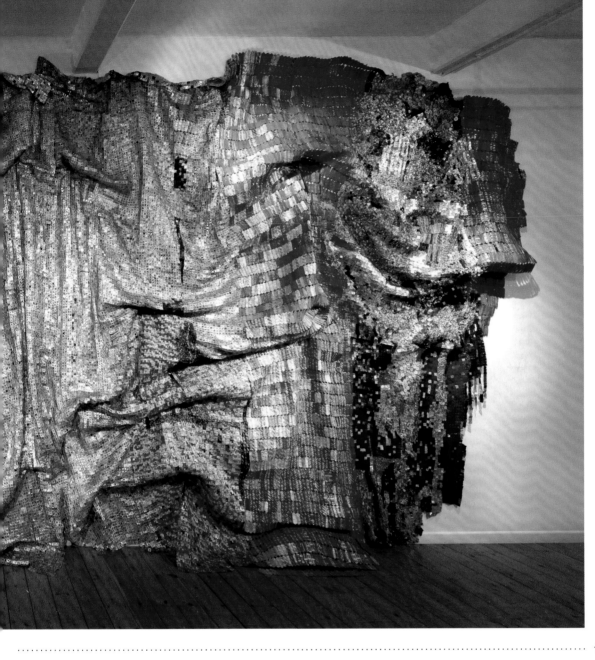

# Anatsui El

## In the World, But Don't Know the World, 2009

A huge, hanging cloak of shimmering gold, red, blue and black from a distance looks like an irregular tapestry or piece of ceremonial cloth, but, up close, viewers see that it is made from thousands of pieces of metal, individually wired together. Some bear fragments of lettering. Anatsui trained in Ghana, and in early work he incorporated discarded items such as metal trays or driftwood into abstract assemblages that equally evoke Western Modernist traditions and African fabric design. In Nsukka, Nigeria, where he has lived since 1975, he experimented with aluminium bottle tops, which he flattened and wired together into

metal wall hangings such as *In the World, But Don't Know the World*. Since the early 2000s Anatsui has become widely recognized for these works, which crumple to fit into whatever display space is available or, as with the massive *TSIATSIA – searching for connection* (2013), cover whole facades of buildings.

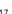 Gaillard, Ndiritu, Perry, Shonibare

**El Anatsui. b** Anyako, Ghana, 1944. **In the World, But Don't Know the World**. 2009. Aluminium and copper wire. **h** 560 x **w** 1000 cm. **h** 220 1/2 x **w** 393 3/4 in

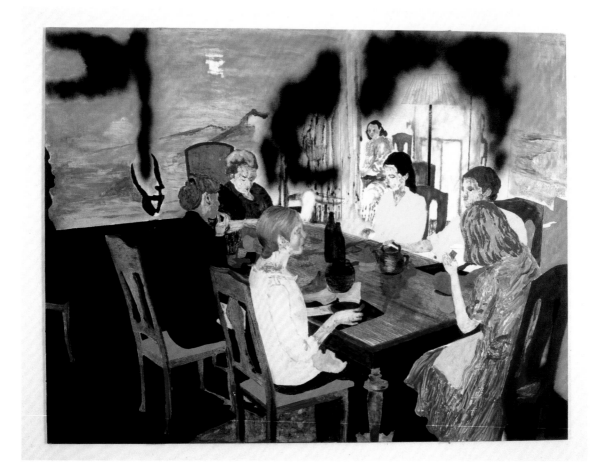

# **Andersson** Mamma

## Travelling in the Family, 2003

In this painting a family are sitting around a dining table, yet there is little engagement between them. Hovering above the figures is what appears to be an ominous cloud of black smoke, though perhaps it is just dirt on the windowpane through which we, the observers, look. Behind them is a landscape scene painted onto a wall, or maybe it is the view through another large window. This type of visual ambiguity is regularly employed by Andersson, whose seemingly unexceptional interiors and landscapes become increasingly perplexing on closer inspection. Abstract elements disrupt figurative passages, while thick paint gives way to transparent areas where sketchy pencil lines are visible. Inspired by dreams, myths and memories, Andersson's paintings are often populated by people who seem distracted or distant, as if lost in their own inner worlds. For all their apparent ordinariness, her images are strange and disconcerting, perhaps pointing to realms beyond the visible.

⋯⋰ Ghenie, Hatoum, Rauch

**Mamma Andersson. b** Luleå, Sweden, 1962. **Travelling in the Family**. 2003. Acrylic and oil on panel. **h**92 x **w**122 cm. **h**36 1/2 x **w**48 in

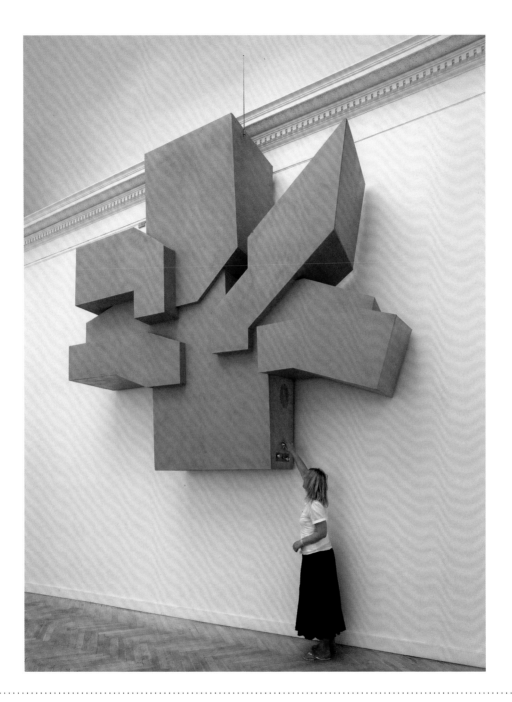

# Aranberri Ibon

## Gaur-Egun (This is CNN), 2002

Created from memory, this wooden sculpture is a rudimentary copy of a work by Nèstor Basterretxea hanging in the assembly hall of the Basque parliament. Representing a tree of seven branches, Basterretxea's original oak sculpture is symbolic of the traditional meeting place of Basque political assemblies in Guernica and, since the early 1980s, has provided a backdrop for all political activity in the assembly. Aranberri's mental reconstruction speaks to the fact that the work has become ingrained in the popular imagination after being endlessly reproduced in newspaper photographs and television reports. Furthermore, the artist has transformed his version into a functioning radio with an AM/FM dial and speakers. The interface of the natural world and human culture is a central concern for the artist, whose sculptures and installations explore the relationship between politics, nature and society. By decoding familiar images, signs and objects, he challenges popular values and questions societal preconceptions.

⋯⋮⋅ Fast, Penone, Tiravanija

**Ibon Aranberri. b** Itziar, Spain, 1969. **Gaur-Egun (This is CNN).** 2002. Wood, radio, speakers. **h** 560 x **w** 580 x **d** 120 cm. **h** 220 1/2 x **w** 228 1/2 x **d** 47 1/4 in. Installation view, 'Ibon Aranberri. Gaur-Egun', Trayecto Galería, Vitoria-Gasteiz, Spain, 2002

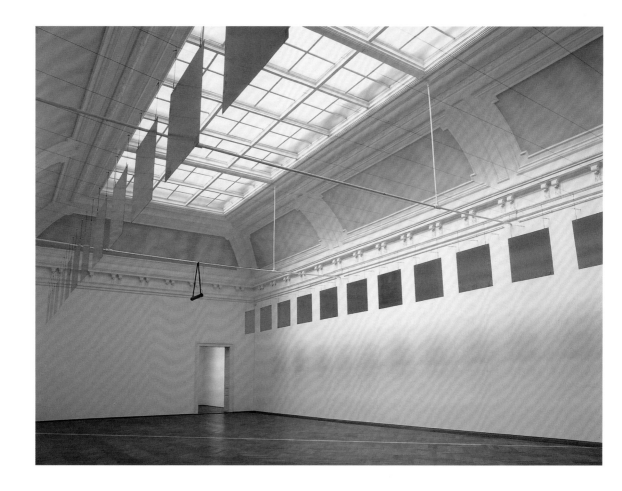

## **Assaël** Micol

### Chizhevsky Lessons, 2007

Suspended rows of copper plates surround an adapted power generator so that the whole room is transformed into an electrostatic field. Electrostatic phenomena can be experienced when, for instance, we rub synthetic cloth against a balloon and a charge is created by friction. This build-up can be discharged by bringing the surface into contact with a non-conductive surface, and is sometimes experienced as a mild 'shock'. The air around Assaël's *Chizhevsky Lessons* becomes tangibly charged and visitors are warned not to touch each other's faces. The artist produced the work in cooperation with a physics research institute in Moscow and drew on the investigations of Alexander Chizhevsky who studied the impact of electrostatic fields on the human psyche. Assaël, who was the *Future Generation Art Prize 2012 Special Prize Winner*, often uses obsolete scientific apparatus in her work to explore scientific and physical phenomena and their interaction with the human body.

·····⊹ Hatoum, Mirza, Sugimoto

**Micol Assaël. b** Rome, Italy, 1979. **Chizhevsky Lessons**. 2007. Copper plates, steel wire, cascade generator, transformers, voltmeter. Dimensions variable

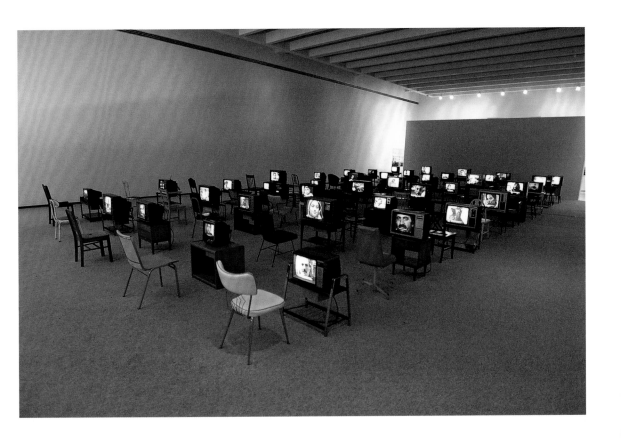

# **Ataman** Kutluğ

## Küba, 2005

A room is filled with the sound of chattering voices. The sound comes from forty television screens, each showing a person talking. All are residents of Küba, a slum neighbourhood in Istanbul that sprang up in the late 1960s as a place of refuge for political non-conformists. Ataman spent two years there to create this piece, getting to know the people and recording interviews. The resulting films tell stories of poverty, hardship, crime and addiction, as well as hopes and dreams and possibly fantasies and lies. The television sets are old-fashioned and visitors watch them while sitting on equally well-loved chairs,

giving the installation a homely and intimate feel. Ataman's films and art installations feature stories from both fiction and real people's lives, with the tales coming together to paint a portrait of contemporary life in Turkey, as well as in Turkish communities around the world.

⋯⋮⋅ Belmore, Jacir, Salcedo

**Kutluğ Ataman. b** Istanbul, Turkey, 1961. **Küba**. 2005. Dimensions variable. Installation view, *Carnegie International*, Pittsburgh, PA, USA, 2005

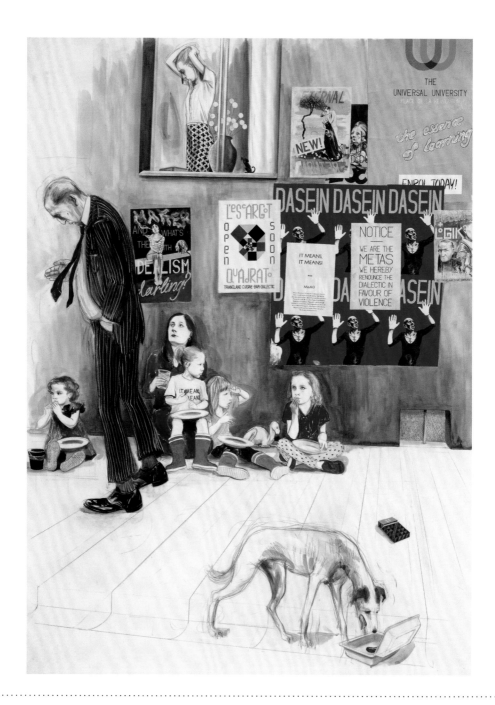

# **Avery** Charles

### Untitled (Beggars near the Octagon of the Noumenon), 2013

In this drawing a downcast man walks past a young mother and her children who are begging in the street. Behind the figures, a wall filled with fly posters provides a glimpse into the culture of the fictional city in which this scene is set. The city – known as Onomatopoeia – is just one element of Avery's epic project *The Islanders* which, since 2004, has employed drawing, sculpture, installation and text to illustrate various facets of life on an imaginary island. The Island is a perplexing and surreal place where distinctions between reality and fiction are routinely blurred. Its landscape, wildlife, people and customs have all been described by Avery, who conceived the project as a way to explore his wider interests in philosophy, literature and art. However, *The Islanders'* various elements provide only snapshots of this mythical world; it is left to viewers to continue the narrative in their own imaginations.

⋯⋮⋅ Cao, Farmer, Kentridge

**Charles Avery. b** Oban, UK, 1973. **Untitled (Beggars near the Octagon of the Noumenon)**. 2013. Pencil, ink, acrylic and gouache on paper mounted on linen.
**h**114 x **w**83.6 cm. **h**44 7/8 x **w**32 7/8 in

# **Baghramian** Nairy

## Class Reunion, 2008

The eighteen abstract sculptures that comprise this work appear like designer lamp stands or hat racks. Made from painted metal and cast rubber, the slender forms are coloured black or white, save for a single burst of flamingo pink. Baghramian has given each sculpture a name, endowing it with character and personality: there's the Dandy, the Slacker and Mr Hunger. Positioned close together, their arrangement, along with the work's title, suggests a social gathering. Yet one notably stands in a corner by itself and another two lean against a wall, away from the crowd. With the simplest of gestures, Baghramian evokes

important questions relating to social inclusion and exclusion. Based in Berlin, the Iranian-born artist is best known for her sculptural installations and photographs that examine the notion of display within the context of art and design history. Her refined and elegant works are rooted in Minimalism but also allude to furniture, interior design and architecture.

⋯⫶⋯ Barlow, Deacon, Gormley

**Nairy Baghramian. b** Isfahan, Iran, 1971. **Class Reunion**. 2008. Mixed media installation. Dimensions variable. Installation view, Contemporary Art Gallery, Vancouver, BC, Canada, 2012

# Baldessari John

### Raised Eyebrows/Furrowed Forehead: Black and Blue Eyebrows, 2008

A surprised facial expression fills this large, strangely-shaped work, which combines photography, painting and sculptural relief. The furrows of the brow have been gouged out and filled with green paint, while the eyebrows, which protrude from the surface of the work, are coloured black and blue. The piece belongs to a series of similar works that recall paintings, based on old billboard posters, made by Baldessari in the late 1950s. In a career spanning over five decades, Baldessari has worked with painting, photography, video, printmaking, sculpture and installation. Though beginning as a painter, he renounced the medium altogether in 1970 by burning many of his works. This act of destruction signalled his transition to the text-based and photographic practices for which he is best known. Fusing Pop art's use of mass-media imagery with Conceptual art's approach to language, Baldessari's witty and subversive works typify a Post-Modern approach to art-making.

⋯⋮ Kelly, Koons, Reyle

**John Baldessari. b** National City, CA, USA, 1931. **Raised Eyebrows/Furrowed Forehead: Black and Blue Eyebrows**. 2008. Three-dimensional archival print, laminated with Lexan, mounted on shaped form with acrylic paint. **h**146.7 x **w**259.1 x **d**17.2 cm. **h**57 3/4 x **w**102 x **d**6 3/4 in

# de Balincourt Jules

## Blind Faith and Tunnel Vision, 2005

A multicoloured rainbow shoots skywards above a desolate, post-apocalyptic cityscape. Perhaps the fallout from some catastrophic explosion, the radiant fan of coloured stripes threatens to engulf the detritus-strewn street below. With its bombed-out high-rises, smashed street lamps and collapsing telephone poles, each element of de Balincourt's composition draws your eye to a single vanishing point. The French-born artist employs a variety of materials and techniques in the creation of his work, including stencilling, masking, scraping and spray-painting. His paintings are filled with detail and odd spatial distortions, often hovering between representation and abstraction. Central to his earlier works were ideas regarding the nature of government and the social, political and economic structures of the USA, where he has lived since childhood. More recently his scenes have shifted in their focus, presenting an imagined world at odds with the rampant consumerism and imperialism that he previously critiqued.

⋯⋮ Grotjahn, Hlobo, Sala

Jules de Balincourt. b Paris, France, 1972. **Blind Faith and Tunnel Vision**. 2005. Oil and enamel on wood. **h** 198.1 x **w** 147.3 cm. **h** 78 x **w** 58 in

# **Balka** Miroslaw

## How It Is, 2009

Appearing like an enormous shipping container, this imposing steel structure dominated the Turbine Hall of London's Tate Modern. Raised up on 2-metre-high stilts and accessed via a ramp at one end, visitors were invited to enter its pitch-black interior. Many found the experience of negotiating the cavernous chamber to be unnerving and bewildering. With a total absence of internal light, the work provokes feelings of apprehension, foreboding and, upon leaving, a sense of relief. Much of Balka's work is concerned with the fate of the Jews in his native Poland during the Second World War, the majority of whom were exterminated by the Nazis. This temporary piece alluded to that history, evoking the freight trains that transported victims to concentration camps such as Auschwitz. Known primarily for his non-figurative sculptures using ordinary industrial materials, Balka also works with drawing and video to explore themes of history and memory.

·····∴· Boltanski, Höller, Sosnowska

**Miroslaw Balka. b** Warsaw, Poland, 1958. **How It Is.** 2009. Steel, flock. **h**13 x **w**10 x l30 m. **h**42 ft 7 7/8 in x **w**32 ft 9 3/4 in x l98 ft 5 1/8 in. Installation view, 'The Unilever Series', Tate Modern, London, 13 October 2009–5 April 2010

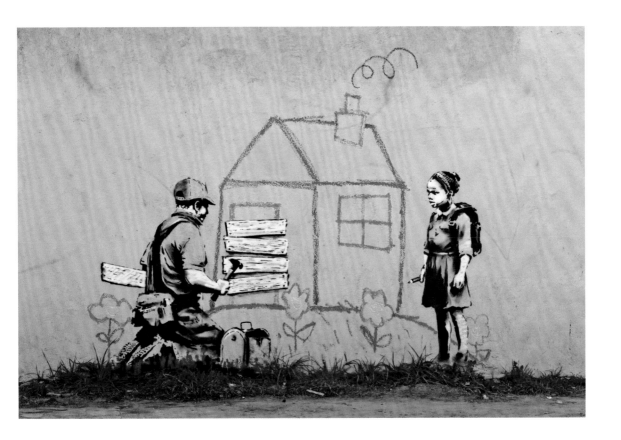

# Banksy

## Untitled (LA, 2011), 2011

A young girl, pencil in hand, watches in annoyance as her simple drawing of a house is boarded up. Applied directly to a Los Angeles wall, this mural is one of several outdoor works by Banksy that appeared across the city in early 2011. While the figures have been rendered using the artist's familiar stencil technique, the child's house has been drawn freehand with colourful crayon. With characteristically acerbic wit, the work addresses the issue of foreclosure that plagued the US housing market during the early 2010s, speaking bluntly of the callousness of those involved in repossessing people's homes.

Appearing on city streets throughout the world, Banksy's satirical art combines subversive humour with social and political commentary. Starting out as part of the British graffiti subculture in Bristol in the early 1990s, he has since become one of the world's most famous street artists. Preferring to remain anonymous, speculation is rife regarding his true identity.

⋯⋮ JR, Pettibon, Shrigley

**Banksy. b** Bristol, UK, c.1974. **Untitled (LA, 2011)**. 2011. Spray paint and crayon on wall. Installation view, 1547 E Washington Blvd, Los Angeles, CA, USA, 2011

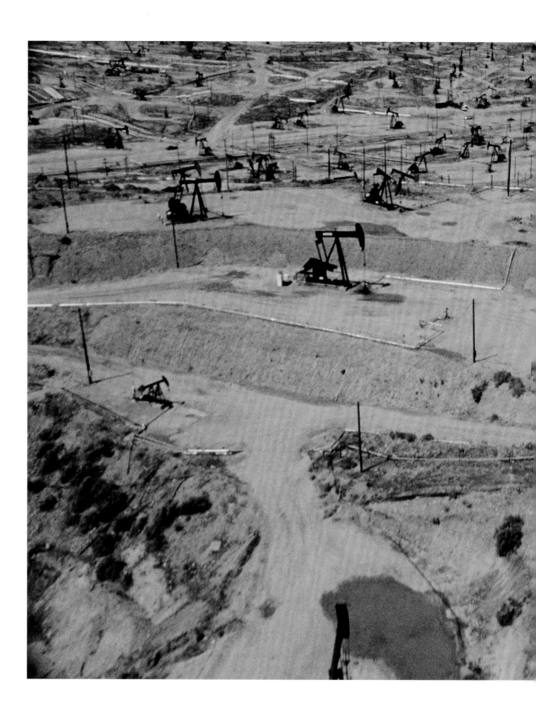

# **Barba** Rosa

Time as Perspective, 2012

Aerial views of the Texan desert are intercut with close-up shots of enormous nodding oil pumps. Inspired by the seemingly endless perspective of this vast American landscape, Barba's film is a meditative study of the elusive nature of time. Like gigantic metronomes, the pumps' steady and incessant rhythmical movements allude to time's passing, as does the clacking film projector, which extends the experience of time to the gallery space. Enigmatic locations – ranging from military test sites and abandoned racetracks to concrete igloos near Mount Vesuvius – are an important element of the Berlin-based artist's films. Equally significant is the medium of analogue film itself: many of her installations and sculptural works deal with its materiality. To accompany her exhibitions Barba also creates publications called 'Printed Cinema'. These are distributed for free for the duration of the exhibition in which they appear.

⋯⋮ Almond, Gormley, Gusmão & Paiva

**Rosa Barba. b** Agrigento, Italy, 1972. **Time as Perspective**. 2012. 35 mm film. **dur** 12 min

# Barlow Phyllida

## Untitled: hoardings, 2012

Reaching up from the floor, Barlow's enormous scaffold-like sculpture dominates the display space. The complex work consists of numerous vertical and horizontal wooden poles that have been roughly joined together with cement and fabric, evoking something that might be seen on a construction site. Barlow's apparently slipshod assemblage, as with much of her work, takes its inspiration from the urban environment. She has made work since the 1970s, alongside a career as a celebrated art tutor, and is best known for her large-scale sculptures using cheap, readily available materials such as plywood, plaster, cement, fabric, paper and cardboard. She assembles them intuitively, often in situ, by throwing, pouring, stretching and balancing their component parts to create unexpected formal relationships that often respond to their surrounding architecture. The results are abstract, resolutely anti-monumental and many are crudely coloured with industrial paint. Reflecting the transience of life, the fragile sculptures are typically dismantled after they have been shown.

⋯⋰ Halilaj, Neto, Sze

**Phyllida Barlow. b** Newcastle upon Tyne, UK, 1944. **Untitled: hoardings**. 2012. Timber, scrim, cement, black felt, paint. **h**600 x **w**1400 x **d**700 cm. **h**236 1/4 x **w**551 1/8 x **d**275 5/8 in. Installation view, 'First International Biennale of Contemporary Art: The Best of Times, The Worst of Times. Rebirth and Apocalypse in Contemporary Art', Mystetskyi Arsenal, Kiev, Ukraine, 2012

# **Barney** Matthew

### Cremaster 3, 2002

Barney's epic *Cremaster Cycle* (1994–2002) consists of five feature-length films that explore processes of biological reproduction and development with *Cremaster 3* as the final, and at over 3 hours, longest of the series. The films have stylized futuristic settings and are peopled by exotic and hybrid creatures. The enigmatic narrative incorporates elements of genetic science, body modification, sport, mythology and sexuality. It seems to dramatize a yearning to transcend the genetic limitations of the human condition, which resonates with contemporary issues of cloning and biological engineering. The films are notable for their production values, which aspire to the gloss of high budget mainstream cinema. Barney's long-time collaborator Jonathan Bepler composed and arranged the films' soundtracks. The cycle unfolds not just cinematically, but also through related photographs, drawings, sculptures and installations produced in conjunction with each film and often presented alongside them.

⋯∴ McCarthy, McQueen, Sherman

**Matthew Barney. b** San Francisco, CA, USA, 1967. **Cremaster 3**. 2002. 35 mm film. Colour, sound. **dur** 182 min

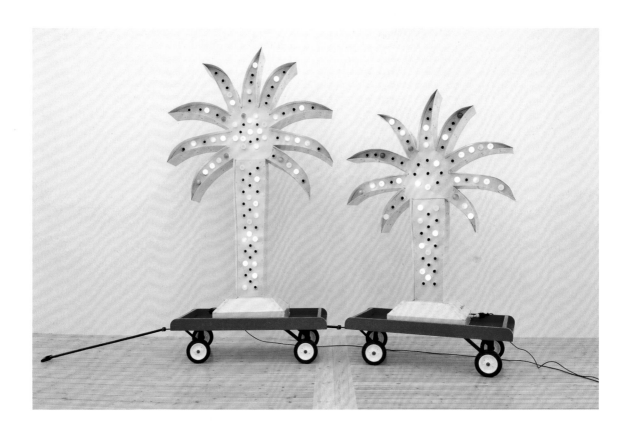

# Barrada Yto

## Twin Palm Island, 2012

Yto Barrada's hometown of Tangier provides the socio-political backdrop for her manifold activities as an artist and an activist. Just 13 kilometres (8 miles) from Europe, the city is both a jumping off place for the hopes of African migrants, and a crossroads of civilizations. Barrada's early work as a photographer offered quietly haunting images of the landscapes and people of Tangier, and often relied on implied absences: a book of her photographs published in 2005 was titled *A Life Full of Holes*. Her 2012 touring exhibition 'Riffs' and 2013 monograph expanded the scope of her inquiry beyond the city to the surrounding

'third landscape' at the edges. The toy-like fairground signage of *Twin Palm Island* is part of the artist's critical assessment of uses of the botanical in Moroccan public space, including photographs, films, sculptures, and posters featuring the polyvalent symbol of the palm tree.

⋯⋰ Genzken, Paci, Vo

**Yto Barrada. b** Paris, France, 1971. **Twin Palm Island**. 2012. Steel structure with galvanized sheet metal and coloured electrical bulbs. **h** 272.5 x **w** 390 x **d** 127 cm. **h** 107 1/4 x **w** 153 1/2 x **d** 50 in

# Bartana Yael

## Mur i Wieża, 2009

In this film a group of men and women dressed in 1930s-style clothing construct a wooden kibbutz on the site of the former Warsaw Ghetto in Poland. A high wall and a large watchtower dominate the structure, which is modelled after similar buildings seen in Palestine during the 1930s. Yet, despite the group's heroic endeavour, the result recalls a concentration camp. *Mur i Wieża* (Wall and Tower) is the second in Bartana's trilogy of films *And Europe Will Be Stunned*, which addresses notions of homeland, nationhood, Zionism and anti-Semitism. The trilogy centres on the activities of a fictional Jewish political group who desire to see over three million Jews return to Poland. In the first film, *Nightmares* (2007), the group's leader gives an impassioned speech, while in the third, *Assassination* (2011), he is murdered. Mixing together fact and fiction, Bartana's films, videos, photographs and installations examine issues of personal and national identity with reference to her native Israel.

⋯⋗ Boltanski, Sasnal, Żmijewski

**Yael Bartana. b** Kfar Yehezkel, Israel, 1970. **Mur i Wieża**, 2009. One channel RED transfer to 35 mm film. **dur** 16 min

# **Bas** Hernan

## Ubu Roi (the war march), 2009

Under a stormy sky a procession of masked revellers are led out of a fantastical city of towers and minarets along a precarious path, into a wild and threatening landscape. The people march resolutely behind the ridiculous figure of King Ubu, the fictional monarch in the fin-de-siecle play by French symbolist writer Alfred Jarry. In his familiar pointed hood and spiral-motif tunic, Ubu stands foot raised, ready to step into the abyss. A decadent bourgeoisie are being led blindly by a fool towards their destruction. The city is painted in a flat, geometric style, while the surrounding landscape is rendered in tempestuous, expressive brushstrokes. This is representative of Bas's lush, painterly style. His paintings often have a narrative, but while his earlier work tended to centre on sensual male youths, this large canvas deals with broader themes that evoke the grand scope of nineteenth-century history painting.

·····⫶ Owens, Perry, Ryden

**Hernan Bas. b** Miami, FL, USA, 1978. **Ubu Roi (the war march)**. 2009. Acrylic on linen over panel. Diptych. **h** 213.5 x **w** 366 cm. **h** 84 x **w** 144 in

# **Belmore** Rebecca

## The Named and the Unnamed, 2002

This video installation captures a performance that Belmore staged on the streets of Vancouver in the summer of 2002. Titled *Vigil*, it commemorated the lives of numerous women who went missing in the downtown east side of the city, many of them victims of an alleged serial killer. After scrubbing the pavement, Belmore reads the names of the missing women, violently pulling red rose stems through her clenched teeth. Later, after nailing her dress to a telephone pole, she pulls and struggles until her clothing rips. Together, this series of acts constitute a purification ritual for the women, many of whom were First Nations. Through her compelling performances, sculptures, videos, photographs and installations, Belmore confronts viewers with images of loss and struggle with particular reference to the political and social issues facing Aboriginal communities today. In 2005 Belmore was the first Aboriginal woman to represent Canada at the Venice Biennale.

⸱⸱⸱⸦ Jungen, Lidén, Ndiritu

**Rebecca Belmore. b** Upsala, ON, Canada, 1960. **The Named and the Unnamed**. 2002. Video installation. **dur** 50 min. Collection of the Morris and Helen Belkin Art Gallery, The University of British Columbia. Purchased with the support of the Canada Council for the Arts Acquisition Assistance program and the Morris and Helen Belkin Foundation, 2005

# Ben-Tor Tamy

### Girls Beware, 2005

Each eccentric character in this series of video vignettes is played by the artist. Donning false beards, sunglasses and even a pig-face mask, Ben-Tor becomes, among others, a Russian prostitute, an academic and a dubious schoolteacher. Their monologues are inspired by a pamphlet distributed in Israel warning young girls about the dangers of Arab men who might take advantage of them. Ben-Tor is well known for her quirky and unsettling performance videos exploring bigotry and racial stereotyping, and also for poking fun at the self-importance of the art world. Populated by a stream of bizarre and increasingly unwholesome characters, the Israeli artist's world is inspired by personal observations and encounters on the streets of New York, where she lives and works. An exploration into the limits of language is another important element of her project: her parodied versions of Arabic, Yiddish, Hebrew and English are at once frustrating and hilarious.

⋯⫶ Ataman, Belmore, Kelley, Trecartin

**Tamy Ben-Tor. b** Jerusalem, 1975. **Girls Beware**. 2005. Digital video. **dur** 8 min 34 sec

# Bhabha Huma

## Bumps in the Road, 2008

A grotesque-looking head and a rudimentary pair of wooden legs sit atop a blackened platform. The figures are at once horrific and absurd, appearing as the victims of some violent attack yet also possessing a humorous quality. Constructed from rusty car parts, Styrofoam, newspaper and other friable materials, the fragile sculpture appears to be either unfinished or disintegrating. The head is crumbling, exposing a chicken-wire frame beneath, while the striding legs balance precariously on a pair of metal feet. This is typical of Bhabha's approach, and though her works can appear slapdash, they are in fact carefully crafted. The Pakistani artist is well known for using cheap and salvaged materials; for her they contain a latent, mystical power that can be released as they are moulded by the hand of the artist. Referencing the history of sculpture, from ancient to modern, Bhabha's works address themes of war, suffering and displacement while commemorating the victims of conflict.

⋯⋮⋅ Abidi, Man, Ortega, West

**Huma Bhabha. b** Karachi, Pakistan, 1962. **Bumps in the Road**. 2008. Clay, wood, wire, Styrofoam, metal studs, acrylic paint, cast iron, burlap, newsprint, sand and ash. **h**153.7 x **w**168.3 x **d**203.8 cm. **h**60 1/2 x **w**66 1/4 x **d**80 1/4 in

# **Black** Karla

## At Fault, 2011

Huge, boulder-like formations of crumpled sugar paper sitting atop fields of coloured powder paint fill the gallery with pastel shades of green, pink, yellow and blue. Bath salts, cellophane and chalk are among the other materials Black has used to create this fragile sculpture, which, like all her work, is a celebration of materiality. Black's abstract constructions are strictly non-representational; they have no meaning or message, and though the Scottish artist favours domestic materials such as cosmetics and soap, she has no interest in their narrative associations. It is the physical properties of materials, including their smell, that attract Black, whose work is at once painting, sculpture and performance. Colour is also an important factor and she has spent years perfecting her distinctive palette. Although her pieces sometimes appear haphazard, they are in fact carefully composed with great attention to detail. Like a painter, she adds layer upon layer until the desired result is achieved.

 Barlow, Lambie, Sze

**Karla Black. b** Alexandria, UK, 1972. **At Fault**. 2011. Cellophane, paint, Sellotape, plaster powder, powder paint, sugar paper, chalk, bath bombs, ribbon, wood. Dimensions variable. Installation view, 'Scotland + Venice', Palazzo Pisani (S. Marina), *54th Venice Biennale*, 2011. Tate, London

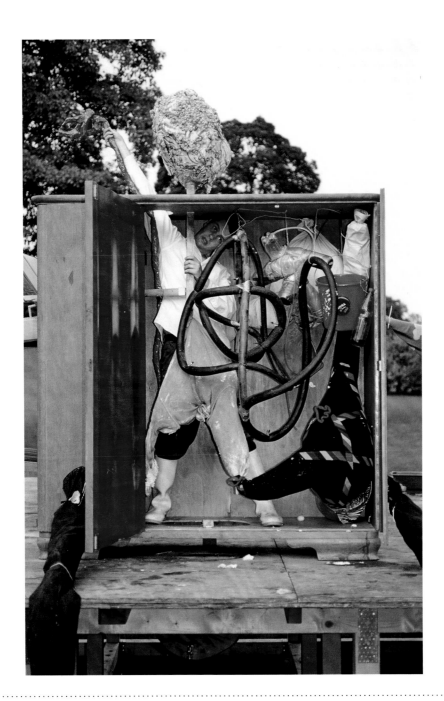

# **Bock** John

### Gribbohm II b, 2002

This series of performances, or 'lectures' as Bock prefers to call them, formed the artist's contribution to the 2002 edition of *Documenta*, the five-yearly exhibition of contemporary art held in Kassel, Germany. Performing in the gardens of Kassel's Orangerie, the artist assumed the roles of mad scientist, puppeteer and slapstick comic. One lecture featured bizarre puppets and strange contraptions built from old furniture and other domestic bric-a-brac, while in another Bock performed face down from inside a hole in the ground. Bock's absurd, semi-improvised theatrics are a mixture of science, philosophy and art, with dialogue ranging from serious drama to childish babbling. Bock emerged onto the German art scene in the late 1990s, creating intricate installations and exuberant performances. The transgressive nature of his work has drawn comparisons with Theatre of the Absurd, the avant-garde 1950s genre that, with seemingly irrational and incomprehensible pieces, sought to shock and provoke audiences.

⋯⫶ Kelley, McCarthy, Trecartin

**John Bock. b** Gribbohm, Germany, 1965. **Gribbohm II b**. 2002. Installation and lectures. *Documenta 11*, Kassel, Germany, 2002

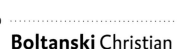

# **Boltanski** Christian

### Personnes, 2010

For this temporary installation Boltanski collected thousands of items of second-hand clothing and arranged them in rectangular clusters throughout the vast hall of the Grand Palais in Paris. Rusty iron posts marked out each group and harsh fluorescent strip lights shone overhead. Together, the old coats, cardigans, threadbare sweaters and other discarded garments suggested mass graves, or corpses awaiting identification. The eerie sound of recorded heartbeats filled the space, along with the noise of a mechanical claw that repeatedly plucked clothes from an enormous mound, only to drop them back down

again. Since the mid-1980s Boltanski's installations have repeatedly addressed the horror of the Holocaust – his Jewish father, living in Nazi-occupied Paris, hid under the floorboards of the family home for over a year. His works, however, transcend such historical specificity, speaking to the universal themes of death, loss, and the fragility of human existence.

 Bartano, Serra, Whiteread

**Christian Boltanski. b** Paris, France, 1944. **Personnes**. 2010. Dimensions variable. Installation view, Grand Palais, Paris, France, 2010

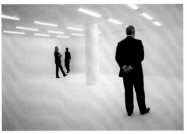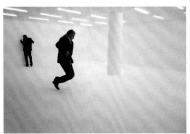

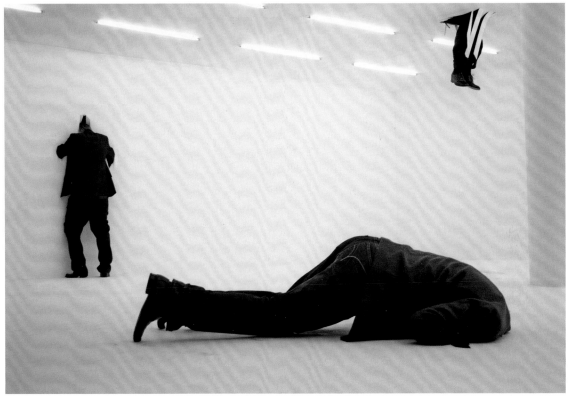

# Bonvicini Monica

### No Head Man, 2009

In this video, three middle-aged business men pace up and down in a gleaming white interior. They keep their distance from one another, as if wishing to be alone, or perhaps waiting for someone else to arrive. Eventually one of the men turns his back to the camera and begins to slowly masturbate. Suddenly he throws himself into a wall, breaking it with his fists, head and penis. Following his lead and rhythm the other two men smash themselves into the opposite wall and floor, lodging their arms and head in the fabric of the room. Finally, once the fast action and violent noise is over, a pair of legs erupts from the ceiling.

This Keatonesque video typifies the concerns of Bonvicini's work which, since the 1990s, has probed the complex relationships between architecture, gender and sexual identity. Through her installations, sculptures, drawings and videos, the Berlin-based artist examines the physical and psychological effects of the built environment. Architectural conventions and traditionally masculine materials are subverted to create dynamic, playful and provocative works.

····⊹ Lidén, Mik, Ono

**Monica Bonvicini. b** Venice, Italy, 1965. **No Head Man**. 2009. Single-channel video projection with sound. **dur** 8 min

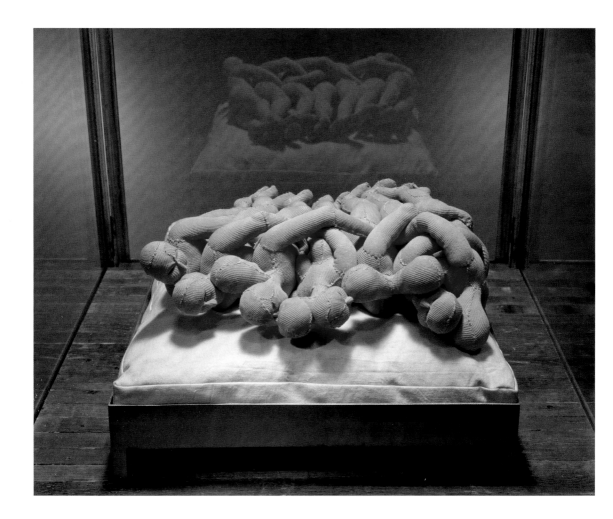

# **Bourgeois** Louise

### SEVEN IN BED, 2001

Lying within a glass display case, seven doll-like figures huddle together on a small bed. Perhaps they are trying to keep warm, or engaging in some kind of erotic orgy. The children's rhyme in which 'they all rolled over and one fell out' also springs to mind, but with more heads than bodies, these depersonalized figures possess an uncanny quality. Here Bourgeois examines childhood innocence in the light of adult experience, a theme to which she returned frequently during her long career. Femininity, sexuality and isolation were also important subjects and much of her work contains autobiographical elements from her troubled childhood. Despite her association with the Surrealists in Paris and the Abstract Expressionists in New York, Bourgeois never aligned herself with any movement, preferring to maintain a highly personal approach. Embracing sculpture, printmaking, drawing, painting, installation and performance, her work has been highly influential on subsequent generations of artists.

⋯⋰ Emin, Gelitin, Nara

**Louise Bourgeois. b** Paris, France, 1911. **d** New York, USA, 2010. **SEVEN IN BED**. 2001. Fabric and stainless steel. **h** 29.2 x **w** 53.3 x **d** 53.3 cm. **h** 11 1/2 x **w** 21 x **d** 21 in. The Easton Foundation

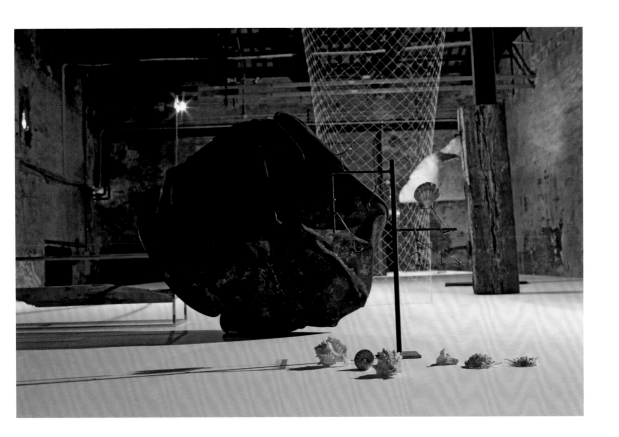

# Bove Carol

### The Foamy Saliva of a Horse, 2011

This installation, conceived for the *54th Venice Biennale*, features an array of found objects displayed on a huge stage-like plinth. Among them are chunks of polystyrene, exotic shells, driftwood and peacock feathers. The work's title derives from a tale about the ancient Greek painter Apelles: while struggling to paint a horse's mouth it is said that he threw a sponge at his painting that left a mark producing the desired effect. Finding coherence in apparent randomness is a central concern for Bove, whose intricate assemblages emphasize relationships between objects and often generate unexpected meanings.

The artist's childhood in 1970s' Berkeley, California – home of the hippie subculture – has coloured much of her work: early installations involved shelves of books and objects relating to the movement. Although Bove's recent practice has moved away from overt references, it still contains oblique cultural commentary and many of her objects are charged with personal meaning.

⋯⋰ Barlow, Dion, Baghramian

**Carol Bove. b** Geneva, Switzerland, 1971. **The Foamy Saliva of a Horse**. 2011. Found metal, bronze, driftwood, sea shells, peacock feathers, steel, gold chain, silver chain, foam, and Styrofoam on MDF plinth. **h**442 x **w**1524 x **d**548.6 cm. **h**174 x **w**600 x **d**216 in

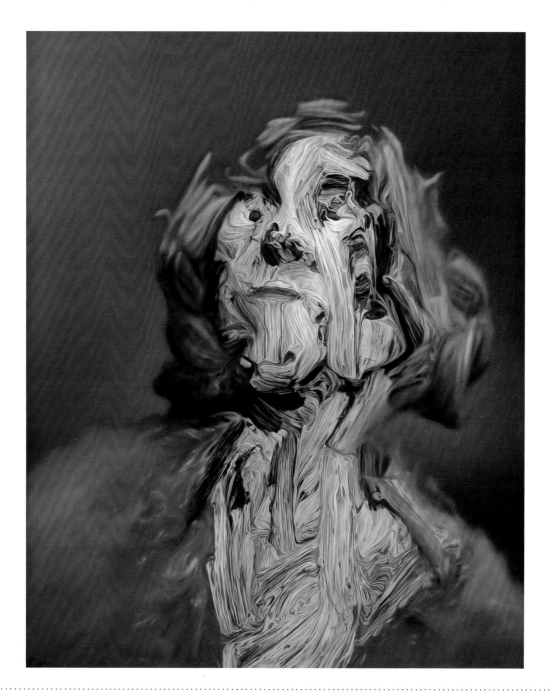

# **Brown** Glenn

## The Real Thing, 2000

Plundering imagery from art history and popular culture, Brown makes his own versions of other artists' paintings. *The Real Thing* derives from Frank Auerbach's *Head of J.Y.M.* (1973), a tormented portrait to which Brown has returned many times. Thick daubs of paint seem to be slathered over its surface, yet, like a photograph, some parts appear out of focus. In fact, the entire painting is perfectly flat and each apparently gestural brushstroke has been laboriously recreated using tiny brushes and thin layers of paint. Furthermore, Auerbach's original colour scheme has been altered and the entire composition subtly adjusted. Recognizing that the majority of art is encountered through reproduction rather than in the flesh, Brown's preferred source materials are art books, posters and postcards. His ironic approach typifies a generation of artists concerned with notions of authorship and originality. His antagonistic stance subverts the claims to an authentic, individual vision held by older artists such as Auerbach.

⋯⋮ Currin, Dumas, McKenzie, Woods

**Glenn Brown. b** Hexham, UK, 1966. **The Real Thing**. 2000. Oil on panel. **h**82 x **w**66.5 cm. **h**32 1/4 x **w**26 1/8 in. Rennie Collection, Vancouver, Canada

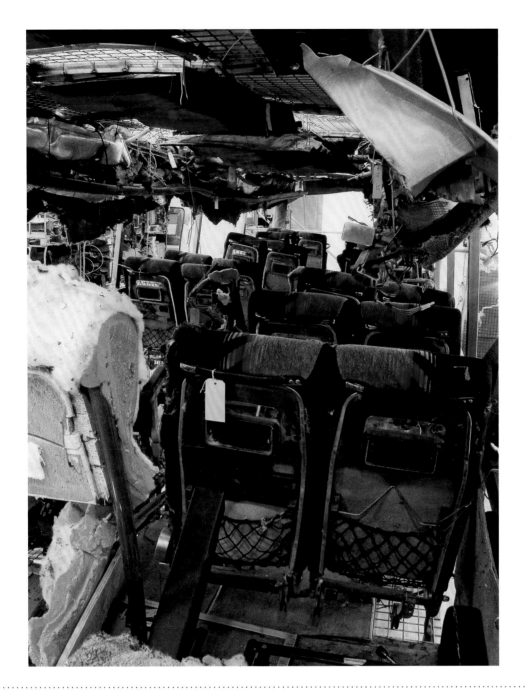

# **Büchel** Christoph

## Hole, 2005

Büchel's immersive installations allow gallery visitors to travel into parallel worlds. In *Hole*, constructed specially for the Kunsthalle Basel, the public entered not by the museum's stairs (bricked up for the installation) but by a lift. On exiting, they found themselves in a perfect simulation of a psychotherapist's waiting room. A hole knocked in the wall of the adjacent office allowed access to a bathroom, which then opened onto a cavernous tent, the kind used in police forensic examinations. At the centre of the space was an exploded tourist bus surrounded by pieces of mangled metal and debris, arranged as if an

investigation was still in process. In Büchel's work, spaces of rational understanding connect – physically and conceptually – to sites of social trauma and surrealistic nightmare. *Piccadilly Community Centre* (2011) was a functioning, populated community centre temporarily located within the Hauser & Wirth gallery in central London; squatters, however, appeared to be resident in the filthy attic.

 Hirshhorn, Schabus, Schneider

**Christoph Büchel. b** Basel, Switzerland, 1966. **Hole**. 2005. Mixed media. Installation view, Kunsthalle Basel, Switzerland, 2005

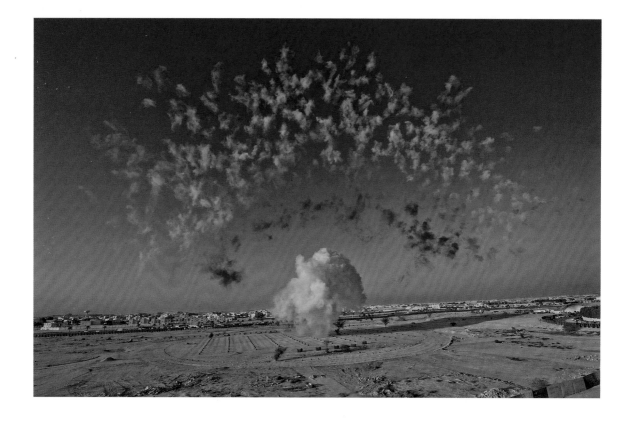

# Cai Guo-Qiang

### Black Ceremony, 2011

In an event to mark the opening of the artist's first solo exhibition in the Middle East, at Mathaf: Arab Museum of Modern Art in Qatar, a sequence of spectacular explosions caused shapes to blossom and slowly disperse in the daytime sky above the desert. The circles, pyramids and rectangles formed by bursts of black and multicoloured smoke drew on iconography that is shared by both Arab and East Asian cultures and relate to the themes of 'death' and the spiritual return of those that have died far from home. Cai was reflecting on the ancient trade links, via the Silk Route, between his hometown and the

Arab states, as well as the Islamic history of Quanzhou. The artist has employed a variety of art forms and media but is best known for his use of gunpowder to make drawings and controlled explosions. These works express his interest in the transformative potential of acts of creative destruction. Designed to be site-specific, he frequently alters or develops his projects in relation to the cultural context of location.

⋯⋰ de Balincourt, Black, Finch, Parker

Cai Guo-Qiang. b Quanzhou, China, 1957. Black Ceremony. 2011. Commissioned by Mathaf: Arab Museum of Modern Art, Doha, Qatar, 2011

# **Calle** Sophie

## Take Care of Yourself, 2007

When Calle's lover ended their relationship by email, the French artist decided to turn her heartbreak into art. Comprising photographic portraits, video and text, this sprawling installation features contributions from 107 women, each of whom were invited to use their professional skills to analyse and interpret the break-up message. The results are poignant, funny and highly imaginative: a copy editor critiques the boyfriend's grammar; an etiquette consultant condemns his manners; an actress performs his text; and a forensic psychiatrist declares him twisted. Employing photography, film and text, Calle has been exploring the emotional and psychological aspects of her own and others' lives since the late 1970s. Her controversial works merge the private with the collective and have involved trailing a stranger through the streets of Venice, and contacting all the people listed in a lost address book, probing them about its owner and then publishing the results in a newspaper.

 Abramović, Ben-Tor, Jacir, Landy

**Sophie Calle. b** Paris, France, 1953. **Take Care of Yourself. Laurie Anderson, Singer**. 2007. Portrait: Fine Art print dry mounted on aluminium, wooden frame, glass. Film: video screen. Portrait: **h**98 x **w**78.5 cm. **h**38 1/2 x **w**31 in. Film: **dur** 3 min 13 sec

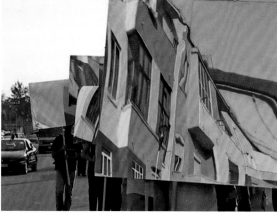

# **Cantor** Mircea

The Landscape is Changing, 2003

A group of demonstrators marches silently through the busy streets of Albania's capital city, Tirana. Instead of bearing political slogans their placards are mirrors that reflect everything around them, from cars and buildings to pedestrians and street signs. Cantor undermines the language of protest, exchanging clear political demands for absurdity; without a clear message, the protesters can only reflect, distort and disrupt their immediate environment. Yet there is perhaps also the suggestion here of a society in which there is nothing to protest against, indicating something of the optimism running through the Paris-based artist's work. Informed by his formative experiences growing up in Romania during its turbulent transition from socialism to democracy in the early 1990s, Cantor's videos, photographs, sculptures and mixed media installations are pervaded by themes of uncertainty and displacement. Nevertheless, his work routinely proposes a world where harmony and understanding arise from the tensions of opposing ideologies.

····⠒· Hayes, Wallinger, Żmijewski

**Mircea Cantor. b** Oradea, Romania, 1977. **The Landscape is Changing**. 2003. DVD. **dur** 22 min

# Cao Fei

## Deep Breathing (COSPlayers Series), 2004

A series of photographs and an 8-minute video shot in Guangzhou in China, *COSPlayers* features a group of Chinese teenagers who are dressed as their favourite characters from animations or computer games. The 'cosplayer' – short for 'costume play' – trend began as a hobby among young people in Japan in the 1990s. In Cao's artwork, the players act out various fantastical scenes against a backdrop of mass construction in the city. The costumes here represent escapism but also the divide between the generations in modern China, with the film ending when the players, in full regalia, return home to be greeted

with dismay by their families. Cao has explored themes of fantasy, consumerism and the effects of economic change in China across film, dance, installation and theatrical works. She has also created artworks in the online virtual world of Second Life, under the name China Tracy.

⋯⋰ Feng, Nara, Tan, Zhang

Cao Fei. b Guangzhou, China, 1978. **Deep Breathing (COSPlayers Series)**. 2004. Digital C-print. **h** 74 x **w** 100 cm. **h** 29 1/8 x **w** 39 3/8 in

# **Cattelan** Maurizio

Untitled, 2001

A bell chimes, doors slide open, and the playful world of Cattelan beckons us in. The lifts to his world, however, are too tiny for human use. Cattelan's miniaturized sculpture mimics the anonymous machinery found in office blocks, hotels and museums throughout the world, yet its scale evokes a fairy-tale world where Lewis Carroll's Alice might be glimpsed. Electronic lights and sound effects convey a sense of functionality, but these lifts do not move. Viewers are therefore invited to suspend their disbelief and embrace the artifice. With a reputation as a prankster, Cattelan is Italy's most famous

contemporary artist and is often compared to the radical and irreverent twentieth-century 'anti-artist' Piero Manzoni. Cattelan's humorous and often provocative works combine the accessibility of Pop art with the unexpected qualities of Surrealism. He pokes fun at social conventions, religion, nationalism, and even the art world itself.

⋯⋮⋅ Fischer, Gober, Mueck, Slominski

**Maurizio Cattelan. b** Padua, Italy, 1960. **Untitled**. 2001. Stainless steel, wood, electric motor, light, bell and computers. **h**60 x **w**85.5 x **d**47cm. **h**23 5/8 x **w**33 5/8 x **d**18 1/2 in. Los Angeles County Museum of Art

# Celmins Vija

## Night Sky #21, 2009–13

Repetition is a feature of Latvian-American artist Celmins's art, and this painting is one of a series that depicts the sky at night. Photographs of real constellations form the basis for the 'Night Sky' images and Celmins has used a variety of different media in the creation of the works, including alkyd, oil, charcoal and woodprinting. In addition to her portrayal of star-studded skies, Celmins regularly explores other scenes from nature, including spiderwebs, the surface of the moon and ocean waves. Photorealism has been a feature of Celmins's art stretching back to the 1960s, when her early work was influenced by

Pop art and portrayed everyday objects such as TVs or furniture, as well as violent scenes featuring guns and explosions. Her interest in nature began in the late 1960s and has continued since. Presented in close-up, the 'Night Sky' works are simultaneously highly realistic and abstract.

⋯⋮⋰ Finch, Gowda, McKenzie, Sietsema

**Vija Celmins. b** Riga, Latvia, 1938. **Night Sky #21**. 2009–13. Alkyd oil on canvas. **h**85.1 x **w**81.3 x **d**3.8 cm. **h**33 1/2 x **w**32 x **d**1 1/2 in

# Chan Paul

### 1st ~~Light~~, 2007

*1st ~~Light~~* is one in a series of large-scale digital projections and charcoal drawings, entitled *The 7 ~~Lights~~* in reference to the Biblical creation story. The six animations, which are often shown together, are projected onto the walls and floor, and are cyclical, with the colour and intensity of light changing as if over a day and night. In *1st ~~Light~~*, silhouettes of familiar objects rapturously float upwards whilst flailing figures fall quickly to earth. The atmosphere is apocalyptic and this unease is reiterated in the work's title, where the word 'light' is struck out, as if extinguished. Created in part as a response to 9/11 and the subsequent war in Iraq, Chan, who was raised in Nebraska before settling in New York, is also well known as a political activist. His art borrows from wide-ranging references including religion, philosophy, art history and hip-hop culture, to address issues central to contemporary American culture and politics.

·····⫶· Lozano-Hemmer, Parreno, Raad

**Paul Chan. b** Hong Kong, 1973. **1st ~~Light~~**. 2007. From *The 7 ~~Lights~~*. 2005–8. Digital video projection. **dur** 14 min

# **Chapman** Jake & Dinos

## The Chapman Family Collection, 2002

When first exhibited at White Cube in London, this installation of thirty-four wooden carvings was described by the gallery as a collection of rare ethnographic and reliquary fetish objects that had been amassed by the Chapman family over seventy years. On close examination, however, some unexpected elements become evident, suggesting that the objects are not what they first appear to be. One sculpture is actually a portrait of Ronald McDonald, while another is shaped like a packet of McDonald's fries. Several also reference works by Modernist artists such as Constantin Brancusi, indicating that the installation is a comment both on the appropriation of the 'tribal art' style by European artists and on how fetish objects have themselves become commodified over time. The cheeky provocation of this piece is typical of the Chapman Brothers, who have worked together since 1991, creating sculptures and paintings exploring themes of war, religion and sexuality.

⋯⋮⋗ Farmer, Hirst, Superflex, Xu

**Jake Chapman. b** Cheltenham, UK, 1966. **Dinos Chapman. b** London, UK, 1962. **The Chapman Family Collection**. 2002. Thirty-four wooden sculptures, metal, horn, coin, bones and shells. Dimensions variable. Tate, London

# **Chopra** Nikhil

### Yog Raj Chitrakar: Memory Drawing V (Part II), 2010

For this performance Chopra transformed himself into a character called Yog Raj Chitrakar, a travelling artist based loosely on his grandfather. Dressed in a specially designed costume, Chopra walked from an Oslo art gallery to a city pier where, attracting a crowd of onlookers, he made a large charcoal drawing of the harbour. The performance belongs to an ongoing series titled *Memory Drawing*, which from 2007 has charted the journeys of this fictional draughtsman in cities that include Tokyo, Venice, New York, London and Mumbai. Drawing from personal, national and colonial histories, Chopra has

developed a whole repertoire of characters through whom he explores issues of identity and autobiography. Lasting anything from a few hours to a few days, his pieces merge theatre, drawing, installation and performance. Employing both choreographed and improvised actions, the Indian artist creates a kind of silent storytelling that often spills outside of galleries and into the streets.

⋯⁚ Gupta, Sherman, Singh

**Nikhil Chopra. b** Calcutta, India, 1974. **Yog Raj Chitrakar: Memory Drawing V (Part II)**. 2010. Digital photograph on archival paper

# **Cidade** Marcelo

### Imóvel, 2004

Sixty-one concrete breeze blocks have been neatly stacked up in a supermarket trolley. As well as borrowing from the language of Minimalism, the sculpture evokes the Modernist tower blocks in the artist's home city of São Paulo. As the work's title suggests, the trolley has been rendered useless, made immobile (imóvel) by the sheer weight bearing down on it. Concrete is a recurring material in the young Brazilian artist's work, alluding to the wave of utopian Modernist architecture that promised to transform so many Latin American cities, yet arguably failed to deliver. The urban environment is a central

concern for Cidade, whose works engage with language, politics and art history. His sculptures, installations, films and actions explore the Post-Modern condition of the city and the relationship between public and private space. While Cidade's studio pieces often incorporate urban elements, the former graffiti artist also performs subtle and anonymous interventions in the streets themselves.

⋯⋮ Renata Lucas, Neto, Salcedo

**Marcelo Cidade. b** São Paulo, Brazil, 1979. **Imóvel**. 2004. Supermarket trolley and sixty-one concrete bricks. **h**190 x **w**55 x **d**100 cm. **h**74 3/4 x **w**21 5/8 x **d**39 3/8 in

# **Cragg** Tony

### Lost in Thought, 2011

This towering sculpture is made from hundreds of layers of laminated plywood. Its twisting curves and recesses allow viewers to see inside and right through the complex structure. Adopting an intuitive approach, Cragg let the work take shape organically, building it up layer by layer from the inside to the outside. For the artist, it relates to the idea of being lost in one's thoughts and the social defences that we erect to protect ourselves. Cragg emerged in the 1980s as a key figure of the New British Sculpture movement, a group of sculptors whose production of objects marked a departure from the conceptual practices that had characterized the preceding decade. Drawing on his early training as a scientist, Cragg constantly experiments with new materials, styles and techniques. Working with bronze, glass, plaster, steel, wood, clay, plastics as well as found objects, he continues to explore and expand the language of sculpture.

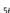 Deacon, Sarah Lucas, Šarčević

**Tony Cragg. b** Liverpool, UK, 1949. **Lost in Thought**. 2011. Wood. **h**438 x **w**145 x **d**145 cm. **h**172 1/2 x **w**57 x **d**57 in

# Creed Martin

### Work No. 227 The lights going on and off, 2000

This work consists of an empty room in which the lights go on and then off again at five second intervals. It was originally created for the 2001 Turner Prize exhibition at Tate Britain in London. Creed won the prize, but *Work No. 227* caused a furore in the media, with many journalists questioning whether such a gesture could be considered an artwork. It is in keeping with other works by Creed, who has also exhibited a crumpled up piece of paper, a piece of Blu-Tack and live runners in gallery spaces. All of these works accentuate the act of looking at and experiencing art, asking audiences to consider these everyday objects or activities in new ways. By manipulating the light in the gallery, *Work No. 227* encourages visitors to think about the room itself, bringing a space that is usually a backdrop to other artworks into the centre stage.

·····⫶· Jaar, Margolles, Sehgal

**Martin Creed. b** Wakefield, UK, 1968. **Work No. 227 The lights going on and off**. 2000. **dur** 5 seconds on / 5 seconds off. Installation view, MoMA, New York, 2007

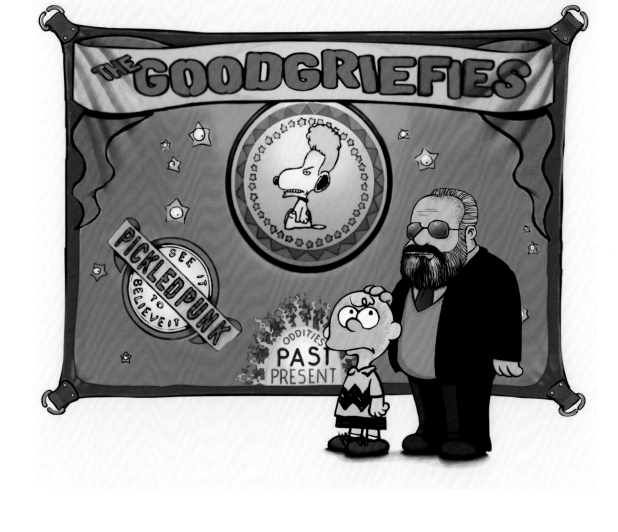

# **Cuoghi** Roberto

The Goodgriefies, 2000

A motley cast of seemingly familiar American cartoon characters parades across the screen in this animated film. It soon becomes apparent that these are hybrid creatures, conflations of classic figures and their modern heirs. Charlie Brown, for instance, is crossed with Bart Simpson, while characters from 'Looney Tunes' and 'The Flintstones' are merged with those from modern creations such as 'Beavis and Butt-Head' and 'South Park'. Although the film initially appears light-hearted, it quickly progresses from the playful to the disturbing as Cuoghi's animated mongrels begin to atrophy. The piece was produced in parallel with the artist's attempt, for seven years during his twenties, to transform himself into his elderly father by gaining significant weight, dyeing his hair white and wearing his father's clothes. A self-imposed outsider, Cuoghi is concerned with cultural and social estrangement. Through his videos, sculptures, paintings and all-consuming performances, he explores the possibilities for transformation while questioning the nature of identity, authority and authorship.

⋯⋮⋯ Ray, Shrigley, Stark

**Roberto Cuoghi. b** Milan, Italy, 1973. **The Goodgriefies**. 2000. Video animation on DVD. **dur** 5 min

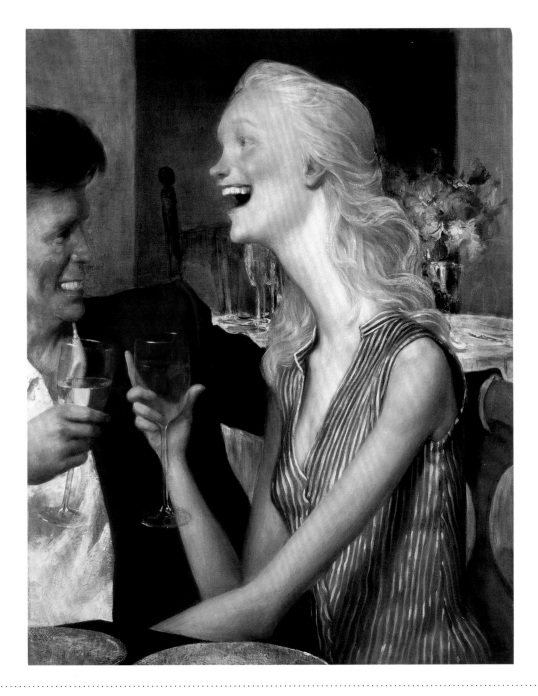

# **Currin** John

## Park City Grill, 2000

A young woman and her male companion are enjoying a glass of wine in a restaurant. The woman's feathery blonde hair flows down her impossibly long neck, which, along with her spindly arms, seems awkwardly disproportionate to the rest of her body. Her pale complexion and rosy cheeks contrast with the man's tanned skin. Grinning and laughing, revealing their perfectly straight, white teeth, the pair appear to be sharing a joke, yet each gazes past the other. Though rendered in a realistic style, Currin's off-kilter paintings are characterized by exaggeration and distortion. Drawing inspiration from aspects of Northern Renaissance art and Italian Mannerism, his central concern is the human form, and the female body in particular. Endowing his women with anatomical anomalies such as absurdly large breasts and elongated limbs, Currin has inevitably faced accusations of sexism – charges to which he has remained ambivalent. Growing ever more controversial, his recent canvases have depicted explicit pornographic scenes.

 Murakami, Ryden, Sherman

**John Currin. b** Boulder, CO, USA, 1962. **Park City Grill**. 2000. Oil on canvas. **h** 96.7 x **w** 76.2 cm. **h** 38 1/8 x **w** 30 in. Walker Art Center, Minneapolis

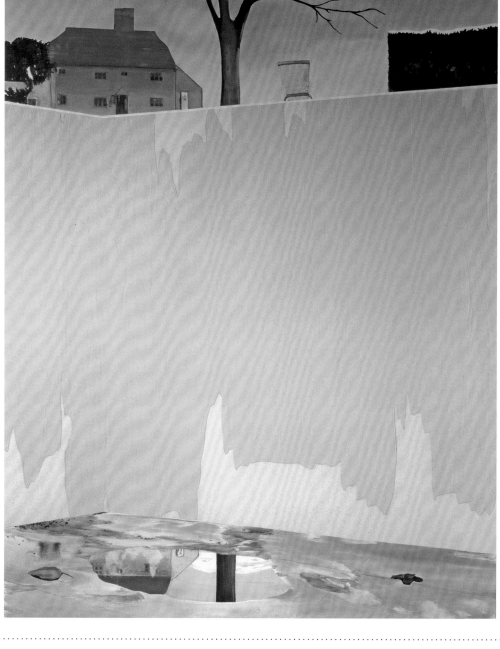

# **Dalwood** Dexter

## Brian Jones' Swimming Pool, 2000

This deserted scene depicts the empty interior of an outdoor swimming pool. Although it appears innocuous, the painting represents the site where Brian Jones of The Rolling Stones was discovered dead in 1969. Mortality is a recurring theme for Dalwood, whose large canvases often feature the locations of famous celebrity deaths. Particular attention is given to those who died under mysterious circumstances. Jones's death, for instance, was officially attributed to a drugs overdose, yet conspiracists insist he was murdered. Like all of Dalwood's paintings, the scene is painted from imagination. His invented interiors, belonging to tragic figures such as Kurt Cobain, Jackie Onassis and Sharon Tate, feel like images from an off-kilter lifestyle magazine. Indeed, the models for these paintings are miniature collages, comprised of cuttings from such publications. Despite owing much to Pop art, Dalwood's works are more concerned with the construction and interpretation of history than a celebration of popular culture.

⋯⋮ Hockney, Peyton, Tuymans, Zeng

Dexter Dalwood. b Bristol, UK, 1960. **Brian Jones' Swimming Pool**. 2000. Oil on canvas. **h**275 x **w**219.1 cm. **h**108 1/4 x **w**86 1/4 in

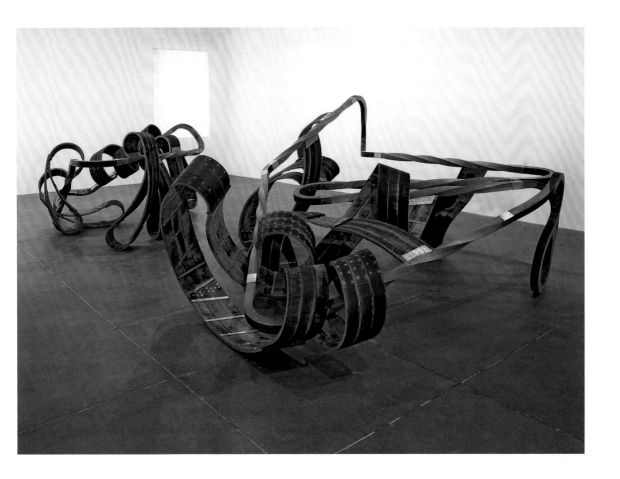

# **Deacon** Richard

## Red Sea Crossing, 2003

Two large forms made from oak and stainless steel twist and coil across the gallery floor. In each, thin, sinuous loops of wood are entwined with ribbons of oak that have been bent, rounded, glued and pinned together. Deacon's title refers to the Bible story telling the Israelites' escape from Egypt and a narrow gap between the sculpture's two halves evokes the parting of the Red Sea. Deacon was a central figure of the New British Sculpture movement in the 1980s and is known for his large-scale works, many of which are sited in the public realm. The physical act of making is extremely important for him, though unlike traditional sculptors he does not carve or mould; rather, he constructs using techniques developed for the manufacturing industries. Working with wood, metal and plastics, he softens and bends his materials to create works that appear abstract yet often carry metaphorical references.

····ᐉ Cragg, Halilaj, Rothschild, Tuazon

**Richard Deacon. b** Bangor, UK, 1949. **Red Sea Crossing**. 2003. Steamed oak and stainless steel. Sculpture in two parts. A: **h**163 x **w**345 x **d**320 cm. **h**64 1/8 x **w**135 7/8 x **d**126 in. B: **h**204 x **w**520 x **d**390 cm. **h**80 1/2 x **w**204 3/4 x **d**153 1/2 in

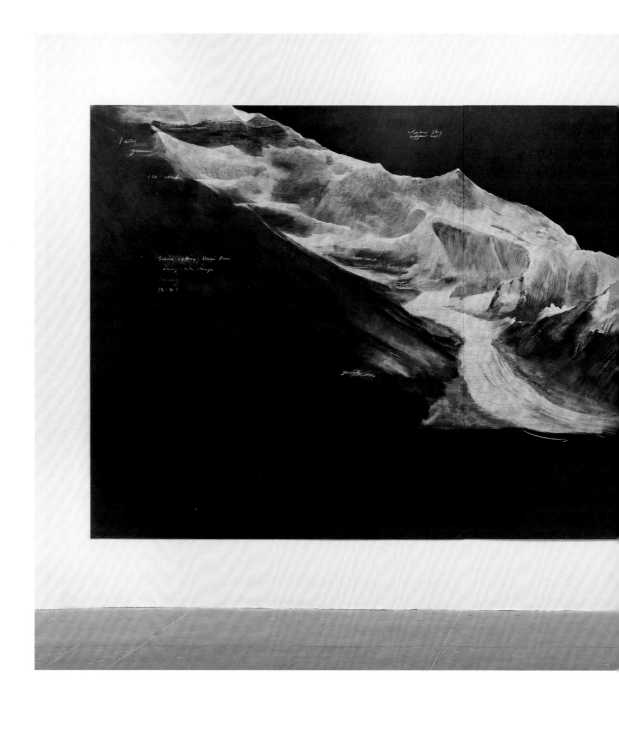

# **Dean** Tacita

### Fatigues (F), 2012

When Dean was invited to contribute to *documenta 13*, the exhibition that in 2012 took place both in Kassel and Kabul, she resolved to make a film. Since she was unable to travel to Afghanistan she sent a loaded camera to a cameraman in Kabul, but due to a misunderstanding the film he shot was entirely unusable. Instead of her 'blind' film, as she put it, Dean decided to make a 'blind' drawing of the mountains of the Hindu Kush, where the glacier that feeds the Kabul river is located, which she herself has never seen. In a former Kassel tax office, she drew with chalk on panels painted with blackboard paint – a medium that

she had used, much earlier in her career, for dramatic seascapes. The widescreen drawings retain some of the cinematic slowness of the films for which Dean is better known, such as *FILM* (2011), made for the Tate Turbine Hall, London.

⋯⋮ Graham, Sugimoto, Xu

**Tacita Dean. b** Canterbury, UK, 1965. **Fatigues (F)**. 2012. Chalk on blackboard, three panels. **h** 228 x **w** 613.4 cm. **h** 89 3/4 x **w** 241 1/2 in

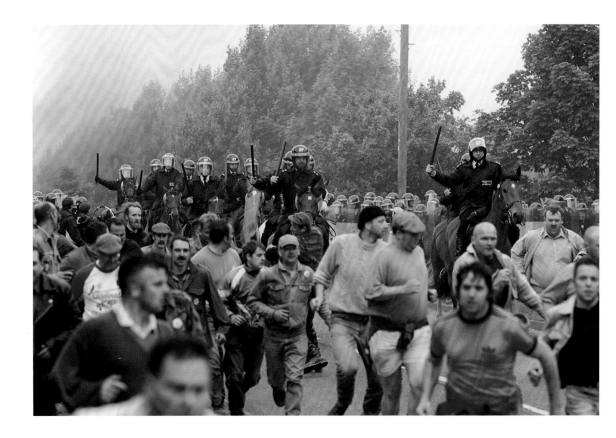

# **Deller** Jeremy

## The Battle of Orgreave, 2001

Deller mobilized over 800 people to re-enact the Battle of Orgreave, one of the central, and most violent, confrontations between the police and picketing miners during the British miners' strike in the mid-1980s. Meticulously orchestrated by a historical re-enactment expert, the event involved members of re-enactment societies as well as former miners and policemen who had taken part in the actual clash. Mike Figgis directed a film of the event, which included a montage of footage from the re-enactment, photographs from the 1984 event and poignant, sometimes emotional, recollections from original participants. The film records the power of the re-enactment as a way of constructing a complex historical narrative and of commemorating an event that continues to have cultural relevance. Deller is a conceptual artist who uses performance, video and installation to make politically and socially charged work. He often works collaboratively, encouraging interaction between different communities.

⋯⋯ Bartana, Emin, Wallinger

**Jeremy Deller. b** London, UK, 1966. **The Battle of Orgreave**. 2001. Still from live re-enactment Orgreave, South Yorkshire, co-production with Artangel, London

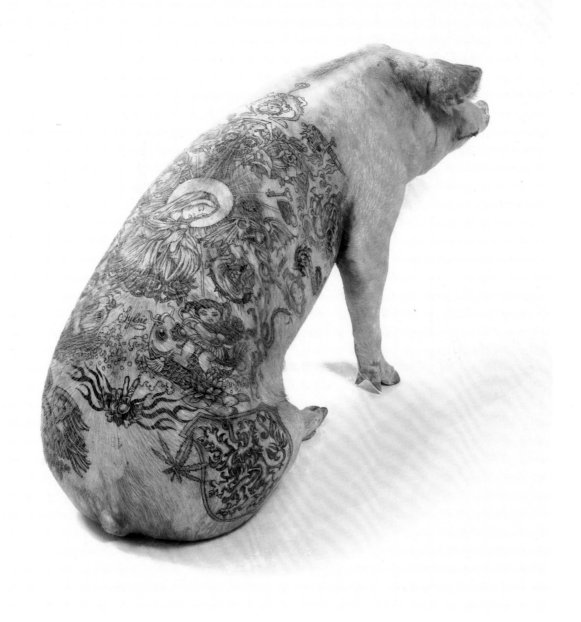

# **Delvoye** Wim

### **Sylvie, 2006**

Cartoon characters, religious iconography, and a host of other designs are tattooed onto the back of this stuffed pig. Controversially, Delvoye had the tattoos inked onto the skin while the animal was still alive. His projects are deliberately provocative, testing the boundaries of art and ethics. He began tattooing dead pigs in the early 1990s, but in 1997 he started working on live animals, intending to challenge the art market by creating living works of art. In 2004 Delvoye relocated to China where he reared pigs on his Art Farm near Beijing; the farm was closed in 2010. The tattooed pigs can be owned by collectors while alive,

but only physically possessed after their deaths. Less contentious are Delvoye's gothic sculptures and his *Cloaca* machines that replicate the human digestive system.

⋯⋮ Hirst, Huang, McCarthy

**Wim Delvoye. b** Wervik, Belgium, 1965. **Sylvie**. 2006. Stuffed, tattooed pig. **h**67 x **w**140 x **d**30 cm. **h**26 3/8 x **w**55 1/8 x **d**11 3/4 in

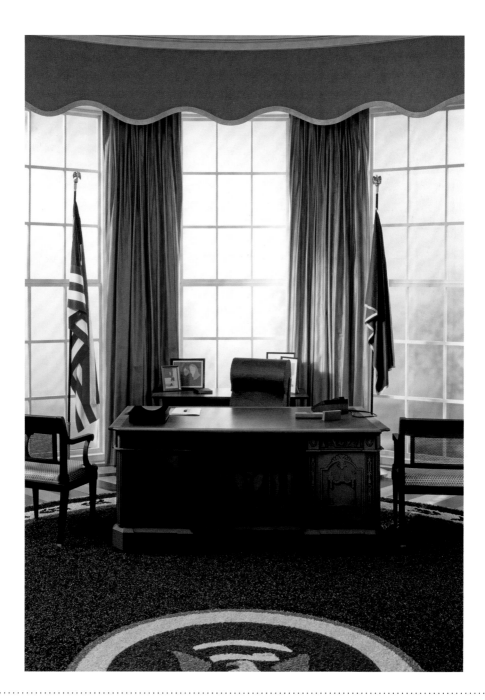

# Demand Thomas

### Presidency 1, 2008

This photograph belongs to a five-part series commissioned by *The New York Times* and published following the election of President Barack Obama in 2008. Its subject is the famous Oval Office of the White House in Washington, DC. As with all of Demand's images, it is actually a photograph of a life-sized model constructed from paper and cardboard. The President's furniture, curtains, carpet and windows have all been meticulously handcrafted by the artist and his assistants, who can spend several months creating a single work. Once the scene is captured by Demand's camera, however, the intricate models are

destroyed. In the context of the American presidency, this series brings the ephemeral nature of political power sharply into focus. Significant socio-historical events and the specific places associated with them provide Demand with his subject matter. Calling the authenticity of photography into question, his work serves to highlight the constructed nature of our media-saturated culture.

⋯⋮⋅ Gonzalez-Foerster, Koons, Struth

**Thomas Demand. b** Munich, Germany, 1964. **Presidency 1**. 2008. C-print / Diasec. **h**310 x **w**223 cm. **h**122 x **w**87 3/4 in. National Gallery of Art, Washington, DC

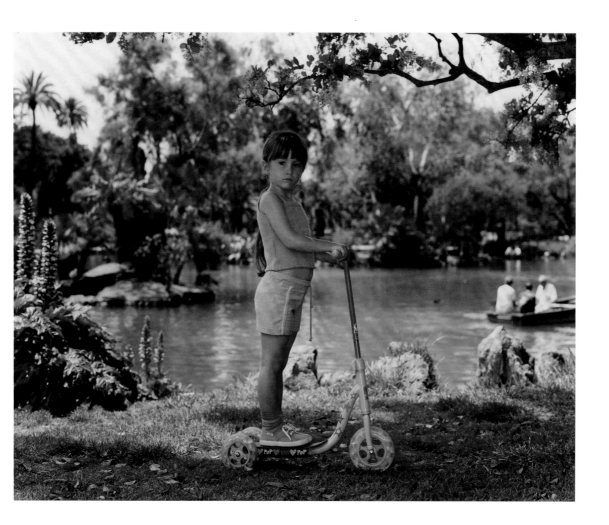

# Dijkstra Rineke

Parque De La Ciudadela, Barcelona, June 4, 2005, 2005

Dijkstra's photographs of young people have the stately composure of eighteenth-century portraits by Thomas Gainsborough or Joshua Reynolds. This is partly because Dijkstra shoots on a bulky large-format camera, requiring her subjects to sustain their poses as they would for traditional oil paintings. As a result, figures like the young girl in *Parque De La Ciudadela, Barcelona, June 4, 2005* have time to choose how they present themselves and Dijkstra captures them trying out identities that they have yet to fully grow into. The girl on her scooter gazes impassively down at us, as if she were mounted high on a hunting steed.

Unlike Dijkstra's famous early portraits of teenagers such as *Kolobrzeg, Poland, July 26, 1992* (1992), which were shot against featureless seascapes, *Parque De La Ciudadela* reveals a bucolic boating pond. The setting adds to the timeless feel of the image, which is simultaneously classic and contemporary.

⫶ Cao, Gursky, Ray, Trecartin

**Rineke Dijkstra. b** Sittard, Netherlands, 1959. **Parque De La Ciudadela, Barcelona, June 4, 2005**. 2005. C-print. **h**108.6 x **w**127 cm. **h**42 3/4 x **w**50 in

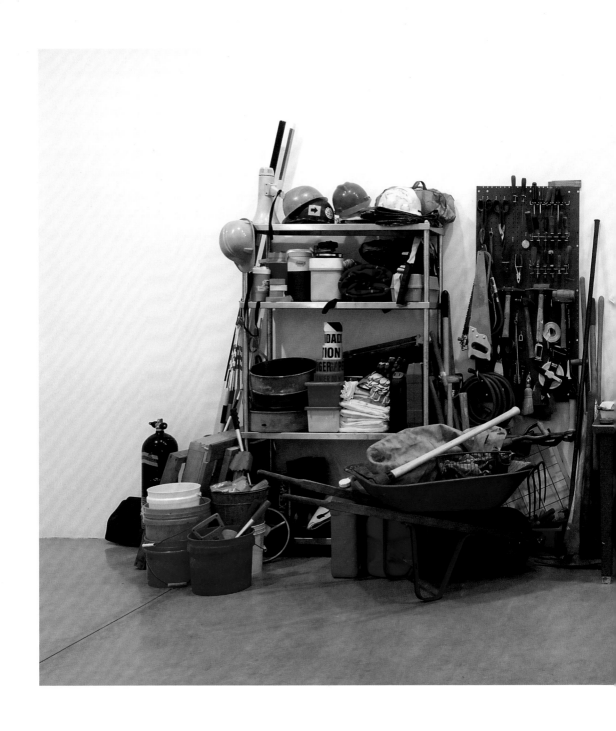

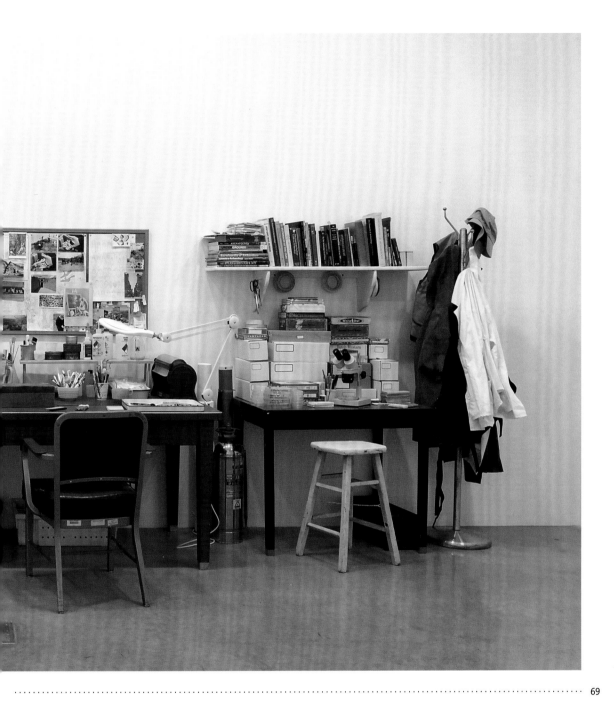

# **Dion** Mark

## Concerning The Dig, 2013

Hard hats, plastic containers and other items of equipment are stacked neatly on shelves, alongside two desks piled high with papers and files. A wheelbarrow filled with objects is positioned in the foreground, and a coat stand is displayed, hung with jackets and white coats. This installation is meticulously detailed, and forms an ethnographic study of a professional archaeologist, illustrated through the tools of the trade. While the focus of archaeology is on the finding of artefacts, there are no such items on obvious display here, and instead the work becomes a kind of archaeological find in itself, a portrait of the profession as it is performed today. Archaeology is a subject central to Dion's art, and he has often taken part in digs. References to these are subtly inserted into this installation, and the books featured are all taken from Dion's personal collection, giving the piece a semi-autobiographical quality.

⋯⋮ Landy, Parker, Song

**Mark Dion. b** New Bedford, MA, USA, 1961. **Concerning The Dig**. 2013. Mixed media. **h** 243.8 x **w** 624.8 x **d** 162.6 cm. **h** 96 x **w** 246 x **d** 64 in

# **Djurberg** Nathalie **& Berg** Hans

## Tiger Licking Girl's Butt, 2004

The medium of claymation seems so innocent, so redolent of childhood television shows and feel-good family movies, that Djurberg is able to use it as an innocuous outlet for her most depraved, sexual, violent and grotesque imaginings. In the short animation *Tiger Licking Girl's Butt* – accompanied by the music of Djurberg's regular collaborator, Hans Berg – a young girl dries herself with a towel after taking a shower, while a tiger watches. When he can restrain himself no longer, he bursts forth and attempts to lick her backside. First she resists, understandably alarmed, but soon she acquiesces, and the tiger slurps away. 'Why do I have this urge to do these things over and over again?' asks the text on the screen. Since no answer is forthcoming, the girl pulls back the bedcovers and the tiger climbs in. For Djurberg, such interactions are metaphors for the unfathomable extremes of human behaviour.

⋯⋮⋯ Lidén, McCarthy, Murakami

**Nathalie Djurberg. b** Lysekil, Sweden, 1978. **Hans Berg. b** Rättvik, Sweden, 1978. **Tiger Licking Girl's Butt**. 2004. Clay animation, digital video. **dur** 2 min 15 sec

# **Doig** Peter

### Red Boat (Imaginary Boys), 2004

This group of six boys sitting in a small boat appear vulnerable, part of an ambiguous, mysterious narrative. The oil painting with its water layers has a fluid, dream-like, hallucinatory quality, hovering between representation and abstraction. A dark shadow, in which the boat is reflected, introduces a sense of foreboding into an otherwise tranquil scene. Born in Scotland but brought up in Canada and Trinidad, Doig's work deftly evokes the contrasting beauty and atmospheres of those landscapes. He also draws on a personal lexicon of motifs such as canoes, cabins and trees. However, his intention is not

autobiographical. Rather, his paintings offer more general ruminations on the elusive and fragmentary nature of memory, and of humankind's relationship to nature. His sensuous, painterly approach draws comparison with Paul Gauguin, Henri Matisse and Pierre Bonnard, but the sense of inquiry and the allusive nature of his imagery seem to be distinctly of his time.

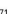 Dumas, Pessoli, Woods

**Peter Doig. b** Edinburgh, UK, 1959. **Red Boat (Imaginary Boys)**. 2004. Oil on canvas. **h**200 x **w**186 cm. **h**78 3/4 x **w**73 1/4 in

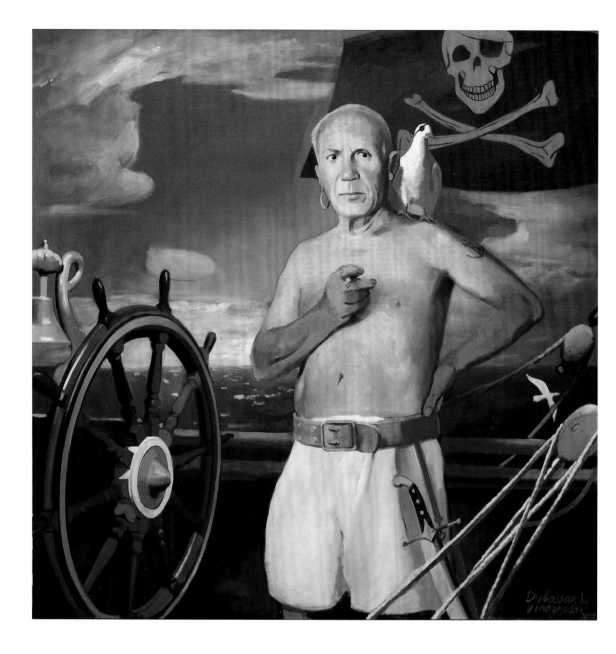

# **Dubossarsky** Vladimir **& Vinogradov** Alexander

The Jolly Roger, 2009

Pablo Picasso, one of the twentieth century's most celebrated artists, is depicted as a pirate. Bare-chested and sporting a gold hoop earring, he stands with a defiant gaze aboard the deck of a ship. Behind him waves a Jolly Roger flag while on his shoulder, in place of a parrot, sits an eye-patched dove. This humorous painting belongs to a series of works called 'Danger! Museum', in which Dubossarsky & Vinogradov celebrate and satirize figures from the history of art. Additionally, each piece contains a hidden video camera, a fact that is only revealed in the last room of the exhibition, where a bank of screens displays the

surveillance footage. Working together since 1994, the duo are well known for their ironic paintings that combine a Soviet version of Pop art known as 'Sots Art' (short for 'Socialist Art') with Socialist Realism, the official style of art in the former USSR.

⋯⋮ Peyton, Rauch, Zeng

**Vladimir Dubossarsky. b** Moscow, Russia, 1964. **Alexander Vinogradov. b** Moscow, Russia, 1963. **The Jolly Roger**. 2009. Oil on canvas. **h**195 x **w**195 cm. **h**76 3/4 x **w**76 3/4 in

# **Dumas** Marlene

## For Whom the Bell Tolls, 2008

This painting is based on a photograph of the film star Ingrid Bergman, taken from the cover of the soundtrack album to her 1943 film *For Whom the Bell Tolls*. It is not a conventional portrait, for the close-cropped image, painted in a fluid, ethereal style, is distorted and unnaturalistic. Dumas's paintings represent emotions or states of mind: this work is a response to the death of her mother. It is as much about transformation and freedom as about loss and departure. Through paint, Bergman becomes a vehicle by which the grief of the artist mingles with the relief of her mother, who is now released from earthly suffering. Based in Amsterdam, Dumas selects her subjects from a vast image bank of newspaper cuttings, magazine pages and personal snapshots. Themes of gender, race and sexuality are central to her work, which above all seeks to explore and respond to the human condition.

⋯⋮⋯ Doig, Lassnig, Peyton

**Marlene Dumas. b** Cape Town, South Africa, 1953. **For Whom the Bell Tolls**. 2008. Oil on canvas. **h**100 x **w**90 cm. **h**39 3/8 x **w**35 1/2 in. Dallas Museum of Art, TX

# Durham Jimmie

**Encore Tranquillité, 2008**

A small, single-seater aeroplane has been crushed by an enormous boulder that appears to have fallen on top of it. The crumpled aircraft lies testament to the destructive event that has now long since passed; this is further emphasized by the fact that Durham has replaced the stone with a fibreglass replica. The work is one of several in which different types of vehicle have been deliberately destroyed by falling rocks. Much of Durham's work relates to his Cherokee heritage and the history of the indigenous American people; here, the boulder refers to the power that the Native American people never had. Durham's

intricate sculptures and installations are often laced with humour yet forcefully challenge prejudices and stereotypical representations of indigenous peoples. Durham has been active since the 1960s and, although working primarily as a sculptor, has also embraced theatre and performance, and published literature, poetry and critical theory.

⋯⋮ Altmejd, Belmore, Ortega

**Jimmie Durham. b** Washington, DC, USA, 1940. **Encore Tranquillité**. 2008. Fibreglass, stone and aeroplane. **h**150 x **w**860 x **d**806 cm. **h**59 x **w**338 5/8 x **d**317 3/8 in. National Gallery of Canada, Ottawa

# Dzama Marcel

## Opportunists mingling with combatants, 2012

In this surreal and unsettling drawing a dead man hanging from a rope is surrounded by numerous masked characters engaged in various activities and interactions. It is left to the viewer to decide whether they are, as the title states, opportunists or combatants. Inspired by history, popular culture, avant-garde ballet and the artist's own imagination, such ambiguous characters including human figures, animals and hybrids appear throughout Dzama's œuvre. With a prolific output of drawings, films and dioramas, his distinctive, muted colour palette and fanciful figurative style makes his art immediately recognizable.

As well as being held in many major public collections worldwide, his works have been used on a number of music album covers. Themes of violence, love, death, abuse of power and music are central, and although many individual pieces appear to belong to a larger narrative, their meaning is ultimately left to viewers to determine.

⋯⋮ Avery, Ghenie, Nordström

Marcel Dzama. b Winnipeg, Canada, 1974. **Opportunists mingling with combatants**. 2012. Ink, gouache and graphite on paper. Two-part work. Overall: **h**41.9 x **w**60 cm. **h**16 1/2 x **w**23 5/8 in. Each: **h**41.9 x **w**29.8 cm. **h**16 1/2 x **w**11 3/4 in

# Eliasson Olafur

### New York City Waterfalls, 2008

For this ambitious public artwork, Eliasson installed four artificial waterfalls along New York's East River, near Lower Manhattan. Constructed from scaffolding and industrial pumps, the enormous falls ranged from 28 to 37 metres (92 to 121 feet) high and ran continually for four months. By simulating nature in this way, Eliasson offered viewers a new way to experience the city's waterfronts, providing them with a phenomenon that was both natural and cultural. Eliasson's immersive installations typically replicate climatic and atmospheric conditions using basic materials such as water, heat and light. One

early work created an ethereal rainbow inside a gallery, using just an electric lamp and a perforated hose; another, made for Tate Modern's gargantuan Turbine Hall, used humidifiers and hundreds of mono-frequency lights to generate a hazy yellow sunset. Yet Eliasson does not attempt to fool anyone with his works, and he deliberately allows viewers to quickly discern how his effects are achieved.

⋯⫶ Elmgreen & Dragset, Kapoor, Leonard

**Olafur Eliasson. b** Copenhagen, Denmark, 1967. **New York City Waterfalls**. 2008. Mixed media. Various dimensions. Temporary installation, New York. Presented by the Public Art Fund, in collaboration with the City of New York

# Elmgreen & Dragset

## Prada Marfa, 2005

Marfa, a small desert town in Texas, USA, has been a hub for artists since the 1970s, when artist Donald Judd moved there from New York. In October 2005 the Scandinavian artists Elmgreen & Dragset sited the permanent sculpture *Prada Marfa* about 60 kilometres (37 miles) outside the city. Resembling a real Prada store, it features shoes and handbags from the designer's fall/winter 2005 collection in its windows. However, the door to the store is permanently closed so nothing can be purchased. Elmgreen & Dragset have worked together since 1995. Their art examines the intersection of art with architecture and design, and the shelving and repeated forms in this piece echo the art of Judd and other Minimalists. The sculpture also provocatively explores the often-contentious relationship between contemporary art, fashion and commerce. It was intended to remain untouched after installation, left to slowly disintegrate, but shortly after completion it had to be restocked when the original contents were stolen.

···ᐟ Cattelan, Gelitin, Hiorns

**Michael Elmgreen. b** Copenhagen, Denmark, 1961. **Ingar Dragset. b** Trondheim, Norway, 1969. **Prada Marfa**. 2005. Adobe bricks, plaster, aluminium frames, glass panes, MDF, paint, carpet, Prada shoes and bags. **h**760 x **w**470 x **d**480 cm. **h**299 1/4 x **w**185 x **d**189 in. Sealed mockup of a Prada boutique, located in the vast American desert landscape near Marfa, Texas. Highway 90 in Valentine, just outside Marfa, Texas

# **Eloyan** Armen

### Untitled (painter), 2009

In this painting Eloyan depicts himself as a stump of wood with spindly arms and legs and a long, Pinocchio-like nose. Wearing oversized red shoes, the bizarre figure sits slumped against a wall, fast asleep. Scattered all around him are the tools of a painter: brushes, paints and an artist's palette. Weird humour is a distinctive trait of Eloyan's canvases, which are populated by a strange cast of grotesque characters with wild eyes, lolling tongues and buck teeth. Inspired by cartoons, fairy tales and Hollywood films, among other things, these anthropomorphic animals, vegetables and other curious entities are

the main protagonists in an absurd and tragicomic world. Working in an expressive style, the Armenian artist frequently applies paint straight from the tube, creating thick, impasto surfaces. Indeed, the physicality of Eloyan's work is a striking feature, reminding viewers that it is the practice of painting itself that is the artist's chief concern.

 Brown, Kiefer, Lassnig

**Armen Eloyan. b** Yerevan, Armenia, 1966. **Untitled (painter)**. 2009. Oil on canvas. **h**250 x **w**178.5 cm. **h**98 1/2 x **w**70 1/4 in

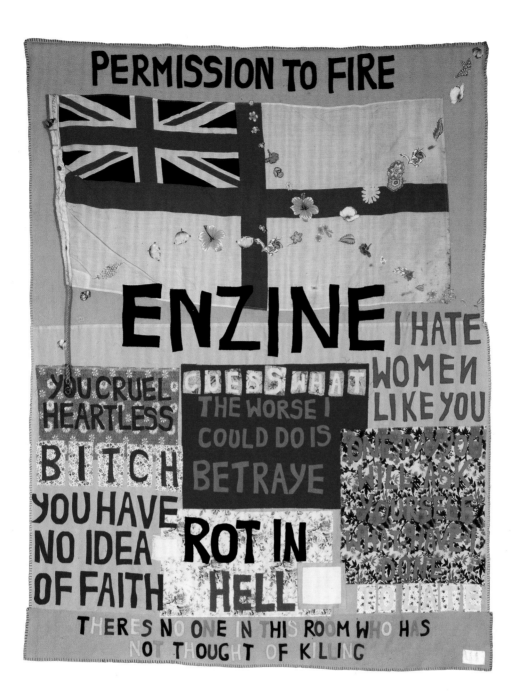

# Emin Tracey

## Hate and Power Can be a Terrible Thing, 2004

A textile wall hanging, this work uses an old pink woollen blanket cut and extended, with cotton as backing, onto which a series of statements are stitched. Emin has used quilting and appliqué in her work since her career-launching solo exhibition in 1993, and is one of a number of women artists to use traditionally feminine crafts to express complex emotions and sexuality. A central player in the loose group of artists commonly referred to as the Young British Artists (YBA), Emin's work is often based on self-exposure, yet this piece is overtly political. Amongst the statements in block capitals, a small section of white fabric features a handwritten text: '1982, A year so many conscripts did not got home – Because you, you killed them all'. This, combined with the use of the British Royal Navy's White Ensign flag, suggests a reference to the Falklands War and the ever divisive then-Prime Minister, Margaret Thatcher.

⋯⋮⋯ Deller, Sarah Lucas, Perry, Rojas

Tracey Emin. b Croydon, UK, 1963. **Hate and Power Can be a Terrible Thing**. 2004. Appliquéd blanket. **h**268 x **w**204 cm. **h**105 1/2 x **w**80 1/2 in. Tate, London

# **Farmer** Geoffrey

### The Surgeon and the Photographer, 2009–13

Hundreds of figures, assembled from images cut from books and magazines, are mounted puppet-like onto cloth-covered mannequins. The act of moving around them brings them to life: their collaged elements shift and change, they cast shadows, stand in altered relationship to each other. Individually the spotlit figures have a compelling presence. They gesture like orators, or stand in mute observance. They have personalities and, sometimes, specific roles: soldier, artist, politician. Developed over a three year period, when presented en masse at the Curve Gallery of the Barbican Centre, London, they became a vast company of actors standing ready to perform their parts in some enigmatic play. Farmer typically makes site-specific work and engages the audience in animating it, thereby playing an active role in constructing its meaning. He combines elements of sculpture, collage, video, film, performance and text, making reference to literature, theatre and cinema.

⋯⋮ Avery, Baghramian, Chapman

**Geoffrey Farmer. b** Vancouver, Canada, 1967. **The Surgeon and the Photographer**. 2009–13. Paper, textile, wood, and metal. Dimensions variable. Installation view, Curve Gallery, Barbican Centre, London, 2013. Vancouver Art Gallery, Canada

# Farocki Harun

## I Thought I was Seeing Convicts, 2000

Grainy surveillance footage from a maximum security prison captures the dramatic moment when an inmate is shot dead by guards. The shooting of William Martinez in 1989 was one of many similar incidents at California State Prison, which became notorious for its brutal conditions. Farocki's film focuses on the investigation into the shootings, revealing that guards intentionally set up fights between prisoners, allowing them to escalate before interceding with live ammunition. The prison footage is juxtaposed with computer-generated graphics based on the movements of supermarket shoppers.

In this way Farocki explores the power relationship between the observer and the observed, drawing parallels between the role of surveillance in the lives of prisoners and those of everyday citizens. The power of images has been a central concern for the German filmmaker since the late 1960s. His film essays and documentaries examine systems of control and manipulation, and the influence of technology on human behaviour.

····: Ghenie, Li Songsong, Sierra

**Harun Farocki. b** Nový Jičín, Czech Republic, 1944. **I Thought I was Seeing Convicts**. 2000. Two-channel video projection. Colour, sound. **dur** 23 min

# **Fast** Omer

## CNN Concatenated, 2002

In creating this video work, Fast edited together thousands of clips of rolling news from the CNN news channel to construct a sequence of just over 18 minutes. An array of different presenters are featured as each speaks just one word. These individual utterances, spliced together by Fast, form awkward, jerky sentences that address the viewer directly. At first the message is personal, conspiratorial, but it soon becomes clear that the newsreaders are berating the viewer, attacking their opinions and ways of life. Watching the resulting work can be an uncomfortable experience. It encourages us to question our passive trust of the media, and in particular to examine how news reporting can foster fear. *CNN Concatenated* is one in a body of work exploring the layers of truth and fiction that coexist within accounts of historical events, particularly war.

·····:· Ataman, Kawara, Mik, Pfeiffer

**Omer Fast. b** Jerusalem, 1972. **CNN Concatenated**. 2002. Colour video, sound. **dur** 18 min (loop)

# Feldmann Hans-Peter

## The Hugo Boss Prize, 2010

As winner of the 2010 *Hugo Boss Prize*, Feldmann was invited to exhibit at the Guggenheim Museum in New York. For his installation *The Hugo Boss Prize* he cashed the $100,000 honorarium and pinned it to the walls of the gallery in neat rows of single United States dollar bills. Aside from the instantly recognizable smell, the viewer's attention was drawn to the differences between the serially produced paper money. Some were folded, creased or defaced, and all, of course, were uniquely numbered. When the exhibition was over, the artist removed the banknotes and put them back into normal circulation. Since the late 1960s Feldmann has been exposing the unstable, human qualities of serialized imagery through books, photographic installations and sculptures. *100 Years* (2001) comprises sequential photographs of people from 0 to 100 years old; *9/12 Front Page* (2001) gathers front pages from newspapers around the world on the day after the terrorist attacks on America.

····⫶· Genzken, Hirst, Kawara

**Hans-Peter Feldmann. b** Düsseldorf, Germany, 1941. **The Hugo Boss Prize**. 2010. Dollar bills. Dimensions variable. Installation view, Solomon R. Guggenheim Museum, New York, 2010

# **Feng** Mengbo

## Long March: Restart, 2008

This enormous, interactive video game towers over viewers who, by using wireless controllers, can also become players. The game's protagonist is a Chinese Red Army soldier who hurls exploding cans of Coca-Cola at all manner of pixelated enemies. Due to its vast scale and quick pace, players must move fast to keep up with the action, which is displayed across two gigantic facing screens. The work's title refers to the retreat of the Communist Party's Red Army in 1934. Pursued by the Nationalist Party and under the command of Mao Zedong, the army travelled over 12,500 kilometres (8,000 miles) through some of

China's most hostile terrain. Despite being based in Beijing, Feng has never exhibited in his native country. His provocative work stems from his involvement with the Political Pop movement in China that, in the 1980s and 90s, fused American Pop Art aesthetics with propaganda imagery from the Cultural Revolution.

····÷ Cao, Holzer, Ruff, Superflex

Feng Mengbo. b Beijing, China, 1966. **Long March: Restart**. 2008. Video game installation. Dimensions and duration variable. MoMA, New York

# Finch Spencer

## Sky Over Coney Island (November 21, 2004 1:14 pm), 2004

Photographed in the sky over Miami is a bunch of helium-filled balloons coloured to perfectly match the shade of the sky over Coney Island at a particular time on a November day. Finch used scientific instruments to determine the precise colour and replicated it by layering violet and cobalt blue balloons one inside the other. He is attempting to fix a moment that exists in an ever-changing continuum. The frivolity and ephemerality of balloons further reinforces the futility of trying to represent our experience of the ever changing world. The image is beautiful and precise, but ultimately inadequate to the task. Finch

produces work in a wide variety of media, including watercolour, photography, glass, electronics, video and fluorescent lights. He brings a poetic sensibility combined with a scientific approach to his investigation of perception, memory and the challenge of communicating visually our experience of natural phenomena.

⋯⋰ Cai, Eliasson, Hashimoto, Kapoor

**Spencer Finch. b** New Haven, CT, USA, 1962. **Sky Over Coney Island (November 21, 2004 1:14 pm)**. 2004. Fifteen to fifty balloons, string, brick. Dimensions variable, each balloon 26 cm. 10 1/4 in

# Fischer Urs

## Untitled, 2011

A casually dressed man stands before an accurate, full-size replica of Giambologna's sixteenth-century sculpture *The Rape of the Sabine Women*, apparently carved from marble. Both are steadily melting. Like giant candles, they are made of wax, with strategically placed wicks. The melting wax has its own beauty, which stands in contrast to the sense of permanence embodied by the original sculpture. The work dramatizes the passage of time. It was created for the 2011 Venice Biennale, where it had a particular resonance within the beautiful, slowly decaying city. Fischer, who is based in the USA, makes installations and sculptures, often on a large scale, that evoke traditional art-historical genres, such as still lifes and nudes, imbuing them with humour and rich new meanings. He often uses perishable materials that introduce elements of performance and temporality into art forms that are usually associated with eternal verities. They evolve and disappear as the viewer stands before them.

⋯⋰ Demand, McKenzie, Mueck, Ray

**Urs Fischer. b** Zurich, Switzerland, 1973. **Untitled.** 2011. Wax, pigments, wicks, steel. Giambologna sculpture: **h**630 x **w**147 x **d**147 cm. **h**248 1/8 x **w**57 7/8 x **d**57 7/8 in. Rudi figure: **h**197 x **w**69 x **d**49 cm. **h**77 1/2 x **w**27 1/8 x **d**19 1/4 in. Chair: **h**116 x **w**72 x **d**78 cm. **h**45 5/8 x **w**28 3/8 x **d**30 3/4 in. Installation dimensions variable. Installation view, 'ILLUMInazioni / ILLUMInations', *54th Venice Biennale*, 2011

# Fischli Peter & Weiss David

### Rat and Bear, 1981/2004

Two animal costumes – one a bear, the other a rat – hang suspended within large, tinted perspex cases. These characters, the artists' alter-egos, were first introduced in 1981 in a film satirizing the art world called *The Least Resistance*. They appeared again in *The Right Way* (1983), in which the pair are seen rambling through the Alps, trying to find their way. In these pivotal films the restless rat (played by Fischli) and the apathetic bear (played by Weiss) squabbled, schemed and yearned for success; now the characters appear frozen, as if cryogenically preserved. Those early works contained many themes

explored by the artists throughout their long collaboration, which lasted from 1979 until Weiss's death in 2012. Working with a wide range of media including photography, sculpture, moving image and installation, the Swiss artists created a body of work characterized by deadpan humour that celebrated the banality of everyday life.

⸫ Altmejd, Rondinone, Signer, Slominski

Peter Fischli. b Zurich, Switzerland, 1952. David Weiss. b Zurich, Switzerland, 1946. d Zurich, Switzerland, 2012. Rat and Bear. 1981/2004. Cotton and perspex.
Each: h 280 x w 100 x d 80 cm. h 117 x w 38 1/2 x d 49 1/2 in. Overall: Dimensions variable

# Floyer Ceal

## Warning Birds, 2002

In this installation a window teems with bird-of-prey-shaped silhouettes. The mass-produced, readily available stickers are normally used to reduce the risk of birds flying into plate-glass windows. But instead of using a single sticker, Floyer introduces an entire flock, creating a composition that is at once striking and slightly uncanny. Through repetition, the familiar shapes are made to feel unfamiliar. By drawing attention to the stickers' abstract qualities, the work addresses the relationship between nature and artifice while highlighting the absence of the real birds to which they refer. The work's title can be understood either as a simple description or a cautionary statement. This kind of ambiguity is typical of Floyer, who became known in the mid-1990s for her subtle interventions using everyday objects and materials. Infused with an elegant simplicity, her works challenge assumptions about art and the world in which we live.

····⫶· Finch, McKenzie, Salcedo, Kara Walker

**Ceal Floyer. b** Karachi, Pakistan, 1968. **Warning Birds**. 2002. Self-adhesive stickers on window. Dimensions variable. Installation view, Kölnischer Kunstverein, Cologne, Germany, 2013

# Friedman Tom

## Up in the Air, 2009–10

This large-scale installation consists of nearly one thousand hand-crafted objects suspended from the ceiling. All manner of everyday items, consumer knick-knacks and disparate forms have been painstakingly fabricated by Friedman, including a toy aeroplane, a crumpled packet of cigarettes, a lollipop and a baseball bat. Filled with references ranging from science and politics to religion and popular culture, the colourful constellation of floating objects was in part created as a response to the economic crisis of 2008; taking nearly two years to complete, it is one of the American artist's largest works. Since coming to prominence in the late 1990s, Friedman has constantly challenged audiences to slow down and view the world afresh through his quirky and unusual sculptures. Employing everyday materials such as toilet paper, chewing gum, plastic cups, pencil shavings and toothpaste, Friedman transforms them into extraordinary works of art that are both playful and serious.

⋯⋮ Baghramian, Ortega, Parker, Sze

**Tom Friedman. b** St. Louis, MO, USA, 1965. **Up in the Air**. 2009–10. Mixed media. Dimensions variable. Installation view, Magasin 3 Stockholm Konsthall, Sweden

# **Fritsch** Katharina

## Hahn/Cock, 2013

A huge blue cockerel perches proudly atop the fourth plinth in London's Trafalgar Square. Belonging to a rolling programme of temporary artworks commissioned for the otherwise empty plinth, Fritsch's sculpture pokes fun at the patriarchal history of the square, which commemorates the triumph of British naval power at the battle of Trafalgar in 1805. Standing in the shadow of Nelson's Column, the irreverent rooster, with its double-entendre title, gently mocks the monument's phallic appearance and the site's general air of masculine posturing. Fritsch is well known for her highly detailed sculptures of

animals and people rendered in industrial materials such as fibreglass and aluminium. At once seductive and unsettling, her works transform the familiar into something strange. Colour is an essential element for the German artist, whose works are typically painted with a single matt shade, which gives them a dense, impenetrable feel and a hallucinatory, dream-like quality.

 Elmgreen & Dragset, Genzken, Huang

Katharina Fritsch. **b** Essen, Germany, 1956. **Hahn/Cock.** 2013. Fibreglass. **h**4.7 m. **h**15 ft 6 in. Temporary installation, Trafalgar Square, London, commissioned for the Mayor of London's Fourth Plinth Programme

# Gaillard Cyprien

## Cities of Gold and Mirrors, 2009

The discrete scenes of this short film were shot around the Mexican city of Cancún, a tourist resort founded in 1970. American college students in beachwear are seen competitively glugging tequila; dolphins swim in water that reveals itself as a hotel pool; a sole gang member dressed in red performs a ritualistic dance amid ancient Mayan ruins; and a large mirrored building shimmers before being dramatically blown up. The film ends with flashing disco lights inside the Coco Bongo nightclub. Each scene is accompanied by the distinctive electronic soundtrack from the 1980s Japanese–French animation *Mysterious Cities of Gold*, a television series set during the Spanish conquest of the Americas. Through contemporary culture clashes, Gaillard evokes the rise and fall of nations and empires, reflecting on the precarious nature of civilization. Filled with melancholy, his compelling film and video installations frequently juxtapose scenes of beauty with destruction and consider the failure of the utopian ideals of Modernism.

·····⫶· Ortega, Parreno, Raad

Cyprien Gaillard. b Paris, France, 1980. **Cities of Gold and Mirrors**. 2009. 16 mm film, colour, with sound. **dur** 8 min 52 sec

# Gallagher Ellen

### Bird in Hand, 2006

A strange, pirate-like figure with wild, billowing hair and a peg leg dominates this large, mixed media painting. Submerged under the sea, he is surrounded by seaweed and marine vegetation that entangle his legs. The complex image has been built up in layers with printed paper, Plasticine, salt crystals, silver paint and gold leaf. Fragments of maps, newspaper pages and magazine advertisements aimed at African American women are all visible across the work's textured surface. The painting mixes issues related to the transatlantic slave trade – a long-standing concern in Gallagher's work – with the strange mythology

of Drexciya, which describes an aquatic race of beings descended from African slaves who were thrown overboard during the gruelling Middle Passage journey across the Atlantic. Gallagher emerged in the mid-1990s and has since become well known for her politically charged paintings, drawings, prints, sculptures and films about African American history and culture.

⠿ Julien, Marshall, Mutu, Kara Walker

**Ellen Gallagher. b** Providence, RI, USA, 1965. **Bird in Hand**. 2006. Oil paint, ink, paper, polymer, salt and gold leaf on canvas. **h**238 x **w**307 cm. **h**93 1/4 x 120 7/8 in. Tate, London

# **Gates** Theaster

## Civil Tapestry (Dirty Yellow), 2012

A decommissioned fire hose is the unusual material used to make this work. The formal arrangement, made from long strips of the flattened hose, recalls American abstract art of the early 1960s, especially the famous stripe paintings by Frank Stella. Yet it is to another event from this period that Gates's work points: the violent hosing of civil-rights demonstrators by police in Birmingham, Alabama, in 1963. The enduring challenge of race and class inequality in American cities is a driving force for Gates, whose sculptures, installations and performances are part of a larger vision that aims to effect genuine social change. Originally trained as an urban planner, the Chicago-based artist uses funds raised from the sale of his works to assist in the regeneration of deprived neighbourhoods. Collaborating with architects, craftspeople and unemployed labourers, Gates buys and renovates derelict properties. Salvaged materials from the buildings are then used to create new artworks, and so the cycle continues.

·····⫶· Abts, Gowda, Kounellis, Parrino

**Theaster Gates. b** Chicago, IL, USA, 1973. **Civil Tapestry (Dirty Yellow)**. 2012. Decommissioned fire hose. **h**149.9 x **w**203.2 x **d**12.7 cm. **h**59 x **w**80 x **d**5 in

# Gelitin

## Hase, 2005

A 70-metre-long pink knitted rabbit, stuffed with straw, lies flat on its back across a mountaintop in the Piedmont region of Italy, above the village of Artesina. The floppy rabbit is smashed and broken, as if flung from space, or run over by a giant car, its enormous mouth agape and cloth entrails pouring from its side. It is the work of the Austrian art collective Gelitin, a group of four artists who, according to their official biography, met at summer camp in 1978 and began exhibiting work together in 1993. The group creates sculptures and installations that are by turns mischievous, provocative and hilarious. Much of their work

invites participation from its audience. Gelitin has announced that *Hase* will remain on the mountain, left to slowly disintegrate until 2025, when it will be twenty years old. Despite the artists' desire for decay, the rabbit is often lovingly repaired by visitors.

·····⊹· Bourgeois, Fritsch, Villar Rojas

**Gelitin (formally known as Gelatin): Ali Janka, Wolfgang Gantner, Tobias Urban, Florian Reither.** Formed Vienna, Austria, 1993. **Hase**. 2005. Installation view, Artesina, Italy, 2005

# Genzken Isa

## Hospital (Ground Zero), 2008

An assemblage of disparate objects has been arranged and shrouded in fabric to suggest the outline of a skyscraper. This is one of a series of architectural proposals that the artist made for the former site of the World Trade Center in New York. The appearance is haphazard and precarious. However, Genzken worked with a team of structural engineers to ensure that they could be built to the scale of the Twin Towers. Genzken cannot be defined by a single medium or tradition, but she has developed a distinctive aesthetic and uses recurring motifs. The column, for instance, is employed to explore the relationships between art, architecture, design and social experience. Her work contains a flamboyant sense of humour. She creates monuments and structures that explore notions of both construction and deconstruction through a light-hearted perspective. *Hospital (Ground Zero)* commemorates a destructive historical event, yet builds a colourful, optimistic and humane tribute.

⋯⊹ Baghramian, Harrison, Vasconcelos

**Isa Genzken. b.** Bad Oldesloe, Germany, 1948. **Hospital (Ground Zero)**. 2008. Artificial flowers, plastic, metal, glass, fabric, acrylic, spray paint, mirror foil, MDF, casters. **h**312 x **w**63 x **d**76 cm. **h**122 7/8 x **w**24 ¾ x **d**29 7/8 in

# **Ghenie** Adrian

### The Trial, 2010

This large painting depicts the final hours in the lives of the toppled Romanian ruler Nicolae Ceauşescu and his wife Elena. Ghenie grew up under Ceauşescu's dictatorship, living through the tyrannical leader's trial and execution of 1989 – an event that had a profound impact on him. Based on television images of the military trial, Ghenie's painting shows the fated pair sitting behind some hastily erected trestle tables in a shabby, wood-panelled room; a house plant and an incongruously patterned armchair highlight the improvised nature of the courtroom. The sad, dejected figures are barely recognizable and,

like the rest of the painting, they are caught between figuration and abstraction. Ghenie mines the darker episodes of twentieth-century European history, sourcing imagery from books, films, the Internet and his own personal memories. Filled with existential horror, his dense, meticulously realized works often play on the difference between official history and personal perspective.

······⫶· Dzama, Huyghe, Man

**Adrian Ghenie. b** Baia Mare, Romania, 1977. **The Trial**. 2010. Oil on canvas. **h**200 x **w**363cm. **h**78 3/4 x **w**142 7/8 in. San Francisco Museum of Modern Art (Gift of the artist and Mihai Nicodim Gallery, Los Angeles)

# **Gober** Robert

## Melted Rifle, 2006

A melted Winchester rifle lies draped across a white plastic milk crate that, sat atop an old wooden stool, is filled with juicy looking apples. None of these, however, is real, for they and the rest of this sculpture are fabricated using plaster, paint, beeswax and other materials. The juxtaposition of fruit with rifle may suggest binaries of fertile and sterile, or feminine and masculine. The firearm, known colloquially as 'the gun that won the West' due to its popularity with nineteenth-century American settlers, lies flaccid: a symbol of power and dominance reduced to an impotent oddity. In this way Gober

ostensibly strikes at the heart of American mythology, yet despite attempts to discover a coherent narrative the work remains ambiguous, inviting multiple interpretations. Gober is well known for his disquieting sculptures, drawings and installations that pit the familiar with the strange and call everyday objects into question.

 Cattelan, Graham, Weber

**Robert Gober. b** Wallingford, CT, USA, 1954. **Melted Rifle**. 2006. Plaster, paint, cast plastic, beeswax, walnut and lead. **h**69 x **w**58 x **d**40 cm. **h**27 1/8 x **w**22 7/8 x **d**15 3/4 in

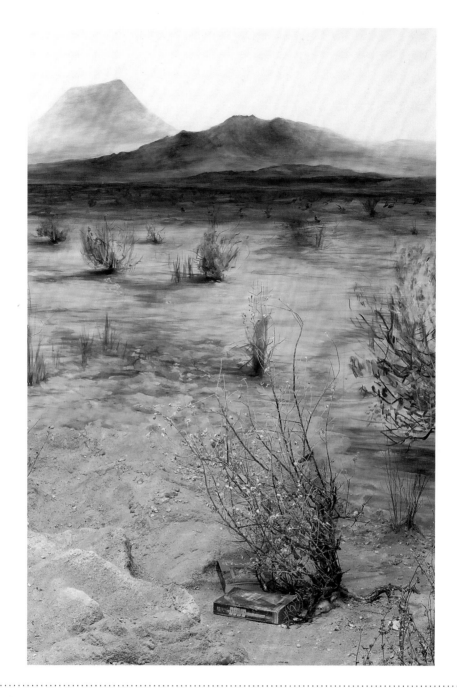

# Gonzalez-Foerster Dominique

### Desertic, 2009

This site-specific installation was created as an annex to the research library at the Hispanic Society of America in New York. Made in response to the library's extensive holdings of books, artworks and other materials, the piece introduced to the collection a number of new texts drawn from the twentieth century, a period with a limited presence in the library. Gonzalez-Foerster creates complex, theatrical installations that often refer to science fiction: for her unusual display of the books here she worked with specialists from New York's American Museum of Natural History to create a series of large-scale dioramas. Three terrains were depicted – desert, the tropics and the North Atlantic. Books by forty authors, including J. G. Ballard, Roberto Bolaño and Jorge Luis Borges, were then inserted, like relics, into the display most appropriate to their place of origin. Texts were also printed as calligrams on the exterior of the dioramas.

⸬ Barba, Kuri, Leonard

**Dominique Gonzalez-Foerster. b** Strasbourg, France, 1965. **Desertic.** 2009. Mixed media. Window size, **h**220 x **w**253 cm. **h**86 5/8 x **w**99 5/8 in. Construction size, **h**570 x **w**323 x **d**250 cm. **h**224 3/8 x **w**127 1/8 x **d**98 3/8 in. Unique. Installation view, 'chronotopes & diorama', Hispanic Society of America, Dia Art Foundation, New York, 2010

# **Gordon** Douglas

## Play Dead; Real Time, 2003

Gordon's fascination with the moving image spans from early twentieth century medical films to the Golden Age of Hollywood to canonical video works by artists such as Bruce Nauman and Dan Graham. He is most famous for his *24 Hour Psycho* (1993) in which he slowed down Alfred Hitchcock's film *Psycho* (1960) to a snail's pace, revealing normally unnoticed details and moments from the nail-biting thriller. Other films have isolated and reworked scenes by directors including Otto Preminger and Martin Scorsese. *Play Dead; Real Time*, by contrast, relies on footage that Gordon shot himself:

a trained elephant, in Gagosian Gallery, New York, where the work was also first shown, is filmed rising heavily to her feet. Schooled in Deconstructionist, Formalist and Structuralist theories of film, Gordon draws our attention to his medium's potential for conjuring – or dissipating – the weight and slowness of the physical world.

⋯⋰ Kawara, Marclay, Rist

**Douglas Gordon. b** Glasgow, UK, 1966. **Play Dead; Real Time**. 2003. Video Installation. Three-channel video (colour, silent), two projectors, two screens, monitor. Dimensions variable. Installation view, Gagosian Gallery, 555 West 24th Street, New York, 2003

# Gormley Antony

## Time Horizon, 2006

In Calabria in Italy, there is a partially excavated archaeological site called Scolacium, once home to the Greeks and later the Romans. Gormley created the temporary installation *Time Horizon* specifically for this atmospheric environment, responding on the one hand to the historical timescale of the ruins, and on the other, to the biological timescale of the gnarled olive grove that surrounds them. Throughout the site he placed 100 solid iron figures facing in different directions, cast, as with most of Gormley's sculptures, from his own body. Some perch on concrete pedestals and some are sunk into the earth and yet all stand at exactly the same datum level of 1.8 metres (5 feet 6 inches), the mean present-day level of the earth's surface above the horizontal plane of the excavated forum. As with Gormley's other outdoor works *The Angel of the North* (1998), Gateshead, UK and *Another Place* (1997), Crosby, UK, *Time Horizon* encourages the viewer to reflect upon the relationship of a human body to its environment.

⋯⊱ Cragg, Deacon, Kapoor, Serra

**Antony Gormley. b** London, UK, 1950. **Time Horizon**. 2006. Cast iron. 100 elements. Each: **h**189 x **w**53 x **d**29 cm. **h**74 3/8 x **w**20 7/8 x **d**11 3/8 in. Installation view, Parco Archeologico di Scolacium, Roccelletta di Borgia, Catanzaro, Italy

# Gowda Sheela

## Darkroom, 2006

This installation is constructed with rusty tar drums, the kind used by road construction teams in India. The barrels, along with other scrap metals, are often recycled and used to build makeshift shelters in slums, and they perform a similar purpose in Gowda's work, where they are combined to form a structure that visitors may enter. However, the humble materials belie an unexpected grandeur: the barrels are stacked in columns that mimic classical architecture and, while the space initially appears confined, the ceiling is peppered with tiny holes, giving it the appearance of a starry sky stretching overhead. The installation is thus simultaneously ordinary and magical. Gowda regularly uses materials reflective of India's everyday life in her work: these include cow dung, needles and thread, and the ceremonial dyes used in traditional rituals. These familiar items are used to explore complex ideas about Indian society and its politics.

····ᐧ Celmins, Gupta, Reyle, Singh

**Sheela Gowda. b** Bhadravati, India, 1957. **Darkroom**. 2006. Tar drums, tar drum sheets, asphalt, mirrors. **h**235 x **w**255 x **d**300 cm. **h**92 1/2 x **w**100 3/8 x **d**118 1/8 in. Astrup Fearnley Museet, Oslo, Norway

# **Graham** Rodney

## Rheinmetall/Victoria 8, 2003

The star of Graham's film is a 1930s black German typewriter made by Rheinmetall, a company that also manufactured arms for the Third Reich. Found by the artist in immaculate condition in a second-hand shop in Vancouver, the object is lovingly examined in the film, with the camera exploring its form from all angles. Over time, flour begins to fall like snow over the typewriter; here Graham is emphasizing the machine's obsolescence. The item's extinction as a useful object in the modern world is further highlighted by its pairing with the Victoria 8 film projector, another beautiful machine from the past whose technology is now largely irrelevant, aside from as a prompt for nostalgia. Graham creates artworks in a wide variety of mediums, regularly making reference to the histories of art and of technology in his work, as well as appropriating ideas from music, literature, philosophy and film.

⋯⋮ Gordon, Jaar, Lawler, Vo

**Rodney Graham. b** Abbotsford, BC, Canada, 1949. **Rheinmetall/Victoria 8**. 2003. 35 mm colour film, film projector, looper, projected on continuous loop, silent. **dur** 10 min 50 sec

# Grotjahn Mark

## Untitled (Colored Butterfly White Background 6 Wings), 2004

Nature meets abstraction in this drawing, one of a series of butterfly artworks by Grotjahn since the late 1990s. His works reference a number of art historical traditions from Renaissance perspective drawings to the work of twentieth-century American painters such as Frank Stella and Jasper Johns. They are also influenced by the bold, flat colours of Pop art. The drawing features multiple vanishing points, stretching the triangular patterning of the butterfly wings so that they appear flat and unreal. Grotjahn is methodical in his approach, while also deliberately allowing for an element of chance in the creation of

the drawings. Each of the wing sections is executed in a different hue; before beginning a new work Grotjahn lays out the required number of coloured pencils and then picks each one at random, so that chance divines the order they appear on the finished work.

⋯⋮ Abts, Guyton, Scheibitz, Shahbazi

**Mark Grotjahn. b** Pasadena, CA, USA, 1968. **Untitled (Colored Butterfly White Background 6 Wings)**. 2004. Coloured pencil on paper. **h**169.5 x **w**119.4 cm.
**h**66 3/4 x **w**47 in

# **Gupta** Subodh

### Line of Control, 2008

A giant mushroom cloud is formed from unusual items – stainless-steel kitchen utensils, pots and pans are jammed together to form a dense explosion of domestic doom that has resonance globally. On closer inspection, the items are revealed to be traditional and ubiquitous objects from Indian life, including thali pans and the tiffin lunchboxes that cross India's rigid boundaries of class. They represent Gupta's personal memories of growing up, but in this context are also symbolic of a country in flux, with this work forming one of a number of paintings, sculptures and installations by the artist that reflect on the rapid economic change taking place in India in recent years. Its title also refers to a phrase used to describe the disputed borderline within the state of Kashmir, and the sculpture evokes the fear of a nuclear threat in the region. By the use of domestic utensils, the risk to ordinary, everyday life is made explicit.

⋯⋮ Barlow, Hirst, Kapoor, Koons

**Subodh Gupta. b** Khagaul, India, 1964. **Line of Control**. 2008. Stainless steel utensils, stainless steel and steel structure. **h**10 x **w**10 x **d**10 m. **h**393 3/4 x **w**393 3/4 x **d**393 3/4 in. Installation view, 'Altermodern: Tate Triennial 2009', Tate Britain, London, 2009

# **Gursky** Andreas

## Pyongyang V, 2007

Seemingly infinite ranks of women wearing identical, bright pink cheerleader costumes are lined up in tight formation. Behind them is a stylized, sweeping panorama of a field of flowers, topped by a frieze of mountains. This is one of a series of photographs that Gursky made at the Arirang Festival, held annually in North Korea to honour the country's late leader Kim Il Sung. The Festival involves more than 50,000 athletes performing rigidly choreographed acrobatics, while 30,000 schoolchildren create an ever-changing sequence of patterns and images by simultaneously turning coloured cards. The epic scale of the scene reduces the individual figures to pixelated elements in a vast mosaic. Gursky documents the landscapes, industries and people of the modern world in highly detailed, rigorously composed, large-format colour photographs. They are often taken from an elevated perspective, their disorientating effects sometimes heightened through digital manipulation. His images emphasize systematized, dehumanizing or environmentally destructive aspects of culture.

⋯⋮⋯ Demand, Ruff, Struth

Andreas Gursky. b Leipzig, Germany, 1955. Pyongyang V. 2007. C-print. h307 x w219 cm. h120 7/8 x w86 1/4 in

# Gusmão João Maria & Paiva Pedro

Columbo's Column, 2006

In this grainy 16 mm film a man is recorded as he attempts to construct a column of eggs. Each step is fraught with tension, as both tower and suspense grow. Eventually, on his third attempt, seven eggs stand on top of each other, recalling Constantin Brancusi's *Endless Column* (1918). In fact, the technique is simple: each egg is first tapped against the table, flattening its tip. This trick supposedly originated with Christopher Columbus who demonstrated it at a dinner party and it is often used as a metaphor for creative thinking. Reflecting Gusmão and Paiva's interest in myth and reality, their enactment of this apocryphal tale belongs to a series of twenty-two short films titled *Magnetic Effluvium* (2004–6). Collaborating since 2001, the Portuguese artists work with photography and sculpture but are best known for their enigmatic films. Weaving together fact and fiction with philosophical and literary references, these enchanting and often uncanny works meditate on the nature of existence.

⋯⋮ Almond, Graham, Signer, Vasconcelos

**João Maria Gusmão. b** Lisbon, Portugal, 1979. **Pedro Paiva. b** Lisbon, Portugal, 1977. **Columbo's Column.** 2006. 16 mm film, projection, colour, silent. **dur** 3 min 2 sec

# **Guyton** Wade

### Untitled, 2006

A series of black Xs parade across the surface of this canvas. Some overlap, while others are smudged and fragmented. Yet despite resembling a painting, not a single brushstroke or drop of paint was involved in creating this piece. Guyton produces these works by folding unstretched canvas in half and feeding, or more commonly forcing, it through a large-format inkjet printer. With such a haphazard technique, Guyton's simple computer-generated imagery is inevitably subject to disruption. The artist embraces such incidental mistakes, allowing drips, blurs, streaks and misalignments to remain. By relying on chance and mechanical reproduction Guyton engages two central approaches to art-making of the twentieth century but, by using home office equipment, updates them for the twenty-first. Coming to critical attention in the early 2000s, Guyton is one of a notable generation of New York-based artists, which also includes Kelley Walker and Seth Price, who have reconsidered appropriation and abstract art by utilizing digital technology.

⋯⋮⋯ Chan, Pica, Seth Price, Kelley Walker

**Wade Guyton. b** Hammond, IN, USA, 1972. **Untitled**. 2006. Epson UltraChrome inkjet on linen. **h**216.5 x **w**175.3 cm. **h**85 1/4 x **w**69 in

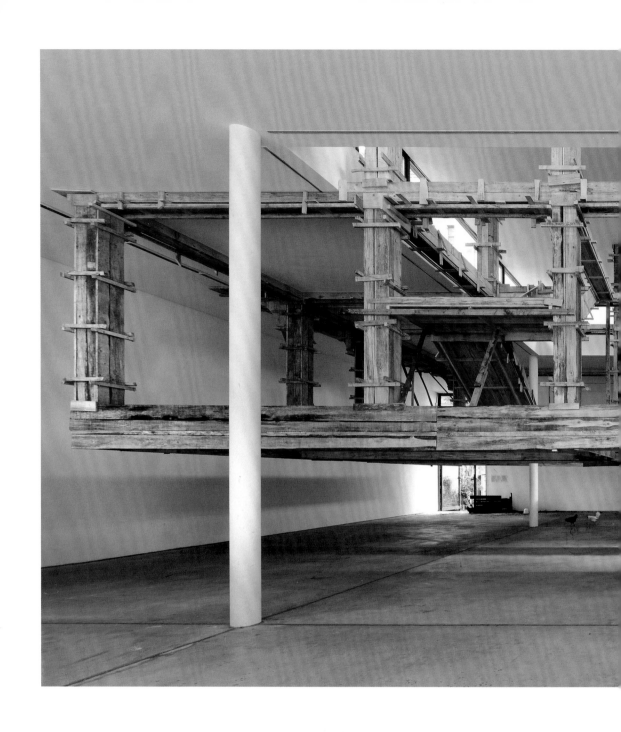

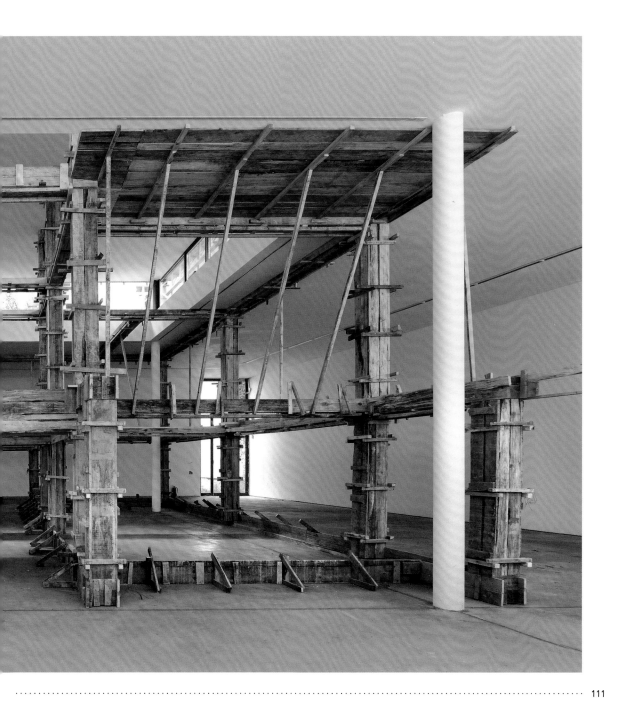

# Halilaj Petrit

### The places I'm looking for, my dear, are utopian places, they are boring and I don't know how to make them real, 2010

Autobiography is a central theme in Halilaj's art. Born in Kosovo in 1986, at the age of thirteen Halilaj fled with his family to Albania during the Kosovo War. His art mixes the personal with the political, his often large-scale installations exploring questions of identity, displacement and the nature of 'home'. This work is a replica of his parents' new house in Kosovo, reproduced twenty per cent larger than in actual life. Depicted halfway through the building process, the artwork suggests new beginnings but also ruination: the family's previous home was destroyed during the war. Halilaj uses materials from real life in his art:

this installation is populated with chickens and he has also exhibited a section of land from his family's property, as well as drawings from his childhood. A complex mix of history, politics and personal memories are presented to the audience to unravel.

⋯⋮⋯ Barlow, Suh, Tuazon

**Petrit Halilaj. b** Kostërrc, Skënderaj, Kosovo, 1986. **The places I'm looking for, my dear, are utopian places, they are boring and I don't know how to make them real**. 2010. Wood, iron, various materials. **h**8 x **w**11 x**d**13 m. **h**26 ft 3 in x **w**36 ft 1 3/4 in x **d**42 ft 7 3/4 in. Installation view, *6th Berlin Biennale for Contemporary Art*, Germany, 2010

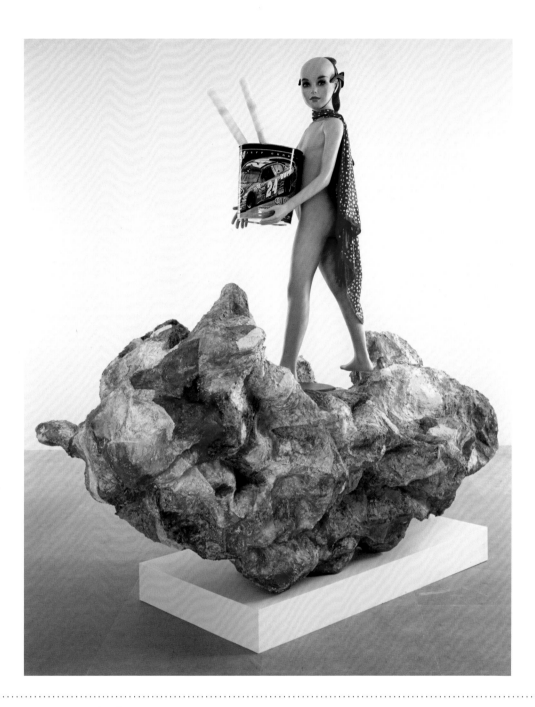

# **Harrison** Rachel

### **Alexander the Great, 2007**

An androgynous mannequin dressed in a red cape and carrying a wastebasket stands on top of a multicoloured boulder. Wearing a mask of Abraham Lincoln on the back of its head, the figure recalls the two-faced Roman god Janus. Like the ancient deity, Harrison's work looks forwards and backwards, gazing simultaneously to the past and the future. It exemplifies the artist's fascination with the evolution of sculpture, from its earliest beginnings to its possible futures. In Harrison's flamboyant assemblages, references to popular culture, archaic statuary and art history collide with mass-produced consumer items and hand-crafted forms made from chicken wire, polystyrene, paint and other commercially available materials. Her approach is reminiscent of the Pop artists of the 1950s and 60s, who derived their imagery from mass media and consumer culture. However, Harrison's works transcend recent art history, bringing together ideas and imagery from around the globe and across the centuries.

⋯∷ Barney, Mueck, Murakami, Wekua

**Rachel Harrison. b** New York, NY, USA, 1966. **Alexander the Great**. 2007. Wood, chicken wire, polystyrene, cement, acrylic, mannequin, Jeff Gordon wastebasket, plastic Abraham Lincoln mask, sunglasses, fabric, necklace and two unidentified items. **h**221 × **w**231.1 × **d**101.6 cm. **h**87 × **w**91 × **d**40 in. MoMA, New York

# Hashimoto Jacob

## Gas Giant, 2012

American-born Hashimoto draws on his Japanese heritage to make kites in a traditional handmade way, from silk or, more commonly, from paper, which is attached to a bamboo frame. He fabricates hundreds at a time – square, round or hexagonal – and meticulously hangs them in a gallery space to create tableaux that are as spatial as they are pictorial. Many of his assemblages, such as *The End of Gravity* (2011), are displayed on the wall and, though densely layered, function similarly to paintings. Others are more elaborate. *Gas Giant*, for instance, consists of around 10,000 delicate kites suspended in groups. Some kites are blank and white, others are coloured in one shade, and yet others are hand-painted with abstract and natural motifs such as waves or grass, the bamboo outline functioning like a picture frame. The entire installation uses the simplest of component images to assemble a shimmering, playful landscape.

⋯⋮⋅ Mehretu, Rehberger, Sailstorfer, Saraceno

**Jacob Hashimoto. b** Greeley, CO, USA, 1973. **Gas Giant**. 2012. Acrylic on paper, nylon, thread, bamboo, wood. Dimensions variable. Site-specific installation

# **Hatoum** Mona

## Homebound, 2000

A table and chairs, beds and other pieces of furniture are placed in the gallery. Laid out on the table's surface are metal kitchen utensils. Despite the familiarity of the objects, the atmosphere is tense and threatening. In fact the whole installation is electrified. As the fluctuating current passes through wires connecting the utensils and pieces of furniture the attached lamps flicker, while speakers in the space amplify the crackling electricity. All the household elements that might make it appear comfortable have been removed: the metal bed is stripped of its mattress, the wardrobe emptied of clothes. *Homebound*

is one of a number of works by Hatoum that presents the domestic environment, traditionally a female domain, as one of violence and entrapment. In addition to gender issues, Hatoum, who in 1975 was exiled from Lebanon, where she was born to Palestinian parents, addresses wider political questions around the nature of 'home'.

⋯⫶⋯ Andersson, Belmore, Kabakov

**Mona Hatoum. b** Beirut, Lebanon, 1952. **Homebound**. 2000. Kitchen utensils, furniture, electric wire, light bulbs, computerised dimmer device, amplifier and speakers. Dimensions variable

# Hayes Sharon

In the Near Future, New York, 2005

Five simultaneous slide projections document a performance-based artwork in which Hayes held up banners carrying anachronistic slogans relating to protest actions from previous eras. The original, collaborative performance took place in various public locations, the sites of historical actions, in New York in 2005. It was then adapted for similarly significant locations in Brussels, London, Warsaw, and Vienna. The intention was not to re-enact the protests but to commemorate those events and to assert the possibilities for future dissention. The artist was also exploring the idea of the protester as an agent of change, the protest sign as a method of communication and the political construction of public space and public speech. Hayes's work combines performance art with direct engagement with the public and her principal concern is the way in which we participate, as both speakers and listeners, in the political discourse of our own time.

⋯⋮· Bartena, Belmore, Cantor, Żmijewski

**Sharon Hayes. b** Baltimore, MD, USA, 1970. **In the Near Future, New York**. 2005. Multiple-slide-projection installation

# Hein Jeppe

**Distance, 2004**

Apprearing like a three-dimensional line drawing, or a piece of minimalist machinery, *Distance* consists of a looping rollercoaster track that is reconfigured each time to occupy the space in which it is shown. When a visitor enters the room, a sensor is triggered, releasing a ball that rolls the length of the track, through loops, curves and other dynamic elements in the circuit. Once the ball is in motion its progress can be followed by walking through the complex maze of the installation. Hein's sculptures and installations often engage the eye with their intricate geometry, but they become truly activated as artworks when the viewer becomes involved. Alongside its formal simplicity, Hein employs humour and delight as strategies for drawing in his audience so that their experience and perceptions become the central elements of the work. *Appearing Rooms* (2007), for example, is a hugely popular interactive public fountain that is activated each summer in London.

⋯⋗ Creed, Höller, Johanson

**Jeppe Hein. b** Copenhagen, Denmark, 1974. **Distance**. 2004. Mixed media. Dimensions variable. Installation view, 'Roller Coaster', Dunkers Kulturhus, Helsingborg, Sweden, 2005

# Henrot Camille

## Grosse Fatigue, 2013

Henrot's thirteen minute film, *Grosse Fatigue,* explores the manifestations and origins of the human desire to grasp the total harmonization of all knowledge. Conceived in response to an artist's residency at the Smithsonian Institution in Washington, DC, the work features footage shot by Henrot alongside found images, all set to a soundtrack of spoken word poetry written by the artist with the poet Jacob Bromberg. The film features creation stories taken from religious, Hermetic and oral traditions, which are mixed with scientific history. The imagery is revealed as if being opened on a computer screen, with pop-up windows layering on top of one other. While *Grosse Fatigue* is a reflection on the vast amounts of knowledge now available to us, and the exhausting contemporary obsession with cataloguing and collecting this information, for Henrot classification anticipates the end of the world as we know it. Scientific categorization may preserve cultures and species, but it also precipitates the destruction of nature, and consequently our own.

⤑ Dion, Fast, Hayes, Elizabeth Price

**Camille Henrot. b** Paris, France, 1978. **Grosse Fatigue**. 2013. Video. **dur** 13 min. Original music by Joakim. Voice by Akwetey Orraca-Tetteh. Text written in collaboration with Jacob Bromberg

# von Heyl Charline

## Slow Tramp, 2012

A field of regularly spaced vertical stripes is interrupted by an anarchic horizontal smear. A muscular black shape snakes diagonally across the canvas. Hovering over all is an irregular grey panel filled with graffiti-like symbols. Although the layers of the painting refuse to resolve into a tidy hierarchy, the disparate composition has a remarkably authoritative sense of coherence. There is an energetic tension between the orderly stripes, the formlessness of the gestural marks and the vestigial hieroglyphics. Von Heyl's paintings often contain fragments of semi-figurative imagery – the suggestion of a face, for instance – but they are not intended to be representational in any way. They are not abstractions based on objects or figures. Starting without any pre-conceived ideas, she employs an improvised process of assembling, erasing and reassembling so that the elements lose any sense of figurative association to become fully integrated into purely abstract compositions.

 Abts, Deacon, Dzama, Woods

**Charline von Heyl. b** Mainz, Germany, 1960. **Slow Tramp**. 2012. Oil, acrylic and charcoal on canvas. **h**208.3 x **w**182.9 cm. **h**82 x **w**72 in

# **Hiorns** Roger

## Seizure, 2008

In his installation *Seizure*, Hiorns covered the walls and ceiling of a condemned council flat in Southwark, south London, with a thick layer of bright blue crystals. The effect was produced by pumping 75,000 litres of liquid copper sulphate into the property, which then formed a crystalline growth on all available surfaces, including the bath. Visitors could enter the flat and walk around the exotic interior, which was both beautiful and threatening. In 2011 the block housing *Seizure* was due for demolition, but after being acquired by the Arts Council Collection the 31-tonne installation was extracted and moved to the Yorkshire Sculpture Park, near Wakefield, where it is now displayed. Hiorns regularly creates transformative effects on objects or spaces, also working with unusual substances such as brain matter and fire. By using reactive materials, Hiorns invites an element of chance into his art.

⤏ Eliasson, Hirschhorn, Landy, Mirza

**Roger Hiorns. b** Birmingham, UK, 1975. **Seizure**. 2008. Installation view, Harper Road, London, 2008. An Artangel / Jerwood Commision. Arts Council Collection

# **Hirschhorn** Thomas

## Cavemanman, 2002

Cardboard boxes and packing tape are the main materials used
to create this sprawling, cave-like sculptural installation. Lit with
fluorescent tubes, the walk-in grotto is crammed with photocopied
texts, posters of celebrities, and numerous books on political theory
and philosophy. Empty drinks cans litter the floor and television
screens in the walls show scenes of Lascaux II, a theme park recreation
of the prehistoric painted caves in Montignac, France. Capitalistic
greed, sadomasochism, martyrdom and the Iraq War are just some
of the themes confronting visitors to this information-saturated
cavern. *Cavemanman* is typical of Hirschhorn, whose complex works
are characterized by their superabundance and use of cheap, readily
available materials. Since the 1990s, the Paris-based artist has used
his room-sized sculptures, drawings, videos and writings to critique
contemporary politics and express his faith in the transformative
power of art. His works are also intended to stimulate dialogue and
provide space for contemplation.

 Gowda, Holzer, Nelson, Schneider

**Thomas Hirschhorn. b** Bern, Switzerland, 1957. **Cavemanman**. 2002. Wood, cardboard, tape, aluminium foil, books, posters, video of Lascaux II, dolls, shelves, fluorescent
light fixtures. Dimensions variable

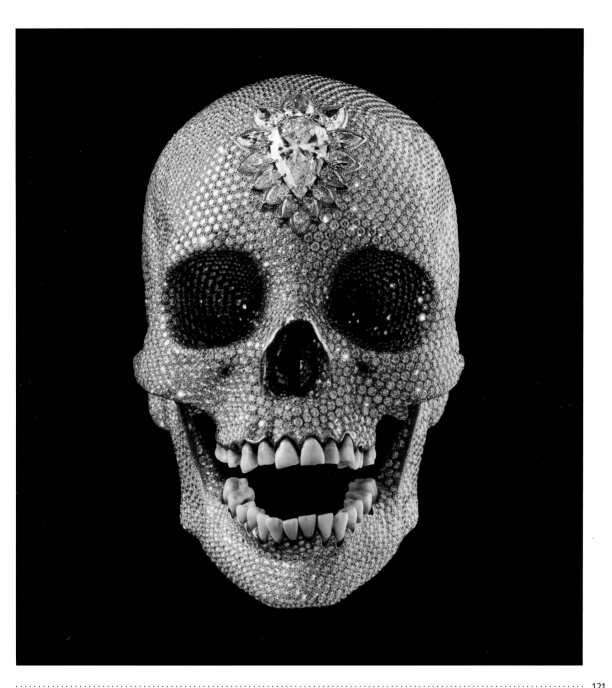

# **Hirst** Damien

### For the Love of God, 2007

A human skull encrusted with 8,601 flawless pavé-set diamonds, *For the Love of God* cost £14 million to create and weighs 1,106.18 carats. Its title comes from an expression regularly uttered by Hirst's mother on hearing his early ideas for artworks. The work was first exhibited at the White Cube gallery in London in 2007, amid heavy security, and attracted queues of visitors. The skull is likely to belong to an eighteenth-century man of European/Mediterranean ancestry and was bought by Hirst from a London taxidermist. Its teeth are real and belong to the skull. The piece acts as a *memento mori*, a reminder of the inevitability of death: in making it, Hirst drew inspiration from Aztec representations of skulls as well as Mexican rituals of honouring the dead. Death has been a recurring theme in Hirst's art, stretching back to his very earliest works.

⋯⋮ Feldmann, Gupta, Koons, Li Yongbin

**Damien Hirst. b** Bristol, UK, 1965. **For the Love of God**. 2007. Platinum, diamonds and human teeth. **h**17.1 x **w**12.7 x **d**19.1 cm. **h**6 3/4 x **w**5 x **d**7 1/2 in

# **Hlobo** Nicholas

### Ndize: Tail, 2012

Working with materials as varied as leather, lace, satin and the rubber inner tubes of car tyres, South African artist Hlobo creates large-scale installations, as well as paintings, drawings and performance-based works. *Ndize: Tail* is displayed across the walls and floor of the gallery space, and the mix of brightly coloured ribbons, leather and rubber come together to form a design that is abstract yet suggestive of something organic, perhaps the remains of an enormous multicoloured beast. The items that Hlobo uses have multiple references, to Xhosa culture as well as urban life in Johannesburg. Their meaning in his work is ambiguous: Hlobo's use of leather, for example, refers to the importance of cattle for the Xhosa people, although is also used by the artist to create sexualized imagery, including allusions to fetish gear. Hlobo also makes reference to gender, deliberately mixing materials regarded traditionally as masculine and feminine.

 Anatsui, Grotjahn, Reyle, Sze

**Nicholas Hlobo. b** Cape Town, South Africa, 1975. **Ndize: Tail**. 2012. Ribbon, steel, rubber and leather. **h**460 x **w**840 x **d**307cm. **h**181 1/8 x **w**330 1/4 x **d**120 7/8 in. Seventy-five balls. Dimensions variable

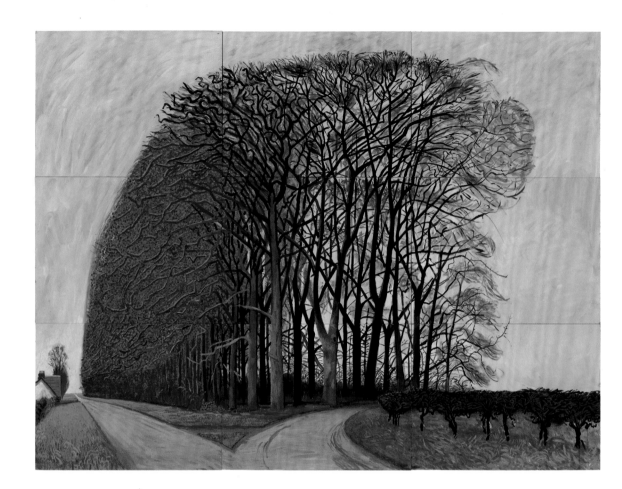

# **Hockney** David

## Bigger Trees Nearer Warter, Winter, 2008

One of a series of landscape paintings depicting the countryside of East Riding in Yorkshire, England, this work shows a copse of trees near Warter, Pocklington, viewed from the road. In another version, Hockney shows the same scene face on, so that each tree can be seen in full, yet here most of the trunks and branches merge together in a blur of pink, green and red. These bright colours are typical of Hockney's work: a major figure in the Pop art movement of the 1960s, he has spent much of his life in California, painting scenes, including swimming pools and palm trees, all bathed in bright sunshine. Hockney regularly returned to Yorkshire and in 2005 began a series of large-scale oil paintings capturing the seasonal changes in the nearby countryside. This work is made up of nine canvases, and is complemented by a summer version from the same viewpoint, showing the trees in full leaf.

⋯⫶ Dalwood, Doig, Li Songsong

**David Hockney. b** Bradford, UK, 1937. **Bigger Trees Nearer Warter, Winter**. 2008. Oil on nine canvases. Each: **h**91.4 x **w**121.2 cm. **h**36 x **w**48 in. Overall: **h**274.3 x **w**365.8 cm. **h**108 x **w**144 in

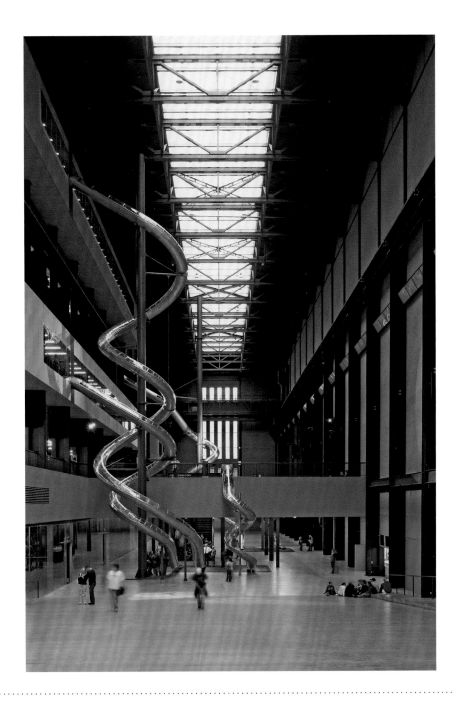

# Höller Carsten

## Test Site, 2006

Resembling something between an industrial landscape and a fairground ride, this was one of a series of slide works produced by Höller since the 1990s. Installed in the vast Turbine Hall at Tate Modern, London, *Test Site* comprised five spiralling tubular slides that ran from the upper floors of the gallery to ground level. The slides had a significant sculptural presence. Although visually spectacular, Höller was interested primarily in the experience of the slider, the giddy excitement and loss of control, the simultaneous pleasure and fear. The slides were essentially opportunities for visitors' participation.

The artist has undertaken many projects that invite visitor interaction, including *Flying Machine* (1996), which flew the user around in circles a few feet off the ground. Originally trained as an agricultural scientist, Höller draws on scientific history and methodologies to create works that alter the audience's physical and psychological sensations, inviting shifts in behaviour and altering our perceptions and sense of logic.

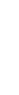 Lozano-Hemmer, Ondak, Sehgal

Carsten Höller. b Brussels, Belgium, 1961. **Test Site**. 2006. Stainless steel slide segments, polycarbonate upper shell, steel supports, canvas mats for sliding. Slide 1: **h**26.6 x **l**55.1 m. **h**87 1/8 x **l**180 3/4 ft; Slide 2: **h**20.3 x **l**44.8 m. **h**66 5/8 x **l**147 1/8 ft; Slide 3: **h**13 x **l**30.9 m. **h**42 7/8 x **l**101 1/2 ft; Slide 4: **h**7.2 x **l**18.3 m. **h**23 5/8 x **l**60 ft; Slide 5: **h**7.2 m x **l**18.3 m. **h**23 1/8 x **l**60 ft. Installation view, 'The Unilever Series', Tate Modern, London, 2006

# Holzer Jenny

## MONUMENT, 2008

In New York in the late 1970s, posters began appearing around the city bearing gnomic messages such as 'torture is barbaric' and 'money creates taste'. The texts were by Holzer; and this art project, titled *Truisms* (1978–83), became much more widely known when it occupied a Times Square electronic billboard in 1982. Since that time Holzer has broadened her media to include scrolling LED signs, paintings, projections on public buildings, T-shirts, phrases chiselled into stone benches and bronze plaques. Her work in the twenty-first century has often focused on the American invasion of Iraq and War on Terror. *MONUMENT*, however, recycles the artist's earliest texts, transposing them onto specially made curved LED screens presented in a column, which fill the gallery with changing coloured light. While many of Holzer's projects rely on the jarring surprise of encountering texts in public spaces, *MONUMENT* constitutes an immersive and profoundly affecting environment in itself.

⋯⋮· Elizabeth Price, White, Wyn Evans

**Jenny Holzer. b** Gallipolis, OH, USA, 1950. **MONUMENT**. 2008. Eighteen LED signs with blue, red and white diodes. **h** 402.1 x **w** 146.6 x **d** 73.3 cm. **h** 158 3/8 x **w** 57 3/4 x **d** 28 7/8 in. Text: U.S. government documents. Installation view, 'ENDGAME', Sprüth Magers, Berlin, 2012

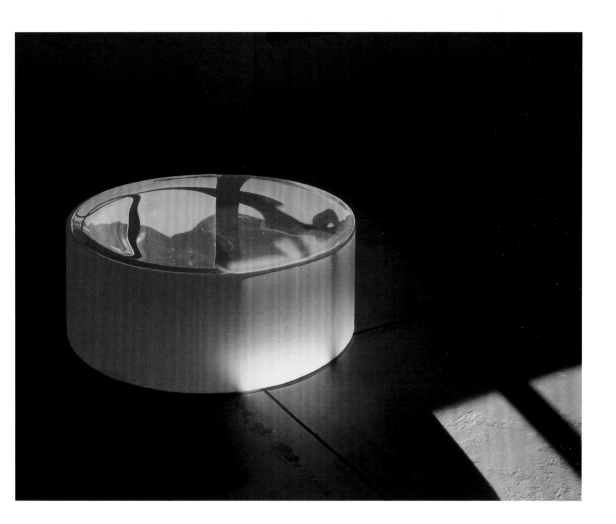

# **Horn** Roni

## Opposite of White, v.1 (Large), 2006–7

This large, cylindrical sculpture is made from solid colourless glass. Its frosted sides have a gritty, rough texture showing traces of the mould in which it was made. In contrast, its polished top is smooth and highly reflective, resembling a pool of water. Its appearance changes subtly depending on the light conditions and on the position from which it is viewed. The sculpture is one of a pair: the other, *Opposite of White, v.2 (Large)* (2006–7), is cast from black glass, offering another manifestation of the absence of colour. Underpinning all of Horn's sculptures, drawings and photographs is a fascination with mutability,

subjectivity and the elusive nature of identity. The physical qualities of Horn's materials are extremely important to her and although she borrows from the formal language of Minimalism, her approach, like her own androgynous identity, resists easy categorization. Fundamentally, her art is about the act of looking itself.

⋯⋮⋅ Finch, Rehberger, Schütte

**Roni Horn. b** New York, USA, 1955. **Opposite of White, v.1 (Large)**. 2006–7. Solid cast glass. **h**50.8 x **w**142.2 x **d**142.2 cm. **h**20 x **w**56 x **d**56 in

# **Huang** Yong Ping

## 11 June 2002 – Nightmare of George V, 2002

Huang moved from Xiamen to Paris in 1989. Following an invitation to participate in the Centre Pompidou's landmark exhibition 'Magiciens de la Terre', while in France he received news of the Tiananmen Square massacre and decided not to return home. Since then his sculptures and installations have frequently alluded to global issues such as imperialism, world religion, ancient mythologies and recent political history. The sculpture *11 June 2002 – Nightmare of George V* is based on King George V's big-game hunting expedition to Nepal in 1911, the tail end of British colonialism. In Huang's life-size recreation a ferocious tiger is about to climb into the royal box. The date mentioned in the title was the opening night of Art Basel, the world's biggest modern and contemporary art fair, where Huang first exhibited the piece. His allegory draws witty parallels between the end of British imperialism and the globalization of the international art market.

 Chopra, Delvoye, Mueck

**Huang Yong Ping. b** Xiamen, China, 1954. **11 June 2002 – Nightmare of George V**. 2002. Concrete, reinforced steel, animal skins, paint, fabric cushion, plastic, wood and cane seat. **h**243.8 x **w**355.6 x **d**167.6 cm. **h**96 x **w**140 x **d**66 in

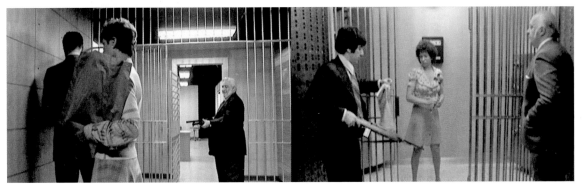

# Huyghe Pierre

## The Third Memory, 2000

The starting point for *The Third Memory* is a bank robbery that took place in 1972 and was immortalized in Sidney Lumet's film *Dog Day Afternoon* (1975). The two-channel video juxtaposes footage from Lumet's film with a reconstruction of the set, in which John Wojtowicz, the mastermind behind the heist, gives his own account of events. Although Wojtowicz had distanced himself from the making of *Dog Day Afternoon* it becomes evident that his own memories have been affected by the fictionalized story. Huyghe's piece, by merging first-hand and fictional accounts, demonstrates the power of the media

to arbitrate our experience and to distort memory. The title refers to what Huyghe describes as three memories: the reality, the media account and the fiction. Working in an array of cultural formats, including billboards, television broadcasts and participatory events, as well as gallery exhibitions, Huyghe seeks to create new experiential possibilities, in which art and life become conflated.

⸱⸱⸱⸳ Bonvicini, Fast, Parreno

Pierre Huyghe. b Paris, France, 1962. **The Third Memory**. 2000. Two-channel video. Colour, sound. **dur** 9 min 46 sec

# **Jaar** Alfredo

Lament of the Images, 2002

Two photographic lightbox tables feature in this kinetic installation by Chilean artist Jaar, which examines the power of images and the role they perform in society. One table is suspended above the other, and as the inverted top table moves slowly up and down it affects the amount of light in the surrounding room. When the two tables are touching, the room is almost pitch black, yet as they separate the space becomes filled slowly with light, until the brightness is almost blinding. Jaar is interested in whether the immense flow of photojournalistic images in the media has lessened the impact that scenes of trauma and suffering have on us, and also in what subjects remain hidden from us, for political or cultural reasons. *Lament of the Images* is one of a series of works by Jaar that features blinding light as a metaphor for our inability to see what is truly taking place in our world.

 Creed, Johanson, Wyn Evans

**Alfredo Jaar. b** Santiago, Chile, 1956. **Lament of the Images**. 2002. Two aluminium tables, glass, Perspex, neon lights and motor.  **h**420 x **w**248 x **d**122 cm. **h**165 3/8 x **w**97 5/8 x **d**48 in. Tate, London

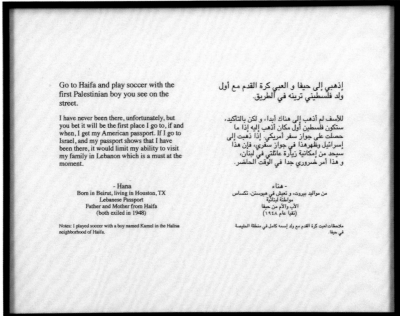

Go to Haifa and play soccer with the
first Palestinian boy you see on the
street.

I have never been there, unfortunately, but
you bet it will be the first place I go to, if and
when, I get my American passport. If I go to
Israel, and my passport shows that I have
been there, it would limit my ability to visit
my family in Lebanon which is a must at the
moment.

- Hana
Born in Beirut, living in Houston, TX
Lebanese Passport
Father and Mother from Haifa
(both exiled in 1948)

Notes: I played soccer with a boy named Kamel in the Halisa
neighborhood of Haifa.

إذهبي إلى حيفا و العبي كرة القدم مع أول
ولد فلسطيني ترينه في الطريق.

للأسف لم أذهب إلى هناك أبداً، و لكن بالتأكيد،
ستكون فلسطين أول مكان أذهب إليه إذا ما
حصلت على جواز سفر أمريكي. إذا ذهبت إلى
إسرائيل وظهر هذا في جواز سفري، فإن هذا
سيحد من إمكانية زيارة عائلتي في لبنان،
و هذا أمر ضروري جداً في الوقت الحاضر.

- هناء
من مواليد بيروت، و تعيش في هيوستن، تكساس
مواطنة لبنانية
الأب والأم من حيفا
(نفيا عام ١٩٤٨)

ملاحظات: لعبت كرة القدم مع ولد إسمه كامل في منطقة الطليعة
في حيفا.

# Jacir Emily

## Where We Come From (Hana), 2001–3

Jacir asked Palestinians who were prohibited from entering their
homeland, or who experienced restricted movement within it, the
question 'If I could do anything for you, anywhere in Palestine, what
would it be?' In 2002 using her US passport, which at the time entitled
her greater mobility through Israeli borders and checkpoints, the artist
carried out these request (due to increased restrictions in the region
the piece would be impossible to make today). The installation
Where We Come From is a photographic, text and video
documentation of these actions. The requests were mostly simple,
often poignantly so. Many were related to family: a kiss for a mother,
an up-to-date photograph of a brother's children. Others were almost
banal, with one person just asking that Jacir do something 'normal' in
Haifa. The installation explores questions of displacement and how
conflict affects individuals on a personal and everyday level. Silenced
historical narratives, resistance and movement are recurring concerns
in Jacir's works.

⋯⋮ Ataman, Bartana, Hatoum, Raad

**Emily Jacir. b** Bethlehem, Palestine, 1970. **Where We Come From (Hana)**. 2001–3. American passport, thirty texts, thirty-two C-prints, video

# Jamie Cameron

## Kranky Klaus, 2002–3

In parts of rural Austria, villagers are visited at Christmas not only by Santa Claus but also by the Krampus, a gang of hairy, quadruple-horned monsters that drag naughty citizens from their houses and beat them up in the snow. In Jamie's work *Kranky Klaus* the artist films this uproarious and frequently terrifying spectacle at close quarters, while the doom metal band The Melvins provides an intensely noisy guitar soundtrack. Jamie is fascinated by the dark and violent sides of American and European folk traditions, and the intersections between contemporary youth subcultures and more timeless customs. Other videos by Jamie have examined the worlds of backyard wrestling – as in *BB* (1998–2000) – and, in *Spook House* (2003), the grotesque pageantry of Halloween in Detroit. In all of these films one gets the uncomfortable feeling that the presence of the camera may itself be instigating much of the extreme behaviour it appears objectively to witness.

⋯⋯⋮ Althamer, Ben-Tor, Kelley

**Cameron Jamie. b** Los Angeles, CA, USA, 1969. **Kranky Klaus**. 2002–3. Colour video, soundtrack by The Melvins. **dur** 26 min

# Jankowski Christian

## The Holy Artwork, 2001

As with many of Jankowski's videos and performances, *The Holy Artwork* uses ironic humour as a carrier for some weighty ideas. The Berlin-based Jankowski persuaded the Texan televangelist Pastor Peter Spencer to collaborate with him in making a piece of contemporary art. The resulting video shows Spencer introducing the artist to his congregation as his special guest: Jankowski, as he approaches, appears to be struck down to the ground by an invisible force, and he remains prone at Spencer's feet, still holding his video camera, while the pastor delivers a sermon on the marriage of religion, art and television. *The*

*Holy Artwork* is, at one level, a genuine sermon, but it is also an act of appropriation by Jankowksi. This duality is comparable to his attempt to sell a luxury yacht at the Frieze Art Fair in 2011. The boat's price tag was €65 million – or €75 million if it was purchased as a work of art by Jankowski.

⋯⫶ Bonvicini, Fast, Lidén

**Christian Jankowski. b** Göttingen, Germany, 1968. **The Holy Artwork**. 2001. Single-channel video. **dur** 15 min 32 sec

# Johanson Chris

### Historical Re-enactment Installation #1 (Going in a Circle), 2002

As part of the Mission School, a group of artists that emerged in the San Francisco Bay Area in the 1990s, Johanson established a reputation as an artist who was open to a wide range of stylistic and conceptual influences. As part of the skateboarding community, Johanson was familiar with the scrappy DIY legacy of punk, but also with the sunny graphics of California surf culture. The vernaculars of street and folk art markedly inflect his aesthetic vocabulary. Brightly coloured paintings reflect an optimistic social agenda in titles such as *Man It's Really Good to be Hanging Out With You Again* (2002). In *Historical Re-enactment*

*Installation #1 (Going in a Circle)* a motorized arm impels a model boat to chase endlessly after a bag of money; in the background, a jolly kaleidoscopic wooden construction looks, on closer inspection, somewhat like a brightly coloured swastika.

⋯⋮⋅ Hein, Lambie, Odita, Reyle

**Chris Johanson. b** San Jose, CA, USA, 1968. **Historical Re-enactment Installation #1 (Going in a Circle)**. 2002. Acrylic on wood, foamcore, motor and metal. Mechanical elements by Kal Spelletich. Dimensions variable

# JR

## 28 Millimètres, Portrait d'une génération, B11, destruction #2, Montfermeil, France, 2013

Over the past decade JR has pasted giant pictures, usually illegally, on buildings all over the world. For one of his most famous projects, *Women are Heroes* (2008–10), he applied black and white photographs of local women, hugely enlarged, onto entire walls of a Rio de Janeiro favela. In 2004, his project *Portrait of a Generation* exhibited images of youths from the Les Bosquets ghetto of Paris in that neighbourhood and also in chic areas of Paris. By bringing these grimacing portraits to prominence, JR was challenging the audience to question the representation of a generation within society and the media. In 2012, JR revisited this project by using the same shots from the original series. As the buildings that featured the original images had been destroyed, JR installed the portraits in buildings that were in the process of being demolished, their re-appearance created a new dialogue that addressed the recent history of Paris and its suburbs.

·····⫶· Banksy, Ben-Tor, Raqs Media Collective

JR. b Paris, France, 1983. **28 Millimètres, Portrait d'une génération, B11, destruction #2, Montfermeil, France, 2013**. Colour photograph, polished Plexiglas, aluminium, wood. **h** 270 x **w**180 cm. **h**106 1/4 x **w**70 7/8 in

# Julien Isaac

## Paradise Omeros, 2002

Julien, like a number of artists of his generation, makes work that belongs to the traditions both of avant-garde cinema and of video art. *Paradise Omeros* exists both as a single-channel video and a three-channel projection in which separate adjacent images intermittently synchronize into one. The latter format is representative of Julien's non-linear approach, which moves between impressionistic or metaphorical images and narrative structure. In *Paradise Omeros* a character called Achilles is shown both in his native Saint Lucia and in his adopted city of London; at one moment he is seen running through Caribbean jungle, the next through an inner-city housing estate. As with many of Julien's films, the protagonist's otherness extends not only to race but also to sexuality. A thuggish white man, who initially eyes Achilles coldly, seems, by the end of the film, to be a potential lover. In Julien's films, fear and desire are often interlaced.

····⊹ Ahtila, Doig, McQueen, Ofili

**Isaac Julien. b** London, UK, 1960. **Paradise Omeros**. 2002. Triple DVD projection, 16 mm film transferred to DVD. **dur** 20 min 29 sec. Installation view *documenta 11*, Kassel, Germany, 2002

# Jungen Brian

## Carapace, 2009

Jungen is one of the Dane-zaa people, a First Nation of northern Canada. Growing up, he experienced the resourcefulness and material innovation of his people due to economic pressures, as well as the wider commercialization of traditional First Nation craft techniques in response to tourism and globalized consumerism. Jungen, who now lives in Vancouver, has made a number of sculptures that refashion box-fresh consumer goods, such as Nike trainers or golf bags, into objects resembling tribal masks and totem poles. *Carapace* is a giant turtle shell – inspired by the early science-fiction writings of Jules Verne

– made entirely from rubbish bins. He has created a fantastical shelter from objects that were intended for the sanitary disposal of waste (of which Western culture now produces more than ever). Jungen's sculptures undergo a process of re-mystification that sees consumer culture appropriated by a First Nations sensibility, and not the other way around.

···⊹· Belmore, Gowda, Paci

**Brian Jungen. b** Fort St. John, BC, Canada, 1970. **Carapace**. 2009. Black, blue and green industrial waste bins. **h**370 x **w**670 x **d**640 cm. **h**144 x **w**264 x **d**252 in

# **Kabakov** Ilya & Emilia

## The Sick Child, 2000

Over his long and distinguished career, Ilya Kabakov has produced paintings, sculptures, conceptual artworks and illustrated stories. He is best known, however, for the ambitious and immersive installations on which, since 1988, he has collaborated with his wife Emilia. In these installations the artists often go to great lengths to fabricate domestic interiors or fantastic tableaux inside the gallery. In *The Sick Child* visitors first enter a rather ordinary kitchen; through a door is a living room with a table set for dinner. Beyond that is a bedroom divided by a curtain, on the other side of which is an empty child's bed, with a small puppet theatre placed nearby, lit from the inside and containing moving puppets as if to entertain the absent protagonist. This theatre, though small, electrifies the otherwise rather drab installation and draws poignant attention to the artifice of the installation and also, implicitly, of the world beyond.

 Hatoum, Manders, Sosnowska

**Ilya Kabakov. b** Dnepropetrovsk, Ukraine, 1933. **Emilia Kabakov.** b Dnepropetrovsk, Ukraine, 1945. **The Sick Child**. 2000. Mixed media. Dimensions variable. Installation view, Galleria Lia Rumma, Milan, Italy, 2000

# **Kapoor** Anish

## Cloud Gate, 2004

This colossal sculpture is made from 168 welded steel plates and weighs around 100 tonnes. Despite its monumentality, its flawlessly reflective surface makes it seem, in certain lights, virtually weightless. Such contradictions are typical of Kapoor's art, which confuses distinctions between inside and out, solidity and the void, reality and illusion, surface and depth. Since his earliest installations in which powdered pigment was sieved onto sculptural forms, Kapoor has strived to eliminate all traces of the human hand in his work. Consequently, his surfaces frequently attain a degree of perfection

that makes them seem other-worldly, even divine. This is an effect that the Anglo-Indian artist welcomes; he is influenced by Hindu, Buddhist and Taoist thought, and consciously makes objects that summon impressions of infinite depth. The variation in convex and concave surfaces of *Cloud Gate* encourages viewers to move around and beneath it, to experience shifting, distorted visions of both the Chicago cityscape and their own reflections.

⋯⋮⋯ Gupta, Horn, Sarah Lucas

**Anish Kapoor. b** Mumbai, India, 1954. **Cloud Gate**. 2004. Stainless steel. **h**10 x **w**12.8 x **d**20 m. **h**32 ft 9 3/4 in x **w**41 ft 12 in x **d**65 ft 7 3/8 in. Millennium Park, Chicago, IL, USA

# Kawara On

## One Million Years, 2009

*One Million Years* is a conceptual artwork about the passing of time. Created in two parts, it comprises *One Million Years* (Past), which was made in 1969 and is a typewritten record of the dates of every year from 998,031 BC to AD 1969, and *One Million Years* (Future), created in 1981, which records the years from AD 1996 to AD 1,001,995. The work is in book form and has been presented in exhibitions around the world, where sections are read aloud to visitors. In 2009, David Zwirner Gallery in New York recorded a reading live, with a CD of the event edited and packaged on site. An installation featuring a recording booth

was displayed in the gallery space. Time's passing is a recurring theme in Kawara's art: since 4 January 1966 he has created a series of paintings titled 'Today', which simply display the date that each work was made.

⋯⋮ Almond, Graham, Marclay, Sugimoto

**On Kawara. b** Kariya, Japan, 1933. **One Million Years**. 1969/81. 2009. Mixed media. Dimensions variable. Installation view, 'On Kawara: One Million Years', David Zwirner Gallery, New York, 2009

# Kelley Mike

## Day Is Done (Extracurricular Activity Projective Reconstructions #2-32), 2005/6

Vampires, hillbillies and rapping Nazis are just some of the bizarre characters appearing in this feature-length video, which is part carnivalesque musical and part anthropological study. Each of its thirty-two chapters is a live-action interpretation of a photograph from Kelley's vast collection of old high-school yearbooks. The selected images reflect the gamut of American folk culture, including Halloween parties, holiday pageants, theatrical productions and musical performances. The ritualistic nature of these extracurricular activities fascinated Kelley, inspiring him to concoct a loose narrative

woven together by song. Broadway show tunes, heavy metal, hip-hop and other popular musical styles are satirized in the film, which was first shown as a fifty-screen video installation in New York. Despite finding inspiration in popular culture, Kelley never intended to glamorize it; rather – through drawing, collage, sculpture, performance and video – he subverted, deconstructed and reconfigured it and explored themes as diverse as American class relations, sexuality, religion and politics.

 Barney, Jamie, Trecartin

**Mike Kelley. b** Detroit, MI, USA, 1954. **d** South Pasadena, CA, USA, 2012. **Day Is Done (Extracurricular Activity Projective Reconstructions #2-32)**. 2005/6. Video, colour/sound. **dur** 169 min

# **Kelly** Ellsworth

### Red Relief Over White, 2012

A luminous red hexagon is superimposed over a white rectangle creating a large, three-dimensional relief. The bright, irregularly-shaped canvas casts subtle shadows onto the pale surface beneath, a phenomenon integral to the piece. Kelly's vibrant, multi-panel works are built up with layers of solid, flat colour; utilizing unorthodox shapes and configurations, they hover between painting and wall-based sculpture. Recent canvases continue to explore the relationships between line, colour and form – themes that have preoccupied the artist for over six decades. A major figure of abstract art in post-war America, Kelly achieved international acclaim in the late 1950s and has influenced generations of younger artists. Despite being associated with various schools of abstract art, Kelly has never aligned himself with any particular group. Unlike other abstract painters, his work is rooted in observed reality: the shape of a plant, a staircase, or shadows on a wall can all provide inspiration.

·····⫶· Abts, Marden, Shahbazi

**Ellsworth Kelly. b** Newburgh, NY, US, 1923. **Red Relief Over White**. 2012. Oil on canvas, two joined panels. **h** 178 x **w** 130 x **d** 7cm. **h** 70 x **w** 51 1/4 x **d** 2 5/8 in

# Kentridge William

## Other Faces, 2011

For the first years of his career, Kentridge was known for his predominantly monochrome drawings, etchings and monotypes that recalled literary or mythological themes. Ever implicit, too, was the turbulent social and political landscape of South Africa, where Kentridge has lived all his life. His first animated film, *Johannesburg, 2nd Greatest City After Paris* (1989), was a pivotal work for the artist. It allowed his drawings to move, through a rudimentary stop-motion technique in which he filmed different stages of his drawings with a 35 mm movie camera. The series of short films that it inaugurated

is titled 'Drawings for Projection'; the latest, *Other Faces* (2011), is his tenth. In this haunting, expressionist work, Kentridge's fictional protagonist Soho Eckstein returns from previous narratives to wander through the streets and homes of Johannesburg, encountering scenes and characters as if in a dream. Kentridge presents his working drawings alongside the film.

⋯⁝⋅ Avery, Pettibon, Sun

**William Kentridge. b** Johannesburg, South Africa, 1955. **Other Faces**. 2011. 35 mm film transferred to DVD and hard drive. **dur** 9 min 36 sec

# **Kiefer** Anselm

**Paul Celan: wir schöpften die Finsternis leer, wir fanden das wort, das den Sommer heraufkam: Blume;
(We scooped the darkness empty, we found the word that ascended summer: flower), 2012**

As one of Germany's most prominent artists, Kiefer has developed a monumental oeuvre that orbits around the theme of *Vergangenheitsbewältigung*. The term translates as 'the struggle to come to terms with the past', and since the Second World War it has been associated with the painful associations that Germany has with its own national identity and recent history. Kiefer's fearlessly direct approach has been controversial ever since his early series 'Occupations' (1969) in which he photographed himself in uniform giving Fascist salutes while travelling through France, Switzerland and Italy. His subsequent paintings and sculptures may be more poetic in their iconography – sunflowers and ploughed fields are common subjects – but their unapologetic forcefulness remains, evoking a national psyche in ruins. Found objects such as photographs or dead plants are embedded into the pictures' thickly impastoed paint, and handwritten inscriptions quote from literary sources such as the Romanian poet Paul Celan.

····⫶ Ghenie, Man, Rauch, Sasnal

**Anselm Kiefer. b** Donaueschingen, Germany, 1945. **Paul Celan: wir schöpften die Finsternis leer, wir fanden das wort, das den Sommer heraufkam: Blume;
(We scooped the darkness empty, we found the word that ascended summer: flower)**. 2012. Acrylic, emulsion, oil and shellac on photograph mounted on canvas.
**h**280 x **w**380 cm. **h**110 1/4 x **w**149 5/8 in

# Koons Jeff

## Acrobat, 2003–9

*Acrobat* is a sculpture in the 'Popeye' series in which Koons casts inflatable toys in aluminium, and combines them in surprising ways with unaltered everyday objects. As with the jolly lobster in this work, these toys are cheap, brightly coloured, lightweight, and made for fun. By casting them in expensive and durable aluminium, Koons signals that he takes the subject of fun very seriously indeed. In the 1980s Koons worked as a commodities broker to fund his early work. The artist has since dwelt upon those aspects of contemporary American culture that are commonly dismissed as banal or tasteless. He sees subjects such as balloons, puppies, flowers and cartoons as redeemable sources of democratic, shameless pleasure to which everyone can relate. As heir to the Pop artists of the 1960s, Koons subscribes to the idea that art can be simultaneously critical and celebratory of the culture it draws on. The artist has observed that *Acrobat* can be seen as a reference to the work of Dalí and Duchamp.

⋯⋰ Hirst, Sarah Lucas, Prince, Ray

**Jeff Koons. b.** York, PA, USA, 1955. **Acrobat**. 2003–9. Polychromed aluminium, galvanized steel, wood, and straw. **h** 228.9 × **w** 148 × **d** 64.8 cm. **h** 90 1/8 × **w** 58 1/4 × **d** 25 1/2 in

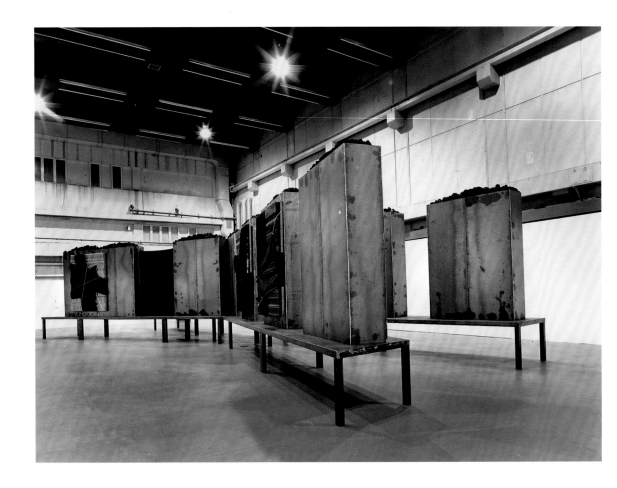

# Kounellis Jannis

### Untitled, 2010

A group of steel trestle tables arranged in the form of a huge letter 'K' are spread out across the floor. Sitting on these are metal containers filled to the brim with coal and adorned with banks of empty glass bottles, burlap sacks and pieces of black cloth. The 'K' stands for Kounellis, but also for Josef K, the protagonist of Franz Kafka's existentialist novel *The Trial* (published 1925). As a whole, the sprawling installation can be seen as a *memento mori*, a symbolic reminder of the certainty of death. The use of everyday objects and industrial materials has typified Kounellis's work since the 1960s when

he was involved with the Arte Povera – literally 'Poor Art' – movement. These artists used elementary substances and attempted to fuse nature with culture as a reflection of modern life. Continuing this tradition, Kounellis regularly combines seemingly contradictory elements to explore the principles of life and death.

·····:· Balka, Barlow, Stingel

**Jannis Kounellis. b** Piraeus, Greece, 1936. **Untitled**. 2010. Steel tables, thirteen steel modules with coal, glass bottles, lead, coats, black cloths, jute sacks and iron hooks. Dimension variable

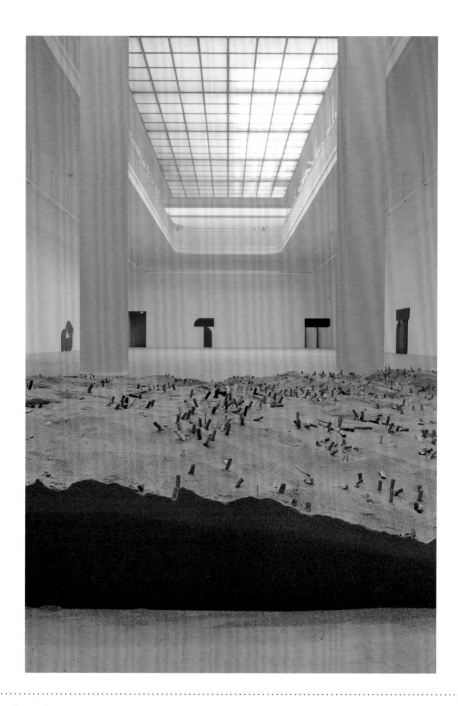

# **Kuri** Gabriel

## Donation Box, 2010

Kuri makes art from discarded or inexpensive materials, not only to communicate ideas about art's commodity status, but also more broadly about cultural value in a philosophical and political sense. He is influenced by the Arte Povera movement, as well as the innovative repair and modification of materials common in Mexico City, where he grew up. In an earlier work, *Waiting stub lettuce* (2004), Kuri tucked supermarket queuing tickets among the crisp green leaves of a lettuce. *Donation Box*, first installed at the Kunstverein Freiburg, Germany, draws attention to the things visitors might give up when visiting a non-profit museum: not money, as the title implies, but spent cigarettes. In *Donation Box* the cigarettes were placed by the artist. In contrast, *Items in Care of Items* (2008) was genuinely interactive: at Berlin's Neue Nationalgalerie, Kuri's Modernist, painted steel sculptures served as a place for visitors to dump their coats and bags while browsing the rest of the exhibition.

·····⫶· Aranberri, Gonzalez-Foerster, Neuenschwander

**Gabriel Kuri. b** Mexico City, Mexico, 1970. **Donation Box**. 2010. Sand, cigarette butts, coins. Dimensions variable. Installation view, 'Gabriel Kuri: join the dots and make a point', Kunstverein Freiburg, Germany, 2010

# Lambie Jim

### The Strokes, 2008

Lambie was a musician and a DJ before he was an artist; his work continues to be shaped by the sensual and material qualities of popular music. *The Strokes* takes its name from the New York rock band, and its design, in part, from the striped grooves on a vinyl record. It is a happy coincidence that the sticky tape that Lambie uses for such floor-based installations is also made of vinyl. The first such work he made was called *Zobop* (1999): in it, he used tape of different colours to trace the floor plan of the gallery from the edges to centre, continuing until the entire space was filled. The result was dazzling, and joyous, and

frivolous – like a catchy tune. As with his sculptures and wall-based work made from thrift store ephemera, Lambie's signature floor-works also have connections to art historical movements such as Colour Field painting and, in the case of *The Strokes*, Roy Lichtenstein's ironic take on the gestural brushstrokes of Abstract Expressionism.

⋯⋮ Black, Renata Lucas, Marden

**Jim Lambie. b** Glasgow, UK, 1964. **The Strokes**. 2008. Vinyl tape. Dimensions variable. Installation view, 'Unknown Pleasures', Hara Museum of Contemporary Art, Tokyo, Japan, 2008

# **Lambri** Luisa

### Untitled (Barragan House, #01), 2005

Though they frequently feature architectural masterpieces by canonical architects, Lambri's photographs forgo the conventional exterior view by which these buildings are generally known. Instead, Lambri spends extended periods of time inside, and takes photographs of closely cropped details that, were it not for her titles, would be hard to identify except by someone who had also spent time in the building. Many of her locations are famous examples of domestic architecture, such as R.M. Schindler's Kings Road House and Pierre Koenig's Case Study House #22, both in Los Angeles, the city in which she now

lives. Lambri's subjective responses to these houses correspond to the interiority of her physical relation to them; she has described her photographs as self-portraits. Often, as with *Untitled (Barragan House, #01)*, she focuses her camera on windows and the changing effects of light, in this instance in the home built by Luis Barragán for himself in Mexico City.

·····⁝· Jaar, Quaytman, Singh

**Luisa Lambri. b** Como, Italy, 1969. **Untitled (Barragan House, #01)**. 2005. Laserchrome print. **h**86 x **w**96 cm. **h**33 7/8 x **w**373/4 in

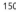

# **Landy** Michael

## Breakdown, 2001

In a closed-down department store on London's Oxford Street, Landy set up an industrial system in order to destroy all of his material belongings. He compiled a detailed list of everything that he owned, which amounted to 7,227 items. Then a team dressed in boiler suits systematically sorted them into categories as they moved along a conveyor belt, before feeding them into a machine to be shredded and granulated. The calm, methodical approach of this destructive act ironically mimicked processes of mass production. At the end of the process the artist walked away with only the overalls that he was wearing. It was a gesture of self-abnegation, against being defined by his possessions, and demonstrates the focus and commitment that is characteristic of Landy's work. Almost a decade after *Breakdown*, Landy presented *Art Bin* (2010), a clear skip into which the public were invited to deposit unwanted artworks, which the artist described as 'a monument to creative failure'.

····⁝· Dion, Jungen, Superflex

**Michael Landy. b** London, UK, 1963. **Breakdown**. 2001. Installation view, C&A building, Oxford Street, London, 2001

# **Lassnig** Maria

## Du oder Ich, 2005

A seated woman stares out urgently at the viewer. Her eyes are piercingly blue, her mouth is agape and she is naked, elderly and hairless, although most arresting are the two guns that she holds, one against her own head, the other pointing outwards, towards the viewer. The work's title, *Du oder Ich* (You or Me) emphasizes that one or other is in the firing line. The woman is the artist herself and the work is part of a series of self-portraits that she has made stretching back to the 1950s. Lassnig coined the phrase 'body-awareness' to describe how she paints her body as it feels to her from the inside, rather than the external view, offering a unique perspective on her own physique. The background to this painting is flat and empty, focusing all the attention on the figure of Lassnig and the challenging situation she presents, with the exchange between subject and viewer suggesting a narrative beyond that of a simple self-portrait.

 Dumas, Eloyan, Li Yongbin, Zhang

**Maria Lassnig. b** Kappel am Krappfield, Austria, 1919. **d** Vienna, Austria, 2014. **Du oder Ich**. 2005. Oil on canvas. **h**203 x **w**155 cm. **h**79 7/8 x **w**61 in

# **Lawler** Louise

### Grieving Mothers (Attachment), 2005

A pair of wings from a stone sculpture, possibly a classical statue of the goddess Nike, are shown strewn casually on the floor. Taken in close-up, the photograph does not reveal their setting, nor where the rest of the sculpture is, though the sharp metal spike that protrudes from one wing suggests they were attached to something larger. The wings seem vulnerable and abandoned, lacking the magnificence such sculptures usually exude and the title speaks of maternal loss. Since the late 1970s, Lawler has explored the presentation of artworks, in order to examine how the context in which we view art affects the way in which we understand or appreciate it. She has photographed paintings and sculptures in museums, galleries and auction houses, as well as in the homes of collectors. Lawler also photographs artworks in storage or during the process of installation, revealing how lost these pieces can seem when outside their usual environment.

⸳⸳⸳ Bourgeois, Chapman, Struth

**Louise Lawler. b** New York, USA, 1947. **Grieving Mothers (Attachment)**. 2005. Laminated C-print on museum box. **h**116.8 x **w**104.1 cm. **h**46 x **w**41 in

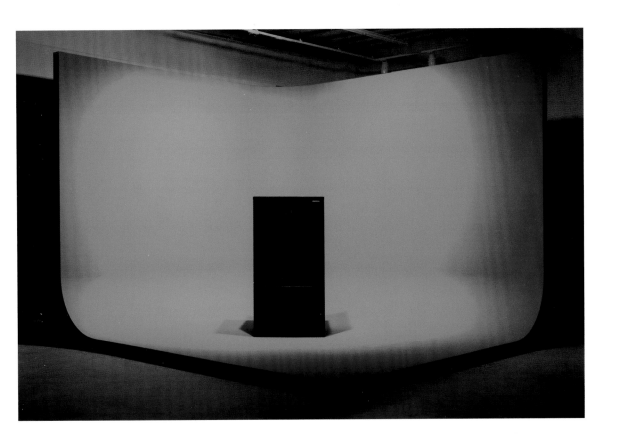

# Leckey Mark

## GreenScreenRefrigeratorAction, 2010

In this installation a large black 'smart fridge' stands against a green screen of the kind used for film and television special effects. Nearby, an elaborate video that at first appears to be an advertisement for the fridge evolves into a surreal journey revealing the device's inner workings. A stream of images is superimposed behind the machine, including mountain views, vegetables and shots of the sun and the moon. With a strange electronic voice, the machine begins to describe its internal processes, though it soon starts to make esoteric statements. The viewer is left to contemplate the nature of artificial intelligence and the relationship between object and image. Leckey – whose disparate works are rooted in performance but also include sculpture, printmaking, sound and video – frequently addresses themes of desire and transformation. His earlier videos used material from popular culture to explore the affective power of images and music. He was awarded the Turner Prize by the Tate in 2008.

⋯⋮ Assaël, Graham, Mirza

**Mark Leckey. b** Birkenhead, UK, 1964. **GreenScreenRefrigeratorAction**. 2010. Samsung refrigerator, rear screen projection rig, digital video, green screen set, PA, can of coolant. Video **dur** 17 min. Dimensions variable

# Leonard Zoe

## Survey, 2009–12

For Leonard, photography is a form of documentation. It is not about technical perfection, nor is it about challenging the hegemony of painting, nor is it necessarily about narrative. It is an immediate and honest way of responding to the world. But neither is it neutral: Leonard knows that the way she frames beauty and pathos specifically reflects her own identity and experience. Her series 'Analogue' (1998–2009), documenting the gritty shopfronts around New York, speaks about her relationship to her home city; in the 'Tree + Fence' series (1998), bark deformed by metal fences evokes human flesh

and the pain of disease. *Survey* consists of over 6,000 photographs not even taken by Leonard: all are found postcards of Niagara Falls. The postcards are piled in stacks on a table, according to the various perspectives from which they were shot. Organization, like framing or editing, is for Leonard a means of representation.

 Dion, Eliasson, Song Dong

**Zoe Leonard. b** Liberty, NY, USA, 1961. **Survey**. 2009–12. 6,266 vintage postcards and work table. Installation view, Camden Arts Centre, London, 2012

# Li Songsong

## Taoyuan Airport, 2008

While Li's thickly impastoed paintings depict potent media images, many relating specifically to China's Cultural Revolution, his treatment of these sources is coolly ambivalent. He emphasizes the mediation of his subjects by dividing the image into separate panels that he paints in different tones, styles or colour palettes. Although he joins the panels to make the image whole again, the individual elements are still apparent, emphasizing the different viewpoints they might represent as illustrations in the news media. The neutral title *Taoyuan Airport* is typical of Li's approach; the photograph that he has reproduced shows excited crowds meeting the Chinese fighter pilot Liu Cheng-szu who defected to Taiwan in 1962. Often the original photographs are black and white and low quality, so Li's painterly handling responds to their formal qualities as well as their ideological content. Abstraction, for the artist, is both a conceptual and political process.

 Peyton, Kelley Walker, Zhao

**Li Songsong. b** Beijing, China, 1973. **Taoyuan Airport**. 2008. Oil on aluminium panel. **h**420 x **w**620 cm. **h**165 3/8 x **w**244 1/8 in

# Li Yongbin

### Face 9, 2001

An image of a skull is projected onto the artist's face at night, the slide projector providing the only source of light. As the sun rises, the skull begins to fade until only Li's face remains. This video belongs to an ongoing series begun in 1995. Filmed in the artist's Beijing apartment, each one features the artist's face in a different scenario. In *Face 2* (1996), for example, Li's face is projected onto a pool of ink; in *Face 9* (2000) he arranges shards of glass until his reflection appears; while in *Face 16* (2008) he emerges through a haze of smoke. Belonging to the first generation of artists to work in the era after the rule of Chairman Mao, Li is self-taught, working initially with painting but now exclusively committed to video. His simple yet affective works stem from a fascination with the representation of time and encourage contemplation of the ephemeral nature of existence.

····⫶ Man, Margolles, Neshat, Zhang

**Li Yongbin. b** Beijing, China, 1963. **Face 9**. 2001. Video. **dur** 62 min

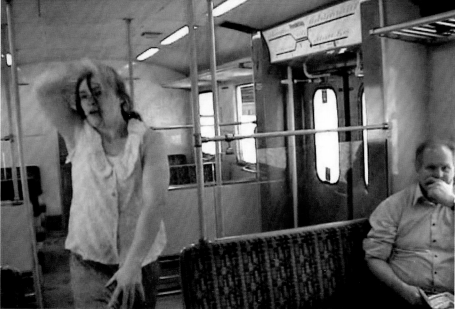

# **Lidén** Klara

## Paralyzed, 2003

A woman on a Stockholm commuter train strips off her coat and dances alone to a tinny soundtrack. Her moves are eccentric; she swings wildly from the poles, and makes full use of the space, unperturbed by the curious looks of other passengers. The dancer is in fact the artist and she captures this action for a video work, revealing herself to be anything but paralyzed. Having formerly studied architecture, Lidén brings an interest in space into her art, devising site-specific pieces for particular environments in a variety of media: video, installation and photography. She even built an improvized house, made from scrap materials, on the banks of the river Spree in Berlin. The house was offered for use by anyone who needed shelter. Usually taking place in an urban setting, and often featuring found materials, Lidén's works playfully explore the accepted codes of behaviour that exist within cities and considers how they can be subverted.

 Allora & Calzadilla, Hayes, Zhang

**Klara Lidén. b** Stockholm, Sweden, 1979. **Paralyzed**. 2003. Video. Colour, sound. **dur** 3 min

# Lozano-Hemmer Rafael

## Subtitled Public, 2005

Visitors entering this installation are immediately detected by a computerized infrared surveillance system that projects words onto their bodies. These words, or 'subtitles', are randomly generated from a list of verbs and, once attached to an individual, follow them wherever they move. The only way to get rid of a subtitle is to transfer it to someone else by touching them. The work not only offers a witty comment on the rise of surveillance culture; it also subverts the normal gallery experience. Instead of viewers observing an object, it is they themselves who become the subject, being watched and 'judged' by an

unseen, autonomous entity. Employing sensors, robotics, projections, custom software and other cutting-edge technologies, Lozano-Hemmer creates interactive environments that encourage public participation. The Mexican-Canadian artist's sophisticated installations are driven by a fascination with the study of human interaction and its relationship to the complexities of our technology-saturated culture.

⋯⋮⋅ Chan, Farocki, Holzer, Sehgal

**Rafael Lozano-Hemmer. b** Mexico City, Mexico, 1967. **Subtitled Public**. 2005. Computerized surveillance system, four projections. Dimensions variable. Tate, London

# Lucas Renata

## Crossing, 2003

Lucas interferes, via subtle site-specific installations, with the habitual and unreflective ways in which citizens move through urban spaces. For *Quick Mathematics* (2006), she laid a second pavement directly beside a pre-existing pavement, on a quiet São Paulo street. For the few who used it regularly, this new widened path was a vast improvement; for the majority of strangers to the neighbourhood, the piece was almost invisible. Lucas's installation *Crossing* was similarly modest in appearance, even if its ramifications were significant. At the intersection between two streets, the artist laid sheets of plywood, creating an interstitial zone that was inviting to pedestrians but that caused cars to cross more carefully, even if their drivers did not fully understand why. Lucas's projects, which often involve major feats of construction, employ a lightness of touch to prompt participants to reflect critically on the patterns of their daily behaviour.

····⫶ Abidi, Floyer, Sala, Salcedo

**Renata Lucas. b** Ribeirão Preto, Brazil, 1971. **Crossing**. 2003. Plywood. Intersection of Rua Dois de dezembro and Praia do Flamengo for Centro Cultural Oduvaldo Viana Filho (Castelinho do Flamengo), Rio de Janeiro, Brazil.

# Lucas Sarah

## Patrick More, 2013

Lucas emerged in the early 1990s as a leading member of the Young British Artists, the irreverent and ambitious group whose affinity for working-class vernacular culture and post-Thatcher DIY resourcefulness lent them swift and widespread acclaim. In 1993 Lucas opened a shop with Tracey Emin, which sold handmade knick-knacks and closed after six months. Lucas's 'Bunny' series, begun in 1997, was based on figurative sculptures made from tights stuffed with cotton wool. The tights became lumpy, sprawling legs, which Lucas often fixed to chairs, as if they were sitting. These works led to another series, 'NUDS' (2009), in which she knotted stuffed tights into abstract (though corporeally suggestive) objects that sit on breeze-block pedestals. In more recent pieces, among them *Patrick More*, Lucas casts the soft sculptures in polished bronze, explicitly acknowledging the influence of mid-century Modernist sculptors such as Henry Moore and Barbara Hepworth who have long shadowed Lucas's work.

⋯⋮⋅ Cragg, Gormley, Neto, Warren

Sarah Lucas. b London, UK, 1962. Patrick More. 2013. Cast bronze. h73.5 x w53 x d80 cm. h28 7/8 x w20 7/8 x d31 1/2 in. Installation View, 'SITUATION Absolute Beach Man Rubble', Whitechapel Gallery, London, 2013

# Macchi Jorge

## The longest distance between two points, 2011

Slowing time to a standstill has been a persistent conceptual strategy in Macchi's diverse art, which spans from drawings and videos to sculptures and large-scale installations. In the earlier work, *Music Stands Still* (2006), three music stands have been modified so that, instead of sheet music, their metal struts spell the words of the piece's title. In *The longest distance between two points*, tensile barriers, familiar to anyone who has ever waited at an airport, are arranged across a blue carpeted gallery. They make movement from one side to the other an absurdly longwinded and frustrating process. Macchi's

gesture is less about critiquing mindless authority (although such thoughts are perhaps inevitable to the visitor who is walking through the installation) and more an attempt to jam the gears of time and space, throwing a spanner in the works of the interpretive process.

⌁ Almond, Creed, Motti, Sosnowska

**Jorge Macchi. b** Buenos Aires, Argentina, 1963. **The longest distance between two points**, 2011. Metal poles, belts, carpet. **h** 5 x **w** 11 x **d** 26 m. **h** 16 ft 5 in x **w** 36 ft 1 3/4 in x **d** 85 ft 3/8 in. Installation view, 'Container', Kunstmuseum Luzern, Switzerland, 2013

# **Man** Victor

### Fragile, 2005

Shrouding his subjects in near total darkness is the most obvious way in which Man withholds his paintings from interpretive certainties. The crepuscular *Fragile* is an image that – were it to be rendered in full daylight – would be unbearably upsetting. Both the arms and legs of a dark-skinned infant appear to have been amputated and replaced with sticks; a blue flame hovers ominously beside her, creating a slightly chiaroscuro effect. By casting the image in tones of dark grey and soft brushwork, Man's painting mercifully seems more hallucinatory than real. Many of Man's small paintings are seemingly ambivalent about

the arresting scenes they portray, as with *Leading By Example* (2006) in which an arm manhandles a woman's inverted legs. By combining such subjects with relatively innocuous abstractions, still lifes and sculptural assemblages of found objects, Man describes an unsettling universe in which cruelty, sex, beauty and horror freely associate.

·····⫶ Bhabha, Li Yongbin, Woods, Zeng

**Victor Man. b** Cluj-Napoca, Romania, 1974. **Fragile**. 2005. Oil on canvas mounted on wood. **h**41.5 x **w**31.5 cm. **h**17 7/8 x 12 3/8 in. Albertotashun Collection, Netherlands

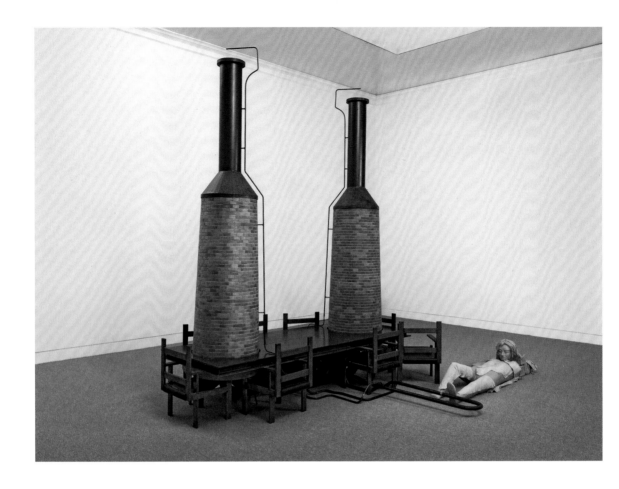

# Manders Mark

## Room with Chairs and Factory, 2003–8

Every artwork that Manders makes contributes to a hermetic world of visual language, reference and symbolism that he has titled *Self-Portrait as a Building* (1986 – ongoing) and which he intends to continue for the rest of his life. The identity outlined in this sprawling body of work, however, is only an alter ego of Manders, who, despite his allusions to self-portraiture, remains a persistently enigmatic figure. Sculptures such as *Fox/Mouse/Belt* (1992) – a fox with a mouse strapped to its chest, made in a clay-like epoxy – deliver philosophical conundrums that hint at dream images or folklore. In *Room with Chairs and Factory*

a dining table is interrupted by two brick chimneys that ascend towards the ceiling. A mannequin – presumably a surrogate for the artist – reclines on the floor, connected to the factory by pipes that emanate from underneath the table to touch his foot. In Manders's art, such delicate connections assume extraordinary significance.

⋯⋮ Harrison, Kabakov, Wekua

**Mark Manders. b** Volkel, Netherlands, 1968. **Room with Chairs and Factory**. 2003–8. Wood, iron, rubber, painted polyester, painted ceramic, painted canvas, unpainted canvas, painted wig, chair, and offset print on paper. **h**318 x **w**240 x **d**405 cm. **h**125 1/8 x **w**94 1/2 x **d**159 1/2 in. MoMA, New York. Marguerite Stone bequest and gift of Mrs. Saidie A. May

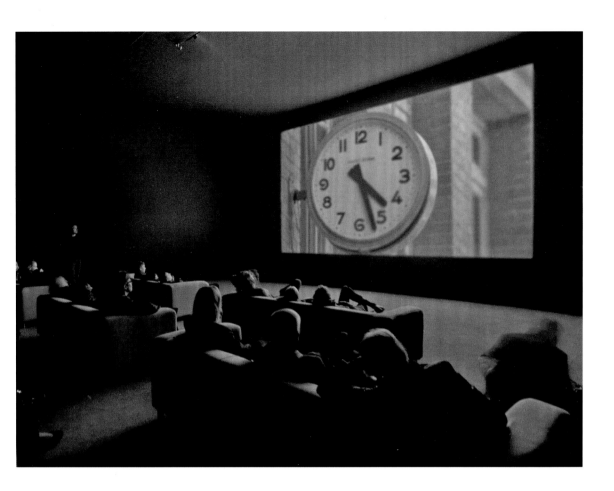

# **Marclay** Christian

## The Clock, 2010

Marclay first found success, after leaving art college, as an avant-garde DJ. An early proponent of scratching records, he also sometimes played cracked or glued-together vinyl on his turntables to deliver collages of noise. It was a natural extension of his DJ practice when he began collaging record covers and even records themselves as visual art. An early foray into video, *Telephones* (1995) is a montage of clips from movies showing people speaking on the phone; the later video *Crossfire* (2007) mixes footage of firing guns. These videos prefigure Marclay's best-known work, *The Clock*, which uses sound to skilful effect but which focuses on the time-based rather than the audio-visual dimensions of the medium. *The Clock* is a 24-hour-long collage of movie clips featuring clocks, watches and spoken references to the time, in which (when projected in a gallery) the time on screen is always the correct time in real life.

⋯⋙ Almond, Fast, Henrot, Pfeiffer

**Christian Marclay. b** San Rafael, CA, USA, 1955. **The Clock**. 2010. Single-channel video with sound. **dur** 24 hr. Installation view, White Cube Mason's Yard, London, 2010

# **Marden** Brice

### Second Letter (Zen Spring), 2006–9

In the early 1960s Marden encountered the work of Jasper Johns, whose gridded paintings made an immediate impact on the young artist. During this period, Marden's mainly black or grey paintings, prints and drawings were composed on simple rectilinear forms, soon becoming entirely monochromatic, as in *The Dylan Painting* (1966/86), its smooth grey surface painted in oil and beeswax. In subsequent years his technique opened increasingly to colour and gestural lines, especially after a trip in 1983 to Thailand, India and Sri Lanka. As suggested in the title *Second Letter (Zen Spring)*, Asian calligraphy

and philosophy assumed a central role in Marden's painting. Notions of balance, quiet, slowness and reflection are expressed in his muted palette and meandering lines. His paintings are designed to return the viewer, with nothing representational to fix upon, to an enhanced consciousness of their own physicality and processes of visual perception.

┈┄┈ Abts, Kelly, Lambie, Odita

**Brice Marden. b** Bronxville, NY, USA, 1938. **Second Letter (Zen Spring)**. 2006–9. Oil on linen. **h** 244 x **w** 366 cm. **h** 96 x **w** 144 in

# Margolles Teresa

## En el aire, 2003

For Mexican artist Margolles, death is a theme both existential and political. When, in her diverse sculptures and installations, Margolles uses as part of her media substances that have come into contact with dead bodies, she summons the unavoidable issues of violence, drug use and social neglect that thread through daily life in much of her country. In the installation *En el aire* (In the Air), gallery visitors encounter soap bubbles floating lazily down from above. The work's listed media reveal – horrifyingly – that the water used in the bubble machine had previously been used to clean dead bodies in a morgue. Even though the water has since been disinfected and is perfectly safe, this ethereal vision of impermanence suddenly assumes much graver metaphorical and substantial significance. In another series, Margolles makes monochromatic paintings from stretched fabric that has been used to clean blood from streets where people have been found murdered.

⋯⋮⋯ Kuri, Li Yongbin, Neshat, Orozco

Teresa Margolles. b Culiacán, Mexico, 1963. En el aire. 2003. Installation with bubbles, machines producing bubbles with water that has been used to wash dead bodies after autopsy. Dimensions variable. Installation view, 'Muerte sin Fin', Museum für Moderne Kunst, Frankfurt am Main, Germany, 2004

# **Marshall** Kerry James

## Vignette #10, 2007

Race is an inescapable theme in the paintings and sculptures that Marshall has made since graduating from art school in Los Angeles in the late 1970s. Born in Alabama in the same year that Rosa Parks famously refused to give up her bus seat for a white passenger, his personal history is inextricably entwined with that of the Afican-American civil rights movement. To anyone confident about how much society has changed since then, Marshall poses some uncomfortable questions. For instance, why does the black couple dancing in *Vignette #10* seem so out of place? The scene collides the stylized kitsch of

greetings cards with the compositional conventions of French Rococo painting. Both genres evoke the kind of carefree joyfulness that is not typically associated with representations of African Americans, which is in itself disturbing. The International Style, Modernist home in the background is an additional jarring detail, posing the question, to whom does such culture belong?

⋯⋮⋅ Gallagher, Shaw, Kara Walker

**Kerry James Marshall. b** Birmingham, AL, USA, 1955. **Vignette #10**. 2007. Acrylic on fibreglass. **h**188 x **w**279.4 cm. **h**74 x **w**110 in

# McCarthy Paul & Damon

## Caribbean Pirates, 2005

A mammoth installation featuring a lifesize frigate and a houseboat, *Caribbean Pirates* is inspired by the theme-park attraction (and later movie franchise) *Pirates of the Caribbean*. The work is a collaboration between Paul McCarthy, who has created influential videos and installations since the 1970s, and his son Damon. The duo has worked together on projects since 2000, exploring themes that include Western consumerism and popular culture. Unlike the clean-cut Disney World imagining of pirate life, the McCarthys' work is a dark and messy vision. The boats and other objects displayed in the space – which the audience can explore – originally formed the set for a month-long series of performances that were filmed at Paul McCarthy's LA studio. The resulting video is projected on the walls around the installation and features grotesque depictions of buccaneers and wenches engaged in simulated scenes of sex and violence, accompanied by lashings of ketchup and chocolate sauce.

⋯⫶ Kelley, Sherman, Trecartin

**Paul McCarthy. b** Salt Lake City, UT, USA, 1945. **Damon McCarthy. b** Los Angeles, CA, USA, 1973. **Caribbean Pirates**. 2005. Performance, video, colour photographs, installation

# **McKenzie** Lucy

### May of Teck, 2010

In 2007, McKenzie enrolled at the Belgian Institut Supérieur de Peinture Décorative Van Der Kelen Logelain, Brussels, to learn traditional *trompe-l'oeil* painting techniques. She applied her newly acquired skills in a suite of paintings that simulated, at life size, the wainscoting, fireplaces and coving of a nineteenth-century domestic interior. The paintings were made to fit exactly the walls of her Cologne gallery, and depicted fluffy clouds where the wallpaper should have been, as if the walls themselves had evaporated into thin air. The interior depicted was inspired by Muriel Spark's 1963 novella *The Girls*

*of Slender Means*. As with much of McKenzie's work, this referred not only to a borrowed (and literary) aesthetic but also its attached web of cultural associations encompassing class, gender and place. Similarly, the 'Quodlibet' series (2008–) conjures found objects and pieces of paper as if pinned to a corkboard.

···؛· Brown, Finch, Pica

**Lucy McKenzie. b** Glasgow, UK, 1977. **May of Teck**. 2010. Oil on canvas. Two parts, each **h**290 x **w**300 cm. **h**114 1/8 x **w**118 1/8 in

# McQueen Steve

## Giardini, 2009

This split-screen film shows the Giardini, the public gardens that host the Venice Biennales of art and architecture each alternate summer. McQueen's film, however, documents the area in in the downtime of midwinter. Through a series of minutely observed vignettes he constructs a portrait of a place where there is beauty and imaginative possibility beyond the glamour and grandeur that occupies the gardens during the Biennale. There is an everyday poetry in McQueen's imagery: stray dogs haunt the boarded-up buildings and scattered rubbish, two men meet and embrace in the dark, a tree trunk presents a sculpted silhouette. A sharply detailed soundtrack contributes to the richness of the film. *Giardini* was presented in 2009 when McQueen was chosen to represent Britain at the Biennale. As well as being renowned as a video artist he has had success directing feature films, winning the *Caméra d'Or* at Cannes for his 2008 film *Hunger* and an Oscar for *12 Years a Slave* in 2014.

·····⫶· Julien, Nelson, Ondak

**Steve McQueen. b** London, UK, 1969. **Giardini**. 2009. 35 mm film transferred to high definition video. **dur** 30 min 3 sec

# Mehretu Julie

## Mumbo Jumbo, 2008

Geometric shapes, fragmented diagrams and billowing clouds of intricate marks fill the surface of this canvas, while flashes of purple, blue and gold add to the cacophony of line and colour. Mehretu's chaotic compositions are achieved by laboriously building up layers of acrylic paint, which are then overlaid with pencil, pen and ink drawings. Working intuitively, she sometimes erases sections, adding more layers until achieving the desired result. But Mehretu's paintings are more than random collections of colour and form: they refer to the accelerated pace of modern city life. The language of architecture

is a central concern, and fragments of maps, plans and buildings are often included alongside references to twentieth-century art movements, such as Futurism and Constructivism. Working on a vast scale, Mehretu's paintings convey a sense of time and space becoming compressed into single images; they are monuments to the bewildering pace of contemporary urban experience.

⋯⋮⋅ Abts, Marden, Reyle, Sze

**Julie Mehretu. b** Addis Ababa, Ethiopia, 1970. **Mumbo Jumbo**. 2008. Ink and acrylic on canvas. **h**243.8 x **w**365.8 cm. **h**96 x **w**144 in

# **Mik** Aernout

## Middlemen, 2001

Mik's video installation appears to be set in a post-crash stock exchange, where traders gaze up at an unseen screen or stare, vacantly, at their notepads. Papers are strewn across the floor and red telephones hang unused on their hooks. The looped scene, which might at first appear relatively realistic, gradually unravels. A number of the dazed figures twitch, as if whatever financial catastrophe has taken place has also crashed their nervous systems. Twins, dressed in traders' blazers, mirror each other's movements. The slow-moving camera suddenly zooms in or out, as if to further unbalance the viewer.

It is easy, following the economic events of 2008, to ascribe a prophetic quality to *Middlemen*, but it may be more valuable to view it in the light of Mik's other dream-like and uncanny visions, such as the pharmacists in the film *Osmosis and Excess* (2005) who work while mud flows around their feet.

⋯⋮⋅ Bonvicini, Huyghe, Żmijewski

**Aernout Mik. b** Groningen, Netherlands, 1962. **Middlemen**. 2001. Single-channel video installation. Loop

# **Mirza** Haroon

The National Apavilion of Then and Now, 2011

Record turntables, wooden laminate speakers, parts of lamps, mid-twentieth-century furniture, old drum machines and televisions have all featured in the sculptural assemblages of Mirza. Interference – whether visual, sonic, electrical or intellectual – has been the subject of his investigations since his early sculptures such as *Nightlight FM* (2007). In that work a radio is balanced on a glass sheet on top of a metal dustbin; ambient noise from the radio and mist from the bin lend the low-tech arrangement improbably bewitching atmospherics. In *The National Apavilion of Then and Now* Mirza uses anechoic foam wedges on the wall of a small chamber. A static buzz rises in volume while a ring of white LEDs hanging from the ceiling increases in brightness. Just as the noise and light are becoming uncomfortable, both the light and the noise abruptly cut out, leaving viewers in total silence and darkness – a kind of technological death, which repeats itself *ad infinitum*.

⋯⋮⋅ Aitken, Assaël, Gowda, Hiorns

**Haroon Mirza. b** London, UK, 1977. **The National Apavilion of Then and Now**. 2011. Anechoic chamber, LEDs, amplifier, speakers, electronic circuit. Approx **h**800 × **w**700 × **d**330 cm. **h**315 × **w**275 5/8 × **d**128 7/8 in. Installation view, 'ILLUMInazioni / ILLUMInations', *54th Venice Biennale*, 2011

# **Motti** Gianni

Plausible Deniability, 2004

With the mischievous work of Motti, the story is usually as important – if not more important – than the artwork itself. After the Space Shuttle *Challenger* exploded in 1986, Motti called news agencies and claimed responsibility. When, in 1992, an earthquake ripped through Los Angeles, the artist was again telling journalists that he had made it happen. Documentation of these events became the series of works entitled *Revendications* (Claims) (1989–94). In 1989 he staged his own funeral procession, with an open coffin. For a retrospective at the Migros Museum in Zurich, in 2004, he chose not to display any of his previous works. Instead Motti built a wooden corridor 600 metres (200 feet) long, which snaked through the museum. The installation was called *Plausible Deniability*: visitors were welcomed by guides who talked them through Motti's past projects, while security guards prevented anyone from retracing their steps. As light-hearted as Motti's exploits may seem, at their root lies a fiercely critical vision of contemporary news media.

⌁ Cattelan, Nashat, Sehgal

**Gianni Motti. b** Sondrio, Italy, 1958. **Plausible Deniability**. 2004. Wood. Dimensions variable. Migros Museum für Gegenwartskunst, Zurich, Switzerland

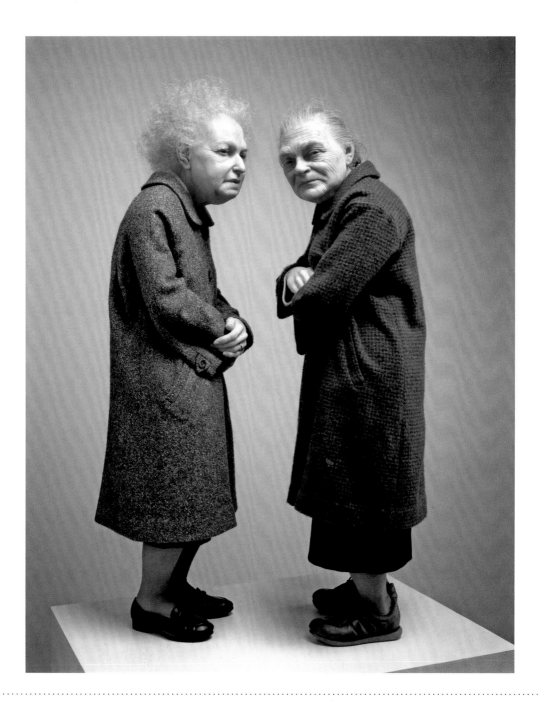

# Mueck Ron

## Two Women, 2005

Two women are depicted deep in conversation, turned towards one another but looking out suspiciously at the viewer, who might in fact be the subject of their whispered conversation. The women are dressed in the uniform of old age: loose, nondescript coats, thick brown tights and comfortable shoes. Like many of Mueck's sculptures, the level of detail here could easily lead them to be mistaken for real people, if it weren't for their diminutive stature. London-based Mueck originally worked as a model maker for children's television and film, and later created props and animatronics for the advertising industry. He began working as an

artist in the mid-1990s, gaining attention for his poignant sculpture, *Dead Dad* (1996–7) when it was exhibited at the Royal Academy of Arts, London, in the exhibition 'Sensation!'. While his work is always highly detailed, Mueck always uses an over- or undersized scale, which adds an unsettling yet captivating element to the work.

⋯⋮ Currin, Shonibare, Wekua

Ron Mueck. b Melbourne, Australia, 1958. **Two Women**. 2005. Mixed media. **h**82.6 x **w**48.7 x **d**41.5 cm. **h**32 1/2 x **w**19 1/8 x **d**16 1/2 in

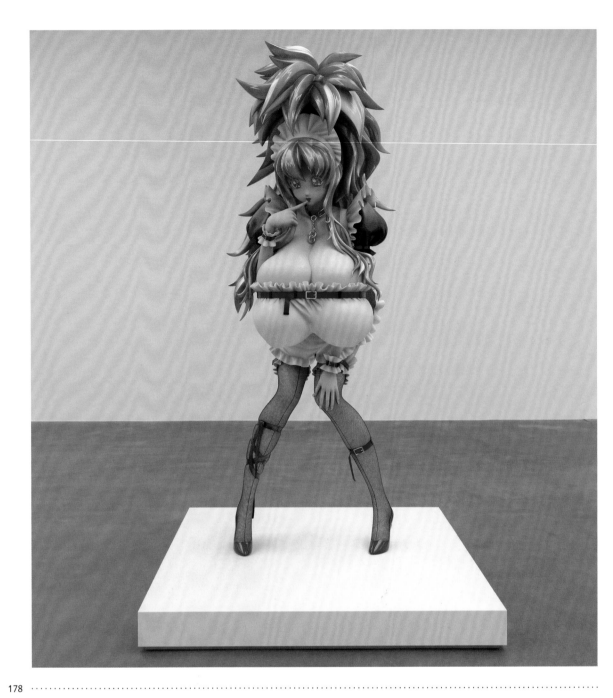

# **Murakami** Takashi

## 3m Girl, 2011

It makes little sense to debate the attractiveness or ugliness of a sculpture like Murakami's *3m Girl*. The object, made from flawlessly smooth fibreglass and airbrushed with exquisitely modulated colour, is, formally, extremely beautiful. And the figure – an idealized female character rendered in the aesthetic style favoured in Japanese *manga* and *anime* – might herself be considered cute if she did not possess the most grotesquely huge pair of breasts, which threaten to burst out of her frilly maid's outfit. Murakami is neither condoning nor denouncing such a problematic image, but merely presenting it as

part of contemporary Japanese culture. That it is at once horrifying and alluring is probably his intention. The prolific artist, trained in traditional Nihonga painting, has built a vast business empire around his 'Superflat' aesthetic, which he applies to paintings, graphics, animation, fashion design and collectable objects.

······ Koons, Nara, Prince, Yuskavage

**Takashi Murakami. b** Tokyo, Japan, 1962. **3m Girl.** 2011. Original rendering by Seiji Matsuyama, modeling by BOME and Genpachi Tokaimura, full scale sculpture by Lucky-Wide Co., Ltd. Stainless steel, fibre reinforced polymer, urethane paint, epoxy resin, leafing, net tights. Sculpture: **h**270 x **w**97 x **d**120 cm. **h**106 3/8 x **w**38 1/8 x **d**47 1/8 inches. Base: **h**18 x **w**170 x **d**185 cm. **h**7 1/8 x **w**66 7/8 x **d**72 7/8 in

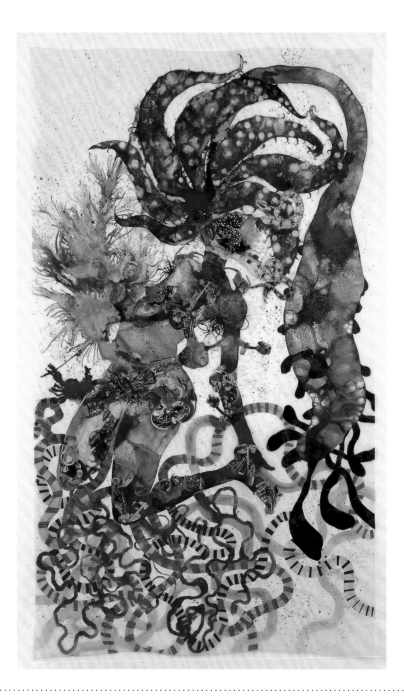

# **Mutu** Wangechi

## A'Gave You, 2008

A terrifying monster towers over a female figure forced to her knees by a writhing mass of serpentine creatures. With billowing tentacles, the beast seems poised to devour her, though an explosion of yellow bursting from her contorted body suggests she has already been bitten. The horrific scene, however, is neutralized by Mutu's decorative patterns and bright colours. This large mixed media collage is typical of the artist's recent works, in which female bodies composed from cut-out images, paint and other materials, are violently stretched, torn and twisted. Confronting racial and gender stereotypes about black women, her work weaves a web of connections between colonial history, African politics and the worldwide fashion industry. Instead of working on paper Mutu uses Mylar, a plastic material that gives her images a synthetic sheen. Relocating from Kenya to New York in the 1990s, Mutu also works with video, installation and sculpture.

····⋮· Dumas, Gallagher, Ndiritu, Ofili

**Wangechi Mutu. b** Nairobi, Kenya, 1972. **A'Gave You**. 2008. Mixed media collage on Mylar. **h**236 x **w**137cm. **h**92 7/8 x **w**54 in

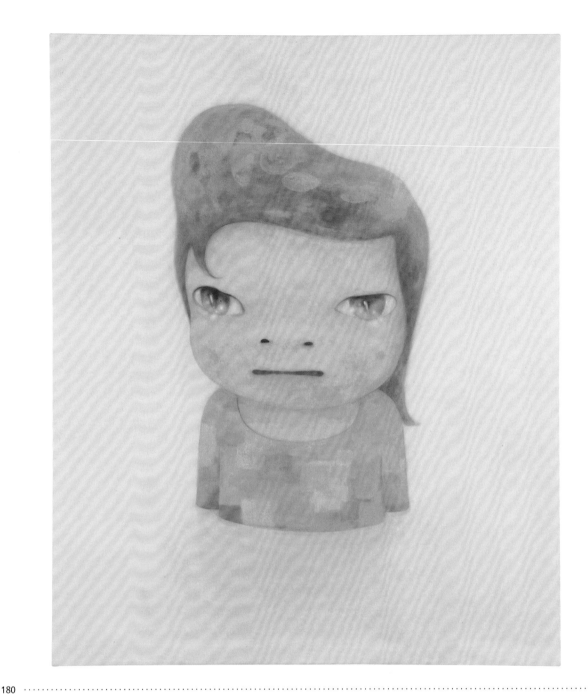

# **Nara** Yoshitomo

## Blankey, 2012

Mixing cartoon cuteness with a sinister edge, Nara creates paintings, sculptures and installations that are peopled predominantly by children and dogs. *Blankey* is a classic Nara character. Set within a uniform background, the focus of the painting is all on the child, who appears sweet, with wide-set eyes. However, Nara's children are usually a mixture of light and shade, and Blankey's determined expression is also suggestive of a mischievous countenance. In other works, Nara's figures have been overtly ominous, shown carrying knives and other weapons, hinting at a savagery rarely seen in images of children and childhood.

Nara's art is influenced by *manga* and *anime*: this is particularly evident in his characters' oversized eyes and stylized features. Music is another important source of inspiration in Nara's work. The artist regularly exhibits installations that feature a mock-up of his studio, accompanied by a punk-rock soundtrack.

⋯⋮⋯ Cuoghi, Shrigley, Stark, Zeng

**Yoshitomo Nara. b** Hirosaki, Japan, 1959. **Blankey**. 2012. Acrylic on canvas. **h**194 x **w**162 cm. **h**76 1/4 x **w**63 3/4 in

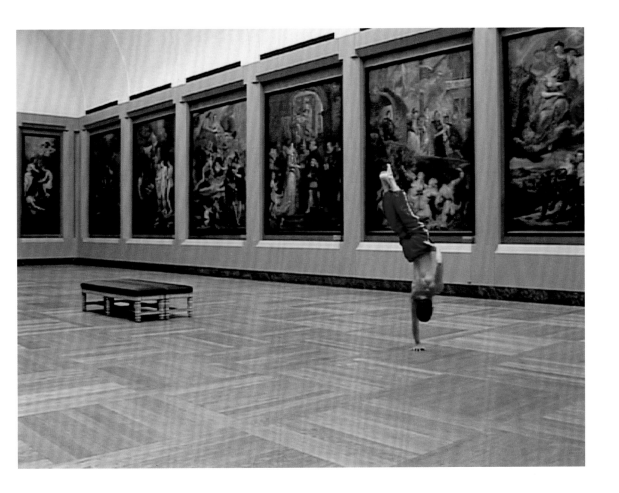

# Nashat Shahryar

## The Regulating Line, 2005

Nashat's elusive art, tied to no particular medium but favouring video and photography alongside sculptural installations, frequently returns to ideas of cultural hierarchies and authority. In his video *The Regulating Line*, a shirtless man walks into the gallery of the Louvre containing the famous *Marie de' Medici Cycle* by Peter Paul Rubens. After contemplating the paintings for a moment, he responds by performing a handstand, then holds himself aloft on one arm alone, his body vertical. Does the 'line' in Nashat's title refer to Rubens's draughtsmanship or the form of the visitor's body? Or does it refer to the invisible boundary that separates the two? Other works, such as Nashat's video *Plaque (Slab)* (2007), focus on the architecture of cultural presentation. The film combines shots of a 1969 televized performance by pianist Glenn Gould with footage of Nashat's recreation, in concrete, of the faux-marble monoliths that flanked the pianist on stage.

····⫶ Allora & Calzadilla, Chopra, Zaatari

**Shahryar Nashat. b** Geneva, Switzerland, 1975. **The Regulating Line**. 2005. Digital video. **dur** 3 min 40 sec

# Ndiritu Grace

## The Nightingale, 2003

Ndiritu actively participates in her videos, performing with fabrics, objects and text. Politics are just part of the fluid, non-linear world that this British artist who claims Kenyan heritage inhabits, as she undermines cultural stereotypes and clichés. In her four screen series *Still Life* (2005–7), she comments on the historical influence of the West in Africa, specifically that of Matisse's odalisques paintings, by inserting her self both as the subject and the observer of her female body against a background of brightly patterned cloth. For *The Nightingale*, Ndiritu's head and shoulders are, at first, entirely covered

in fabric. The African soundtrack abruptly shifts in tempo and tone, and the sepia image flicks into colour. The artist proceeds to twist the red patterned fabric around her head in a deft choreography that causes it to resemble a bandana, then a burka, a yashmak, a turban, then a blindfold and a gag.

·····∵· Anatsui, Mutu, Shonibare

**Grace Ndiritu. b** Birmingham, UK, 1976. **The Nightingale**. 2003. Colour video with sound. **dur** 7 min 1 sec

# Nelson Mike

## I, Impostor, 2011

Since he began making his immersive, hyperrealistic but dilapidated environments in the mid-1990s, Nelson has been conjuring simulacra that are virtually indistinguishable from the places they represent. *I, Impostor* was a reconstruction of a work Nelson made in Istanbul in 2003 titled *Magazin: Büyük Valide Han*, transplanted to the British Pavilion for the 2011 Venice Biennale. Along with the original installation – a reproduction of a seedy photographic darkroom – Nelson remade, inside the classical pavilion, the seventeenth-century Istanbul inn within which the darkroom was originally housed. He went as far as removing the pavilion's skylight in order to recreate the inn's central open-air courtyard. This uncanny doubling also occurred in the photographs hanging, under red lights, in the darkroom: they pictured the building in Istanbul and its surrounding environs. The London-based artist led visitors into a physical and conceptual no man's land between interior and exterior, East and West, past and present.

⋯⋮⋯ Salcedo, Schneider, Whiteread

**Mike Nelson. b** Loughborough, UK, 1967. **I, Impostor**. 2011. Site-specific architectural installation. Dimensions variable. Installation view, *54th Venice Biennale*, 2011

# **Neshat** Shirin

## Passage, 2001

Neshat's film uses an enigmatic, episodic structure to portray a funeral rite. A procession of men moves across a beach holding aloft a body draped in white. In a bleak desert landscape they approach an undulating black dome that resolves into a circle of women dressed in chadors who are digging a grave with their hands. A child crouches by a pile of stones as a ring of fire gradually encircles the funeral party. The film evokes a sense of deep connection between these people and the landscape in which they perform their timeless rituals. A compelling soundtrack composed by Philip Glass underscores the sense of ceremony. Although now based in the USA, Neshat uses film, video and photography to explore society in her native Iran, especially the position of women. She draws on the specifics of Iranian Muslim culture to create works that explore universal ideas about loss, meaning and memory.

····⁝· Margolles, Nashat, Yang

**Shirin Neshat. b** Qazvin, Iran, 1957. **Passage**. 2001. Colour video and sound installation. **dur** 11 min 30 sec. Dimensions variable

# **Neto** Ernesto

## Leviathan Thot, 2006

Pendulous, amorphous forms hung throughout the interior of the Panthéon in Paris, defy its formal, neo-classical symmetry as well as the layers of cultural and historical significance embodied by the building. The space was transformed into something between a ceremonial edifice and the belly of the Leviathan, referencing both Thomas Hobbes's seventeenth-century metaphor for the state as a gigantic beast and the Biblical story of Noah and the Whale. The forms were made from stretchy white fabric filled with Styrofoam balls and aromatic spices. Visitors were invited to walk in the installation and to touch it, the satisfying, visceral sense of gravity and the heady scent of the spices creating a multi-sensorial experience. Neto typically makes biomorphic sculptural installations that fill spaces, which the visitor can enter and interact with. He is concerned with connecting an internalized, embodied sense of being with the external world.

·····⫶· Black, Lambie, Rehberger, Sarceno

**Ernesto Neto. b** Rio de Janeiro, Brazil, 1964. **Leviathan Thot**. 2006. Polyamide tulle, polyamide fabric and Styrofoam balls. **h**53 x **w**62 x **d**56 m. **h**173 ft 10 3/8 in x **w**203 ft 5 in x **d**183 ft 8 3/4 in. Installation view, *Festival d'Automne*, Paris, France, 2006

# Neuenschwander Rivane

## Involuntary Sculptures (Speech Acts), 2001–10

The miniature sculptures that make up this ongoing series are not created by Neuenschwander. Rather, they are objects that she has found in bars and cafés, small sculptural doodles created by strangers while they are chatting with friends. One is a collection of straws idly twisted together; others are bits of paper or napkins moulded unconsciously into shapes. The sculptures pay testament to restless minds and hands, and when placed on a plinth in a gallery become works of art. Other pieces by Neuenschwander invite the audience more directly to participate in their creation, a practice that shows the influence of older Brazilian artists such as Lygia Clark and Hélio Oiticica on her work. There is a celebration of the ephemeral in Neuenschwander's art, as well as the random, and an encouragement for people to see the beauty and interest that can be found in the everyday.

·····⫶ Floyer, Jungen, Leonard, Schütte

**Rivane Neuenschwander. b** Belo Horizonte, Brazil, 1967. **Involuntary Sculptures (Speech Acts)**. 2001–10. Mixed media. Dimensions variable

# Nordström Jockum

## The Coachman, 2002

Although they often include depictions of men in frock coats and top hats, women in long dresses and people riding horses, the paintings and drawings of Nordström are rooted in no particular era. His folkish scenes aspire to a kind of timelessness: people fight, have sex, hunt, dance and play music, just as they always have and probably always will. Nordström, who worked previously as a graphic artist for a Swedish newspaper, draws on traditional Scandinavian design and iconography, as well as the Modernist architecture of Stockholm's suburbs. The latter is the subject for card and paper sculptures such as *Blockhead*

(2010); these constructions also feature, anachronistically, in his collage and painting *The Coachman*, beside a figure in a horse-drawn carriage. Nordström's pictures entice the viewer into an alternative universe that is at once disparate and cohesive, familiar and strange, welcoming and disturbing.

⋯⋮⋯ Chapman, Owens, Parrino, Rojas

**Jockum Nordström. b** Stockholm, Sweden, 1963. **The Coachman**. 2002. Collage with watercolour, gouache and graphite on paper. **h**96.5 x **w**96.5 cm. **h**38 x **w**38 in

# **Odita** Odili Donald

### Give Me Shelter, 2007

Odita moved from his native Nigeria to the United States with his parents when he was only six months old, and so grew up in a country in which his specifically African identity was subsumed within a more general categorization of 'blackness'. Throughout his formative years as an artist he was acutely aware of how inseparable all areas of culture are from their geography and history. Perversely, perhaps, Odita was drawn to Hard-edge Abstraction – a genre of painting that, in America at least, had once aspired to empty itself of such cultural content and traditional associations. Odita's dynamic compositions openly allude to

African textiles and decoration through their improvised and irregular patterns and vibrant palette. Paintings such as *Give Me Shelter* – which is applied directly to the wall of a given space – also evoke the distant open landscapes of Africa.

····⁞· Kelly, Scheibitz, Shahbazi

**Odili Donald Odita. b** Enugu, Nigeria, 1966. **Give Me Shelter**. 2007. Acrylic latex wall paint, coloured pigment on wall. **h**6 x **w**18 x **l**18 m. **h**7 ft 9 1/8 in x **w**59 ft 3 in x **l**59 ft. Installation view, Italian Pavilion, *52nd Venice Biennale*, 2007

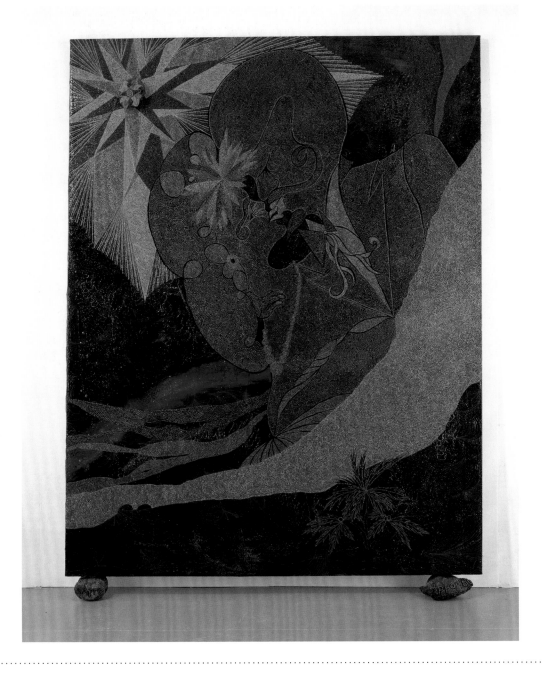

# Ofili Chris

## Afro Apparition, 2002–3

In 1992, while still at college in London, Ofili was awarded a travel scholarship to Zimbabwe. The trip gave him an entirely reinvigorated perspective on his relationship to the African diaspora (his parents are from Nigeria), and suggested to him a number of motifs and effects that he continues to use in his paintings today. Seeing cave paintings made from coloured dots influenced the intricate pointillist technique that Ofili uses to build up shimmering veils of colour; balls of elephant dung (latterly sourced by the artist from British zoos) become pedestals for paintings such as *Afro Apparition*, and are sometimes decorated with map pins and fixed to the surfaces of the paintings themselves. Despite such earthy, traditional allusions, Ofili's art is stridently contemporary, drawing on such subjects as cartoon superheroes, blaxploitation cinema, pornography, reggae and hip hop music. *Afro Apparition* exemplifies the sultry eroticism and distinctive colour palette of much of Ofili's work.

·····⫶· Doig, Gallagher, Shaw

**Chris Ofili. b** Manchester, UK, 1968. **Afro Apparition**. 2002–3. Acrylic, oil, polyester resin, glitter, map pins and elephant dung on linen, with two elephant dung supports. **h**275 x **w**214 cm. **h**108 1/4 x **w**84 1/4 in. Monsoon Art Collection, London

# **Ondak** Roman

## Loop, 2009

When Ondák was asked to represent Slovakia in the 2009 Venice Biennale, in the pavilion of former Czechoslovakia, he laid earth on the floor and planted trees and bushes that were virtually indistinguishable from the gardens of the Giardini della Biennale outside. Doorways at either end of the pavilion were kept open day and night, so that visitors, along with wild animals and birds could move in and out with complete freedom. The work, titled *Loop*, subverts the expectations that visitors might have about where an exhibition – or reality – starts and ends. Like many of Ondák's subtle installations, the gesture gains added

resonance when one remembers that he grew up in Czechoslovakia under communism, an era when movement across borders was strictly controlled. His latter work, *Do not walk outside this area* (2012) consists of an aeroplane wing forming a precarious bridge for visitors between two rooms in a museum.

⸱⸱⸱⋮⸱ McQueen, Penone, Sasnal, Schabus

**Roman Ondak. b** Žilina, Slovakia, 1966. **Loop**. 2009. Mixed media. Installation view, Czech and Slovak Pavilion, *53rd Venice Biennale*, 2009

# **Ono** Yoko

## My Mummy was Beautiful, 2004

For this public artwork Ono distributed images of a woman's breast and crotch throughout the UK city of Liverpool. Inspired by the childhood memories of her late husband, John Lennon, whose own mother died during his adolescence, the work was intended as a homage to motherhood more broadly. While some viewers were offended at Ono's banners, the artist defended her imagery by noting that, as children, our very first encounters with the world are with the female body. The project recalls a number of Ono's earlier works involving dislocated views of the human form, such as *Film No. 4 (Bottoms)*

(1966), which features close-up views of naked buttocks. In the 1960s Ono was an important figure in both the Fluxus and Conceptual art movements, which reacted against traditional art forms, emphasizing ideas over skill. She continues to make provocative new work and has greatly influenced younger generations of artists.

·····⫶ Lassnig, Lawler, Opie

**Yoko Ono. b** Tokyo, Japan,1933. **My Mummy was Beautiful**. 2004. Vinyl banners, site-specific installation for *Liverpool Biennial*, 2004. Dimensions variable

# **Opie** Catherine

### Self Portrait/Nursing, 2004

Since the late 1980s, Opie has been documenting diverse communities, sometimes through images of groups of people, sometimes through pictures of their environments, and sometimes in portraits of individuals. When she began photographing her own Queer and S&M community in San Francisco she included a number of self-portraits in the body of work. *Self-Portrait/Pervert* (1994), for example, is an arresting image, showing the artist wearing a black hood over her head, needles piercing her arms and the word 'pervert' cut into her chest. *Self Portrait/Nursing*, taken a decade later, shows Opie tenderly breastfeeding her son, the scars of her earlier incisions still faintly visible. These intimate images are contrasted with series such as *High School Football* (2008) and *Surfers* (2003), both of which see the artist looking at subcultures from an external, more distanced perspective.

 Abramović, Dijkstra, Ono

**Catherine Opie. b** Sandusky, OH, USA, 1961. **Self Portrait/Nursing**. 2004. C-print. **h**101.6 x **w**81.3 cm. **h**40 x **w**32 in

# **Orozco** Gabriel

### Dark Wave, 2006

When, in 1997, Orozco made *Black Kites*, the sculpture was just one of many seemingly magical transformations that the Mexican artist had rendered on found objects. The work consisted of a human skull with a chequerboard pattern meticulously drawn onto it in graphite, an object that was at once shocking and beautiful. An earlier work, *La DS* (1993), involved the removal of the central third of the length of a Citroën DS car, effectively streamlining the vehicle by making it wide enough for only a single person. Nearly a decade after he made *Black Kites*, Orozco's ambitions (and means) had increased, and he decided

to reattempt his earlier transfiguration with the biggest bones he could find. *Dark Wave* is a graphite drawing on a full-scale replica of a whale skeleton. The artist described his intervention on the object as a process of mapping, orienting the concentric circles on what he imagined as the animal's pulse points.

····⫶· Abdessemed, Kuri, Villar Rojas

**Gabriel Orozco. b** Xalapa, Mexico, 1962. **Dark Wave**. 2006. Calcium carbonate and resin with graphite. **h** 304 x **w** 392 x **d** 1375 cm. **h** 119 5/8 x **w** 154 3/8 x **d** 541 3/8 in

# **Ortega** Damian

### Cosmic Thing, 2002

A Volkswagen Beetle car has been disassembled. The components hang suspended from fine wires in orderly relation to one another, resembling a technical diagram or a frozen moment in an unusually tidy explosion. By drawing attention to the finest details of a familiar object, Ortega reveals it as a work of human ingenuity. While the visual and material aspects of the piece are striking, Ortega also explores the political and cultural currency found in everyday objects, especially as they relate to his native Mexico. Ortega's earlier career as a political cartoonist is reflected in the playfully satirical nature of his work.

*Cosmic Thing* is only one part of Ortega's *Beetle Trilogy* (2002–5), the others being performative actions, concluding with a VW Beetle being driven to a final resting place and buried upside down. Ortega's artistic process typically involves pursuing ideas over an extended period of time and presenting them in a variety of ways.

⋯⫶ Orozco, Parker, Sailstorfer

**Damian Ortega. b** Mexico City, Mexico, 1967. **Cosmic Thing**. 2002. Stainless steel, wire, 1983 Volkswagen Beetle, Plexiglas. Dimensions variable

# **Owens** Laura

## Untitled, 2002

In this idyllic pastoral scene, a bear appears from behind a tree, while a monkey reaches out gently to a passing butterfly. Other animals feature, including a rabbit and an owl. All are set against a backdrop that is a mixture of a moonlit sky and a sky strewn with little fluffy clouds. While Owens's paintings present landscape scenes, filled with flowers and animals, and occasionally people, there is no attempt at realism in her work. Instead she presents an idealized, harmonious view of the natural world. Owen's creation process is lengthy. Beginning with sketched drawings, these are often scanned and then manipulated on a computer using Photoshop to create the perfect composition, the final work is always created in paint and often quite large. Owens openly references other works from art history, from ancient Chinese painting to folk art to pieces by early twentieth-century European painters such as Joan Miró or Henri Rousseau.

····⁝· Rojas, Shaw, Woods

**Laura Owens. b** Euclid, OH, USA, 1970. **Untitled**. 2002. Oil and acrylic on linen. **h**213 x **w**335 cm. **h**84 x **w**131 7/8 in

# **Paci** Adrian

### After the wall there are some walls, 2001

In this installation a video is projected onto a wall of rectangular plastic containers filled with seawater. The film documents Paci's attempt to collect the water from the Strait of Otranto, a notorious stretch of the Mediterranean Sea that provides the main crossing point for illegal immigrants leaving Albania for Italy. The artist is seen sailing on a motorboat, filling his plastic containers, before the coastal police, mistaking him for a migrant, arrive to question him. Displacement, migration and cultural identity are important themes for Paci, who was forced to flee his native Albania after civil war erupted there

in 1997. After finding refuge in Italy he began working with video, photography and sculpture to explore his experiences of being uprooted. Characterized by its emotional impact and autobiographical underpinnings, Paci's work employs both humour and pathos to explore many of the social and cultural problems of our modern, globalized world.

····ː Barrada, Starling, Vo

**Adrian Paci. b** Shkodër, Albania, 1969. **After the wall there are some walls**. 2001. Installation, single-channel video projection, water, plastic containers, metal construction. **dur** 12 min. **h**380 x **w**270 x **d**28 cm. **h**149 5/8 x **w**106 1/4 x **d**11 in

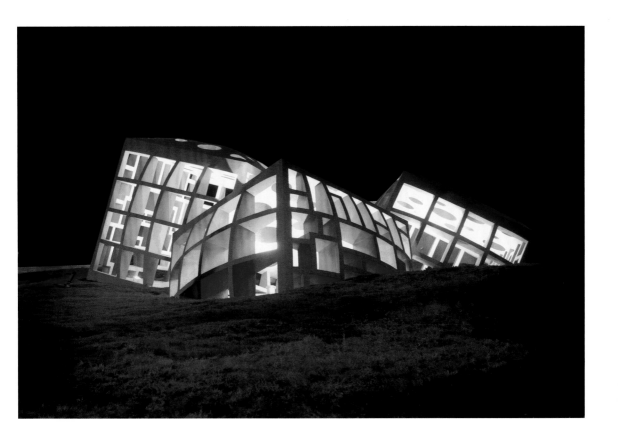

# Pardo Jorge

## Untitled, 2005

The lines between art, architecture and product design are blurred in Pardo's work. The artist, who was born in Cuba but moved to the USA when he was six, even lives in one of his artworks. Titled *4166 Seaview Lane, Los Angeles*, the house was designed by Pardo for the Museum of Contemporary Art in Los Angeles in 1998 and was open to the public for five weeks before he moved in. His work challenges the notion of the gallery as a stark, 'white cube' space and his installations often resemble rooms in a home, featuring photomurals on the walls and furniture, particularly with a retro, 1950s style. He also creates large

light installations combining lamps and sculptures. Among these is this architectural light piece that was installed in a housing complex in Guadalajara in Mexico. The building is swollen, as if holding its breath, and filled with orange light.

⋯⋮· Aitken, Rehberger, Wyn Evans

**Jorge Pardo. b** Havana, Cuba, 1963. **Untitled**. 2005. Concrete and mixed media. Installation view, Guadalajara, Mexico, 2005

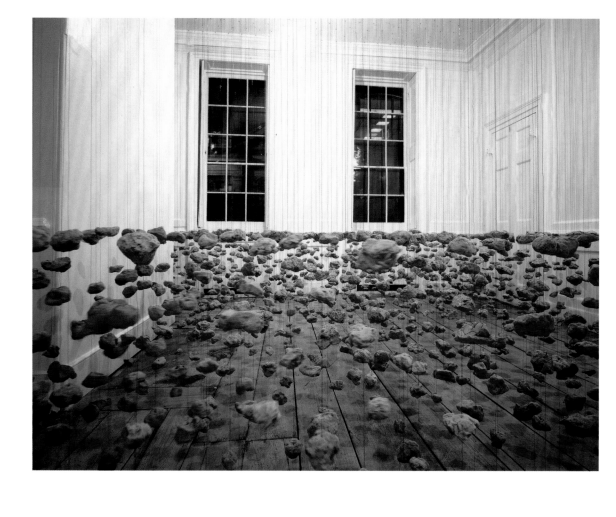

# **Parker** Cornelia

## Subconscious of a Monument, 2003

Destruction, resurrection and the power of objects to retain hidden meanings are recurrent themes within Parker's installations, sculptures and prints. Perhaps less obviously, a wry and ironic seam of humour also runs through her work. One of her most famous pieces involved Parker enlisting the British Army to blow up a garden shed; the finished work consisted of the broken shards suspended on wires as if in mid-explosion. She titled it *Cold Dark Matter: An Exploded View* (1991). In *Subconscious of a Monument* Parker obtained lumps of clay that had been excavated from beneath the Leaning Tower of Pisa in order

to prevent its collapse. Hanging in the gallery, the pieces of earth seem to defy gravity, forever hovering in mid-air, while the massive heavy tower still threatens, one day, to topple. Parker's title for the work acknowledges the psychoanalytical associations between the subconscious mind and subterranean phenomena such as caves, cellars and structural foundations.

⋯⋰ Alÿs, Durham, Friedman, Ruff

**Cornelia Parker. b** Cheshire, UK, 1956. **Subconscious of a Monument**. 2003. Soil excavated from beneath the Leaning Tower of Pisa, wire. Dimensions variable

# **Parreno** Philippe

## Credits, 2000

French artist Parreno's film *Credits* opens on a shot of leafless trees, at night, in a park beside a Modernist housing block. To the trees' branches are tied red, yellow and green plastic bags. Nothing happens, except that the lighting slowly changes, and mist gathers and disperses. At the end of the film, the gallery lights come on automatically to reveal a photograph of a boy by commercial photographers Inez van Lamsweerde and Vinoodh Matadin. Instead of a title label, Parreno lists the names of the people he considers collaborators, including Lamsweerde and Matadin, the designers M/M, Angus Young (who contributed the electric guitar soundtrack), a former French Minister of the Interior and Miko, an ice-cream manufacturer. Parreno plays with the conventions of cinema in other works such as *Marquee* (2009), an old-fashioned illuminated theatre canopy that was first installed above the entrance to his retrospective at the Pompidou Centre, Paris.

·····: Black, Creed, Gaillard, Pardo

**Philippe Parreno. b** Oran, Algeria, 1964. **Credits: Michel Amathieu, Djamel Benameur, Jaques Chabon-Delmas, James Chinlund, Maurice Cotticelli, Hubert Dubedout, Francois Dumoulin, Ebezeber Howard, M/M Paris, Pierre Mendès-France, Miko, Neyrpic, Alain Peyrefitte, Inez Van Lamsweerde & Vinoodh Matadin**. 2000. Mixed media installation. Stills from 35 mm film. **dur** 6 min 30 sec

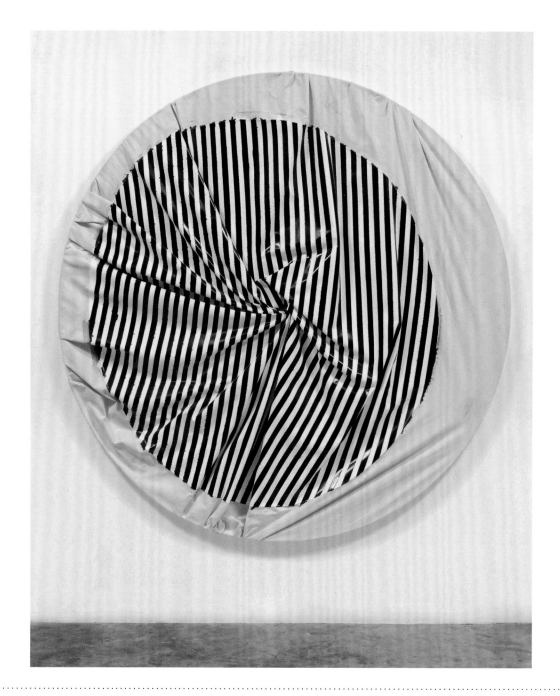

# **Parrino** Steven

## Skeletal Implosion 2, 2001

The canvas of a circular painting hangs sagging and loose from its stretcher, the black and white stripes at its centre bunched and twisted. The violence inherent in *Skeletal Implosion 2*, one of a series of paintings with the same title, is typical of the work of Parrino, who would attack and reshape his canvases, pulling them from their frames and slashing them. This nihilistic approach first appeared in Parrino's work in the early 1980s, a time when many artists and critics alike were pronouncing painting 'dead'. Rather than turning his back on the medium, Parrino embraced then deconstructed it. He mostly created paintings in simple monochrome colours, although he also incorporated imagery from pop culture into his work. Having achieved a mixed reception during his lifetime, after his untimely death in a motorcycle accident in 2005, Parrino's work was included in the prestigious Whitney Biennial for the first time.

⋯⫶⋅ Guyton, von Heyl, Odita

**Steven Parrino. b** New York, USA, 1958. **d** New York, USA, 2005. **Skeletal Implosion 2**. 2001. Enamel on canvas. **h** 213.4 x **w** 213.4 cm. **h** 84 x **w** 84 in

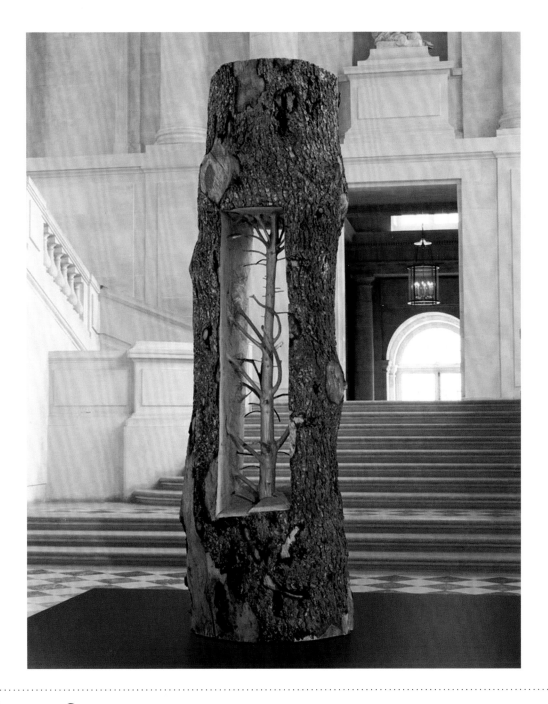

# **Penone** Giuseppe

## Albero porto-cedro (Door-Tree-Cedar), 2012

In the hallway of the Palace of Versailles stands the trunk of a large cedar. At its centre is the form of a sapling, painstakingly carved by the artist who chiselled out the tree's growth rings layer by layer. For Penone a tree exists as a sculpture that memorizes its living in its shape. Through his carving he excavates its past, referencing the tree's humble beginnings and evoking the life force that exists within all living things. Trees have featured throughout Penone's work and he continues to maintain a close relationship with the natural world. Using everyday materials such as stone, resin, leather and wood, he explores the relationship between humans and their environment and considers the nature of temporal experience. As a member of the influential Arte Povera movement that dominated the Italian art scene in the 1960s, Penone made important contributions to the development of installation, performance and Land art.

⋯⋮⋯ Aranberri, Cragg, Neuenschwander

Giuseppe Penone. b Garessio, Italy, 1947. **Albero porto-cedro (Door-Tree-Cedar)**. 2012. Cedar wood. **h**316 x **diam**150 cm. **h**124 3/8 x **diam**59 in

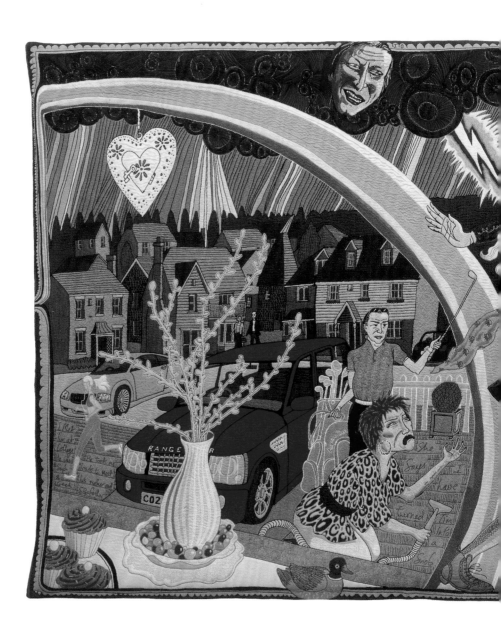

# **Perry** Grayson

### Expulsion from Number 8 Eden Close, 2012

Perry is perhaps best known as a ceramicist and a transvestite. Dressed as his alter ego, Claire, he wears frocks that he often designs himself, embroidered with incongruously sexual or violent motifs. Similar illustrations appear on his pots, which include urban consumer culture, scenes of violence and kinky sex alongside Perry's handwritten annotations. More recently, Perry has designed large-scale tapestries on contemporary themes. The *Walthamstow Tapestry* (2009) used well-known company logos to highlight how each stage of life has effectively been branded. *The Vanity of Small Differences* (2012) explores class mobility and the objects with which we demonstrate our social identity. Drawing on the satirical paintings of William Hogarth, the six-part work chronicles the life of Tim Rakewell as he ascends through British social strata. The fourth tapestry, *Expulsion from Number 8 Eden Close*, illustrates the moment at which Tim leaves his parents' lower middle class housing estate to join a bourgeois north London dinner party.

⤑ Chopra, Emin, Julien, Wallinger

**Grayson Perry. b** Chelmsford, UK, 1960. **Expulsion from Number 8 Eden Close**. 2012. Wool, cotton, acrylic, polyester and silk tapestry. **h**200 x **w**400 cm. **h**78 3/4 x **w**157 1/2 in

# **Pessoli** Alessandro

## Testa farfalla su matrice locomotiva, 2011

Paintings in oil, enamel and sprayed acrylic; drawings in pastels, ink and bleach; animations, ceramics, textiles, bronze and steel sculptures: all these media and more cohere in the hands of Pessoli to evoke a dream world rich with characters and human drama. Indeed, the theatre is a recurring motif in his work, particularly with reference to *teatrini*, the model theatres made by mid-century Italian artists such as Lucio Fontana, Arturo Martini and Fausto Melotti. He is as likely to incorporate characters from the *commedia dell'arte* as he is from contemporary cartoons or from novels such as Cervantes's *Don*

*Quixote*. His painting *Testa farfalla su matrice locomotiva* (Butterfly Head on Locomotive Matrix) belongs to a triptych titled *Fiamma pilota le ombre seguono* (Pilot Light the Shadows Follow), and is based loosely on the Crucifixion, although obvious narrative is subsumed within Pessoli's luminous mists of colour and overlapping figures.

⋯⋮⋅ de Balincourt, Dalwood, Rauch

**Alessandro Pessoli. b** Cervia, Italy, 1963. **Testa farfalla su matrice locomotiva**. 2011. Oil, enamel, spray paint on canvas. **h**195 x **w**300 cm. **h**76 3/4 x **w**118 1/8 in

# Pettibon Raymond

## No Title (Outside! Moondoggie was…), 2013

Few artists are as prolific as Pettibon, who has been drawing in his inimitable style ever since the late 1970s, when he first gained a cult following for the flyers he designed for local punk bands in Los Angeles, where he still lives. Working almost exclusively in ink on paper, and most often in black and white, Pettibon combines appropriated literary texts, dialogue, notes and narrative imagery in a way that recalls comic-book illustration and graphic design, but also the etchings of Francisco Goya and William Blake. For display, Pettibon typically pins up his drawings in groups, sometimes with text and images painted directly onto the walls around. The artist's enthusiasms, from baseball to surfing to punk rock, provide the subject matter for diaristic drawings that also seem to encapsulate an outlook that is more broadly representative of West Coast culture. *No Title (Outside! Moondoggie was…)* relates a bizarre meeting of two stereotypically Californian obsessions, surfing and science fiction.

⋯⋰ Cao, Kentridge, Shrigley

Raymond Pettibon. b Tucson, AZ, USA, 1957. **No Title (Outside! Moondoggie was…).** 2013. Ink, gouache, acrylic, and graphite on paper. **h**57.5 x **w**76.2 cm. **h**22 5/8 x **w**30 in

# **Peyton** Elizabeth

## Pete (Pete Doherty), 2005

In this intense, small-scale portrait, Peyton has painted the famously dissolute British rock star Pete Doherty as a romantic, hollow-eyed poet or maybe a pious saint. The likeness has been realized in deft, vibrant brushstrokes. As in her other portraits of male pop celebrities, Peyton presents an idealized, androgynous version of masculinity. Often based on magazine photographs, they seem to capture the naive and candidly adoring perspective of the teenage fan. This is a watercolour, but Peyton also uses oil paint, ink and pencil as well as various printmaking techniques. On account of their subject matter, source material and apparent superficiality, Peyton's paintings have often been compared with those of Andy Warhol, although stylistically they are more energetically expressive. They also have a depth and poignancy, in this instance reflecting on the vulnerability of the artist as well as capturing the brilliance and fleeting nature of youth.

⋯⋮ Brown, Currin, Dumas, Tuymans

**Elizabeth Peyton. b** Danbury, CT, USA, 1965. **Pete (Pete Doherty)**. 2005. Watercolour on paper. **h**35.6 x **w**25.4 cm. **h**14 x **w**10 in

# Pfeiffer Paul

## John 3:16, 2000

A large basketball floats hypnotically in the centre of a television screen, seemingly defying gravity. In the background a courtside audience blurs and shifts while flickering hands reach up for the ball, as if towards a sacred object. To create this digital video piece, New York-based artist Pfeiffer edited together footage from NBA basketball games onto a loop, containing 1,800 still images, all centred on the ball. The work's biblical title refers both to eternal life and to the near-religious fervour that now surrounds professional sports. *John 3:16* is one of a number of works where Pfeiffer has manipulated film and photography taken from popular culture, to affect our perception of the imagery and to explore themes of religion, race and art. Pfeiffer often erases the central figures from famous movies or sporting events, before displaying the manipulated film on tiny screens, further undermining the power of the original footage.

⋯⋮⋅ Fast, Gaillard, Marclay

**Paul Pfeiffer. b** Honolulu, HI, USA, 1966. **John 3:16**. 2000. Digital video loop, metal armature, LCD monitor, DVD player. Monitor: **h**14 x **w**16.5 x **d**91.4 cm. **h**5 1/2 x **w**6 1/2 x **d**36 in. Video loop: **dur** 2 min 7 sec

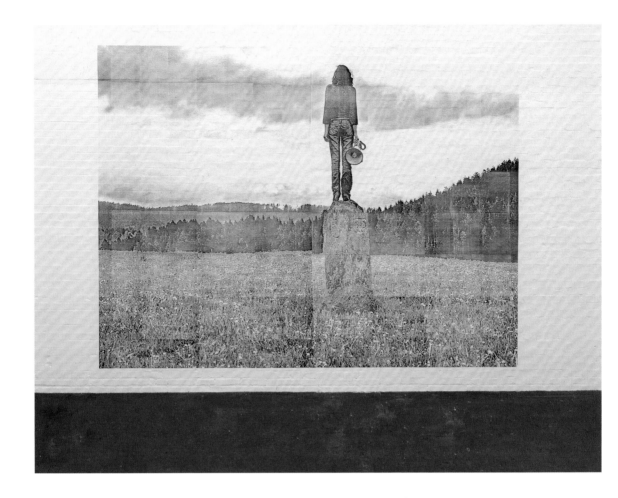

# Pica Amalia

### Sorry for the metaphor #2, 2010

Standing on top of a megalith in a rural landscape, the artist faces away from her audience. A megaphone dangling by her side suggests that she has a message to broadcast, or perhaps it has already been delivered. Comprised from tiled, photocopied sheets of paper, this enormous black and white collage is pasted directly onto the gallery wall. Visual distortions introduced by the process of enlarging the original photograph give the work a grainy, archaic quality. An interest in the nature of human communication lies at the heart of the London-based artist's work, which reflects on the ways that personal and

collective histories are transmitted and received. Pica's photographs, sculptures, films and interactive pieces explore the desire for such interaction, as well as the potential for failure. Megaphones, antennae and semaphore flags are recurring motifs, joined more recently by listening devices that emphasize the importance of making oneself heard as well as the necessity of having something to say.

⋯⋰ Gormley, Guyton, McKenzie, Tiravanija

**Amalia Pica. b** Neuquén Capital, Argentina, 1978. **Sorry for the metaphor #2**. 2010. Photocopied paper, wallpaper paste on wall. **h**336 x **w**472 cm. **h**132 1/4 x **w**185 3/4 in

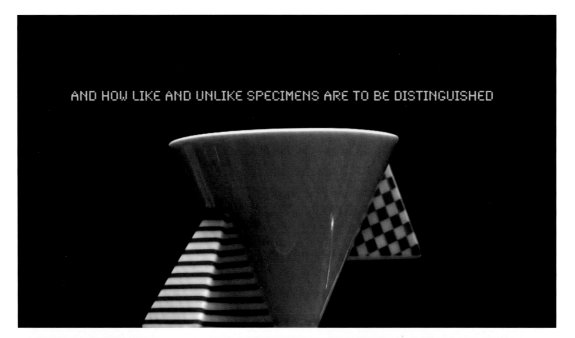

# **Price** Elizabeth

## User Group Disco, 2009

In her densely structured, atmospheric videos, Price combines text and music with footage that she has both appropriated and filmed herself. *User Group Disco* is set in a 'Hall of Sculptures'; nothing of the room, however, is visible, and only the so-called sculptures (everyday objects, utensils and ornaments including chrome desk toys and a golf putting machine) glint and twirl in the blackness. The carefully paced subtitles are excerpts from texts by diverse authors including Theodor Adorno, Edgar Allan Poe and Filippo Tommaso Marinetti, which combine to create a narrative. The soundtrack builds from an electronic soundscape to an instrumental version of the recognizable pop tune, *Take On Me*, by A-ha. *User Group Disco* is on one level, a challenge to the idea of the authoritative museum and how objects acquire value as artefacts. Taken alongside her other works, it is also an exploration of the heterogeneous medium of video in art, advertising and documentary.

⋯⋗ Graham, Henrot, Leckey, Stark

**Elizabeth Price. b** Bradford, UK, 1966. **User Group Disco**. 2009. HD video installation. **dur** 15 min

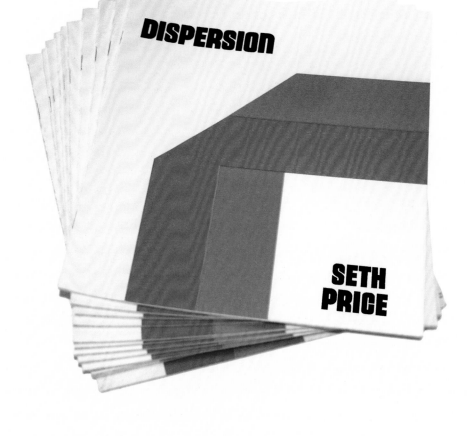

# **Price** Seth

### Dispersion, 2002

New York-based artist Price creates artworks in a number of forms, including sculpture, video and the written word. His work examines the production, packaging and distribution of art and how this impacts on our experience of it. *Dispersion* is an ongoing essay, first published on the internet by Price in 2002. The text is available for anyone to download. It is designed like a long magazine article, complete with illustrations, although its tone is academic. The essay discusses the changing nature of how we interact with art – primarily caused by the internet – and the challenge this presents to the formal structures of galleries, museums and the art market. It further ponders what constitutes 'public art' in the age of the internet, and questions the limits inherent within the term 'artist' itself. *Dispersion* has appeared in a number of exhibitions, both as an essay and as a sculptural work entitled *Essay with Knots*.

⋯⫶ Feng, Henrot, Sehgal

**Seth Price. b** East Jerusalem, 1973. **Dispersion**. 2002. Text, artist's booklet

# **Prince** Richard

### Danger Nurse at Work, 2002

A young female nurse stands against a rich, inky background. Her face is barely discernible, concealed by a surgical mask and smears of paint. Drips of red and white run down her old-fashioned uniform. The work's menacing title, *Danger Nurse at Work*, hovers above her head in block capital letters. The work belongs to a series by Prince inspired by the covers of medical-themed romance novels published in the 1960s. Scanning the covers into a computer, Prince then transfers the images to canvas before overpainting them with lurid colours. 'The Nurse Paintings' play on romantic clichés and address issues of gender

stereotypes and nursing mythology. Since the late 1970s, Prince has explored questions of authorship and originality by appropriating images from the mass media to create new works of art. He is best known for his cowboy photographs from the 1980s, which used imagery from iconic cigarette advertisements.

⋯⊹ Barney, Currin, Murakami

**Richard Prince. b** Panama Canal Zone (now Panama), 1949. **Danger Nurse at Work**. 2002. Inkjet and acrylic on canvas. **h** 236.2 x **w** 142.2 cm. **h** 93 x **w** 55 in

# Quaytman R. H.

## Constructivismes, Chapter 13 (with Painting Rack), 2009

In certain past works, Quaytman has presented her paintings stacked like books on shelves or racks, so that viewers can pull out whichever work they want to see. The paintings themselves are, for the most part, screen-printed images on gessoed plywood panels; sometimes Quaytman bevels the edges of the wood in order to enhance their appealing tactile sense of objecthood. The idea that one painting always defers to another, or is interchangeable, is central to her work. In some pieces, as with the largest panel in *Constructivismes, Chapter 13 (with Painting Rack)* the painting is a screen-printed photograph of another artwork or gallery space. Frequently, however, the source images are degraded to the point of illegibility. Quaytman's reflection on the nature of the digital or broadcast image extends to many of her abstractions in which concentric circles or tight grids create the dazzling moiré effect familiar from magnified views of computer and television screens.

⸱⸱⸱⸱⸱⸱ Guyton, Marden, Parrino, Wool

**R. H. Quaytman. b** Boston, MA, USA, 1961. **Constructivismes, Chapter 13 (with Painting Rack)**. 2009. Silkscreen, oil, gesso on wood, and wood rack; six panels. Dimensions and installation variable

# **Raad** Walid

## I Only Wish That I Could Weep, 1997/2002

In order to find a new means of documenting the armed conflict with which he grew up as a citizen of Lebanon, Raad invented The Atlas Group, an organization with a membership of one dedicated to preserving an archive of photographs, notebooks, videos and films. Many of these documents are fictional, created by Raad himself, but most combine fact, fantasy and conjecture in a way that renders their veracity less important than their subjective insights into the war. Raad is particularly interested in the way in which history itself is a form of fiction, constantly rewritten and edited. The video *I Only Wish*

*That I Could Weep* is attributed to Operator #17, a Lebanese military intelligence officer who was assigned to monitor the Corniche, Beirut's seafront promenade. Instead of videotaping the various political agents, agitators and subversives who gathered there in the evenings, the officer trained his camera, defiantly and poetically, on the beautiful sunsets over the Mediterranean sea.

⋯⋮ Gaillard, Huyghe, Jacir, McQueen

**Walid Raad. b** Chbanieh, Lebanon, 1967. **I Only Wish That I Could Weep**. 1997/2002. Single-channel video, silent. **dur** 7 min 40 sec

# Raqs Media Collective

## The Capital of Accumulation, 2010

This double-screen video projection weaves together filmed images of Berlin, Mumbai and Warsaw to imagine a shared economic, social and urban history of the twentieth century. Its title is a reversal of Rosa Luxemburg's *The Accumulation of Capital* (1913), which described the rapacious nature of capitalism: its tendency to commandeer resources and its intolerance of other economic models. The film reflects on Luxemburg's theories and includes a parallel narrative exploring her violent death and the disappearance of her body. The double screen sets up a dialogue between images, narrative and text, making a work that is hauntingly poetic and polemical. Raqs Media Collective, a group of three media practitioners, operates at the intersections of contemporary art, historical and philosophical enquiry and activism. In 2000 they co-founded the Sarai Programme at Delhi's Centre for the Study of Developing Societies, which encourages creative collaboration between the visual arts and other disciplines concerned with urban spaces and cultures in South Asia.

·····⁝· Alÿs, Fast, JR, Sierra

**Raqs Media Collective.** Founded New Delhi, India, 1992. **The Capital of Accumulation**. 2010. Two-screen video projection. **dur** 59 min

# **Rauch** Neo

## Gold, 2003

Rauch grew up in East Germany in the 1960s and 70s, and it is to the social and cultural privations of this era that would-be interpreters of his mystifying paintings invariably turn. His illustrative style borrows from Socialist Realist art and propaganda, and the figures that inhabit his scenes seem to belong to an indeterminate historical past. He is the most prominent member of the New Leipzig School – a group of technically accomplished painters who came to prominence in the late 1990s. However, Rauch's art is too unwieldy to conform to such straightforward readings as political commentary or ironic pastiche.

Pictures such as *Gold*, in which an elderly couple press their faces up against a shop window while a uniformed figure looks on, seem to derive from the irrationality of dreams rather than the control and specificity of Soviet imagery. Stylistic aberrations – such as the abstract graffiti that appears on the glass – only add to the sense of dislocation.

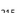 Andersson, Avery, Dubossarsky & Vinogradov

**Neo Rauch. b.** Leipzig, Germany, 1960. **Gold**. 2003. Oil on canvas. **h**250 x **w**201 cm. **h**98 1/2 x **w**79 1/8 in

# **Ray** Charles

### The New Beetle, 2006

Los Angeles-based Ray started out in the 1970s as an artist making minimalist sculptures that were not quite what they seemed: *Rotating Circle* (1988), for instance, is a circular section of wall that spins, via a hidden motor, so fast that it appears static; the white-painted solid steel *7 1/2 Ton Cube* (1990) looks much lighter than it is. A turning point came for Ray when he made the lifesize *Self Portrait* (1990). Since that time his figurative sculptures have drawn richly from his early experiments around formal issues such as weight and surface, scale and material. *The New Beetle*, like many of his recent works,

began with a digital scan of an actual person, then modified and cast, life-size, in steel. Despite – or perhaps because of – the formal precision of the sculpture, Ray has created a poignant and psychologically charged image of absorption that is both timeless and rooted in its contemporary moment.

······⫶· Mueck, Ortega, Warren

**Charles Ray. b** Chicago, IL, USA, 1953. **The New Beetle**. 2006. Painted steel. **h**53 x **w**88 x **d**72 cm. **h**21 x **w**34 1/2 x **d**28 1/2 in

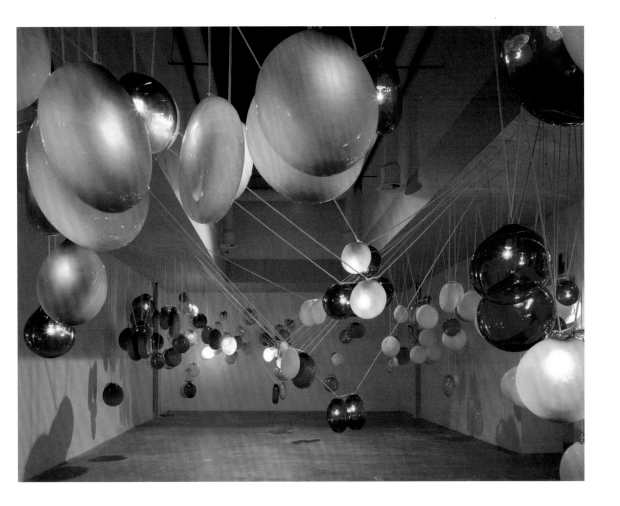

# **Rehberger** Tobias

**7 ends of the world, 2003**

This installation was first exhibited at the 2003 Venice Biennale and featured 222 glass lamps spread across the gallery ceiling. Rehberger collaborated with local artisans to create the piece, the lamps being made of Murano glass. The work features seven areas of colour, designed to represent seven specific places in the world, personally chosen by the artist. These locations are obscure, including a pumpkin field in Romania and a Burger King fast-food restaurant in Kyoto, Japan. Controlled via the internet, the light in each of the colour groups varies in response to changes in sunlight in the seven places across the globe. Rehberger experiments with design – including the production of furniture, clothing and signage – and uses technology to create installations that encourage us to think about what defines a work of art today. Often featuring bright colours and glossy textures, his work is influenced by Modernist art and design as well as the aesthetics of the 1960s and 1970s.

····:· Finch, Horn, Wyn Evans

**Tobias Rehberger. b** Esslingen, Germany, 1966. **7 ends of the world**, 2003. 222 glass lamps, light bulbs, sockets. Dimensions variable. Installation view, *50th Venice Bienniale*, 2003

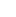

# Reyle Anselm

## Untitled, 2010

A disparate array of metal junk is arranged, lying on the floor or propped against the wall. More scrap spills out of a metal bin. Neon tubes placed amid the junk illuminate the composition in brilliant colours. The poverty of the materials and the nonchalant aesthetic belies the careful structuring of the elements. There is a vibrant interaction between colour and shape. Reyle makes reference to the conventions of Modernist art: the use of found objects, formalism and abstraction; while his choice of materials, use of colour and popular culture allude to the Arte Povera and Pop art movements of the 1960s.

However, such clever art-historical references are not merely playful; Reyle re-evaluates the legacy of Modernism while going beyond purely formal concerns, reflecting on issues relevant to a post-industrial present. If anything, the gaiety of the colour in this work adds to a sense of urban dystopia.

····∴· Gowda, Mehretu, Parreno

**Anselm Reyle. b** Tübingen, Germany, 1970. **Untitled**. 2010. Found objects, neon tubes. **h**190 x **w**330 x **d**320 cm. **h**74 5/8 x **w**130 x **d**126 in

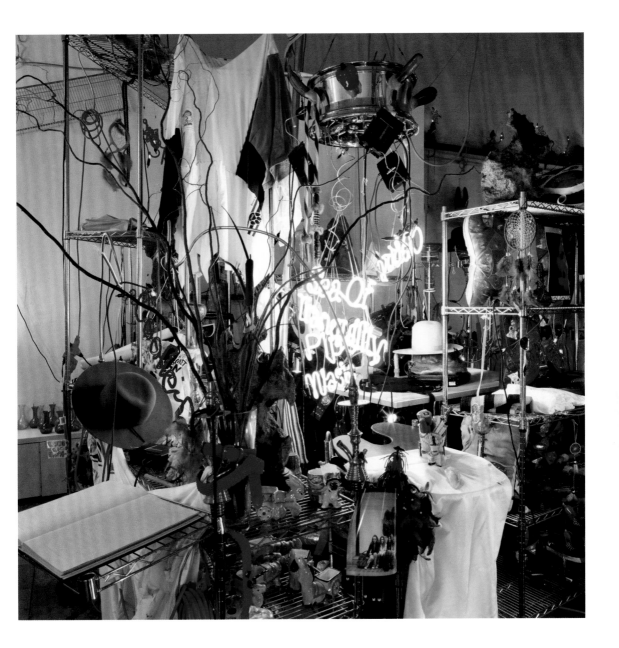

# Rhoades Jason

## Black Pussy Soirée Cabaret Macramé, 2006

*Black Pussy Soirée Cabaret Macramé* was Jason Rhoades's magnum opus, the final part of a trilogy, and one of his most ambitious and complicated works. Soon after its completion, the Los Angeles-based artist tragically died. It was preceded by the sprawling installations *Meccatuna* (2003) and *My Madinah: in pursuit of my ermitage…* (2004), both of which contained, among other things, Rhoades's ongoing collection of words for female genitalia rendered in colourful neon. In *Black Pussy Soirée Cabaret Macramé* these were arranged alongside readymade goods that Rhoades bought in bulk:

dreamcatchers, cowboy hats, hookah pipes and Chinese 'scholar's rocks'. While the objects were installed in his studio, Rhoades hosted a series of ten choreographed dinner parties, attended by art world and Hollywood glitterati. Rhoades considered these soirées an integral part of the patination of the chaotic and now-legendary work, which remains an overwhelming testament to the excesses of Western consumerism.

⋯⋰ Kelley, Song Dong, Sze

**Jason Rhoades. b** Newcastle, CA, USA, 1965. **d** Los Angeles, CA, USA, 2006. **Black Pussy Soirée Cabaret Macramé**. 2006. Mixed media. Dimensions variable

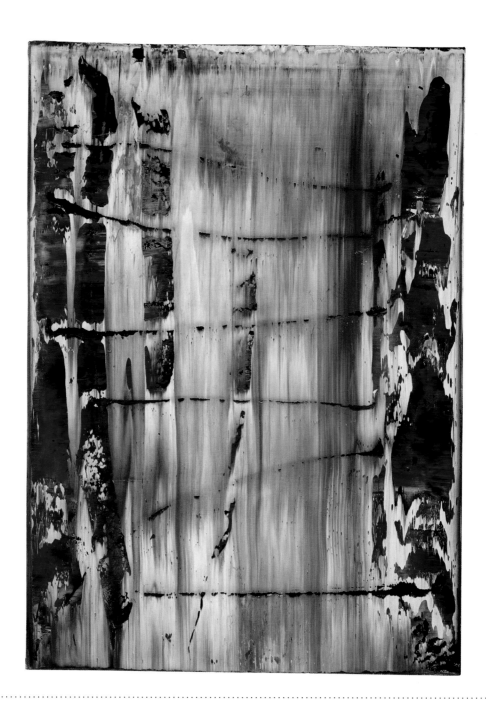

# **Richter** Gerhard

## Abstract Painting, 2004

Paint – predominantly white and pink – has been dragged vertically across a background of blurred red and gold. Horizontal, broken black lines intersect the smear, undermining the formlessness of the image and giving it a powerful sense of structure. Although abstract, the effect is dramatic, elegiac and visceral. The painting evokes an ancient patinated surface and suggests something imminent, coalescing into being or perhaps, contrarily, something dissolving and decomposing before our eyes. Richter works across a vast range of genres and subjects: figurative and abstract; paintings and also

sculptures. He bases many of his figurative images on photographs, often over-painting and wholly or partially eradicating photorealistic images, blurring the distinction between abstract and representational painting. In his wholly abstract works, he frequently relies on chance to form the compositions, and in 2006 produced a six-part series 'Cage' which explores the twentieth-century avant-garde musician John Cage's ideas about silence and aleatory composition.

·····⁝· Marden, Rauch, Tillmans

**Gerhard Richter. b** Dresden, Germany, 1932. **Abstract Painting**. 2004. Oil on canvas. **h** 82 x **w** 59 cm. **h** 32 1/4 x **w** 22 1/4 in

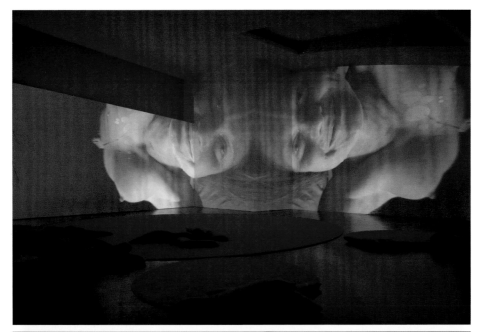

# Rist Pipilotti

## Lungenflugel (Lobe of the Lung), 2009

On three huge screens arranged in a semicircle, an unpredictably fluid series of deliriously colour-saturated and distorted scenes are projected. A female figure in a dress wades through water as the camera moves above and below the surface, before the scene dissolves into a field of brilliant red tulips and looming hands dig into the soil, pulling up earthworms. A disorientating soundtrack created by regular collaborator Anders Guggisberg accentuates the dream-like psychedelic effect. The audience is invited to lounge on cushions so that they can become immersed in the experience. Rist uses film and video to explore issues relating to gender, sexuality and the human body. While her subject matter may sound rather dry, her work is typically exuberant and joyful, and is often presented in ways that are strikingly earthy and visceral. Her name is taken from the free-spirited character Pippi Longstocking of the children's books.

····:· Ahtila, Mutu, Ono

**Pipilotti Rist. b** Grabs, St. Gallen, Switzerland, 1962. **Lungenflugel (Lobe of the Lung)**. 2009. Audio video installation; three projectors, three synchronized HD players, sound system, twenty custom-made pillows, carpet. Dimensions variable: each installation of this work is distinct. Installation view, 'Elixir – Pipilotti Rist', KIASMA Museum for Contemporary Art, Helsinki, Finland, 2009

# Rojas Clare E.

### Untitled (Brother and Sister Quilt), 2009

In a folkloric tableau, two figures, male and female, face away from each other, looking upwards and offering flowers. Forming a bridge between them is a stage on which small male and female figures, dressed in white, adopt different postures. At the bottom corner of the painting, another woman stands under an arch of leaves, with hands together as if praying. This painting is one of number of works by Rojas that draw on the forms, motifs and narrative traditions of American patchwork quilt-making. The imagery suggests an allegorical tale centred around themes of religious devotion and transcendence. Despite its stylistic simplicity and decorative aesthetic, Rojas's work engages with contemporary cultural concerns through a synthesis of personal narrative and traditional female iconography. In a later series of works, 'Spaces in Between', Rojas does away with the figures and storytelling aspects, focusing instead on abstract elements, to create more minimal and architectural spaces with blocks of flat colour.

⋯⊹ Barrada, Grotjahn, Nordström

**Clare E. Rojas. b** Columbus, OH, USA, 1976. **Untitled (Brother and Sister Quilt)**. 2009. Gouache on paper. **h**47 x 59.8 cm. **h**18 1/2 x **w**23 1/2 in

# Rondinone Ugo

## MOONRISE. east. april, 2006

Rondinone is an artist more easily identifiable through his sensibility – gently humorous, melancholic and attuned to quiet moments of surprise and delight in daily life – than he is by his diverse subject matter. Over his career spanning two decades, the New York-based artist has made airbrushed, circular paintings resembling targets, jolly rainbow-patterned signs with messages such as *Hell Yes!* (2001) and, more recently, giant statues made from roughly hewn lumps of rock, installed in New York's Rockefeller Plaza (*Human Nature*, 2012). *MOONRISE. east. april* belongs to a twelve-part series of clay heads,

each titled after a different month of the year. The initial sculptures were made in clay; the artist's finger marks are preserved in the final bronze casts, which were painted to resemble their original material. Sculpting these monstrous though friendly faces, Rondinone meditates on the passage of time and the importance of daydreaming and fantasy.

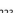 Fischli & Weiss, Sarah Lucas, Schutz

**Ugo Rondinone. b** Brunnen, Switzerland, 1964. **MOONRISE. east. april**. 2006. Cast aluminium, brown enamel, wooden plinth. **h**187 x **w**105.1 x **d**109.9 cm. **h**73 5/8 x **w**41 3/8 x **d**43 1/4 in

# Rothschild Eva

### Sweet Valley, 2011

Three diamond shapes made of painted oak, supported on a steel stand, create a complex framework of intersecting lines. The relationships between the various elements shift constantly as the viewer moves around the sculpture. The work has a highly refined and elegant minimalism that recalls aspects of twentieth-century art movements. It addresses traditional sculptural notions regarding volume and mass, surface and structure. Although resolutely sculptural, the fine lines of the work have a drawn quality that sets up a dialogue between two- and three-dimensional representation.

Rothschild's work embraces a variety of media, including leather, plastic, wood and metal, and processes that range from the industrial to the ready-made to the handcrafted. It can include narrative, figurative, and conceptual content, alongside a consistent concern with material and formal qualities. Part of Rothschild's strategy to prevent a limited interpretation of her work lies with the titles, which are deliberately non-descriptive and ambiguous though nevertheless considered and precise.

⋯⋰ Baghramian, Barlow, Deacon

**Eva Rothschild. b** Dublin, Ireland, 1972. **Sweet Valley**. 2011. Painted oak, steel stand. **h**243 x **w**60 x **d**60 cm. **h**95 5/8 x **w**23 5/8 x **d**23 5/8 in

# **Ruff** Thomas

## jpeg bd01, 2007

Ruff is among a canonical generation of artist-photographers who studied under Bernd and Hilla Becher at the Kunstakademie Düsseldorf. He is often discussed alongside figures such as Andreas Gursky, Thomas Struth and Candida Höfer. Ruff's large-scale prints speak more about the limits of photographic representation than about the medium's ability to capture reality. A series of expressionless portraits from the 1980s reveal as little about the sitters as do Ruff's series 'Sterne', from 1989, of the beautiful but fathomless night sky. More recently, Ruff reduced digital images to very low-resolution JPEG files, then printed them at large scale so that their pixellation obscures the subject. Many, like *jpeg bd01*, are based on images taken from the media, in this case the famous Burj Khalifa skyscraper in Dubai, pictured midway through construction, as if in acknowledgement of the simultaneous magnificence and incompleteness of the photograph itself.

⋯⋮⋯ Gursky, Sasnal, Sugimoto

**Thomas Ruff. b** Zell am Harmersbach, Germany, 1958. **jpeg bd01**. 2007. C-print with Diasec. **h**266.1 x **w**185.1 cm. **h**104 3/4 x **w**72 7/8 in

# Ryden Mark

## Tree of Life, 2006

In a lush, idealized landscape, a creepily doll-like princess sits regally in a tree, holding a baby. An eye embedded in the tree's trunk echoes the directness of her gaze. Nestled into the roots is a skull and crossbones, and hidden among the leaves like fruit, are seven geometric, Platonic solids. Standing in symmetrical relation on either side of the tree are a bear and a king. The painting is set within a baroque frame, richly carved with woodland creatures. The image is dense with esoteric allegory and symbolism. Finely rendered, the painting contains both a sense of lowbrow kitsch and high seriousness, the sentimentality of the style accentuating a deep sense of unease. As in archetypal fairy tales, childhood innocence is confronted with some darker reality. Ryden worked originally as a commercial artist, designing album covers for pop stars such as Michael Jackson. This early work informs his aesthetic and his identification with the 'Pop Surrealist' movement.

⸬ Currin, Murakami, Nara, Shaw

**Mark Ryden. b** Medford, OR, USA, 1963. **Tree of Life**. 2006. Oil on canvas with carved teak frame. **h**215.9 x **w**142.2 cm. **h**85 x **w**56 in

# Sailstorfer Michael

## Wolken, 2010

Three hundred truck tyre inner tubes inflated with air have been twisted together and suspended from the ceiling to form an ominous black cloud (wolken is German for clouds). A strong smell of rubber fills the air, accentuating the physicality of the work. The transformation of industrial objects designed for speed into an evocation of a meteorological phenomenon epitomizes the kind of visual poetry embraced by Sailstorfer, whose gallery installations and site-specific works often address the relationship between movement and stillness. Known for his use of non-traditional art materials, Sailstorfer re-contextualizes everyday objects, imbuing them with new meanings: a street light becomes a shooting star, an aeroplane is turned into a tree house and a cement mixer is used as a popcorn machine. Infused with whimsy, these playful manipulations transcend the visual, exploiting sound, smell and even vibration to create multi-sensorial works that both challenge and expand received definitions of sculpture.

⋯⋮⋅ Finch, Friedman, Hlobo, Neto

**Michael Sailstorfer. b** Velden, Germany, 1979. **Wolken**. 2010. Rubber inner tubes, air. Dimensions variable. Installation view, K20 – Kunstsammlung Nordrhein-Westfalen, Düsseldorf, Germany, 2010

# **Sala** Anri

### Dammi i Colori, 2003

Sala's film – the title of which translates as 'Give me the Colours'– captures the kaleidoscopic transformation of Albania's capital city, Tirana, during the winter of 2002. Scenes of dilapidated streets are contrasted with the patchwork of vivid colours being painted all over the city's dull, grey buildings from the communist era. The project was the brainchild of Edi Rama, a former artist and mayor of Tirana from 2000 to 2011 (who in 2013 became Albania's Prime Minister). Rama, who narrates Sala's film, explains that colouring the facades was intended as a symbol of hope and a sign of things to come for Albania,

which was still recovering after its arduous transition from communism to democracy. However, Sala's film is not a documentary about his hometown, nor its unorthodox mayor; rather it is a series of reflections about the transformative potential of colour and what the true nature of utopia might be.

⋯⋮⋅ Banksy, Cantor, Odita

Anri Sala. b Tirana, Albania, 1974. **Dammi i Colori**. 2003. Video, projection, colour and stereo sound. Dimensions variable. **dur** 16 min

# Salcedo Doris

## Istanbul Project, 2003

In a derelict gap between two buildings 1,550 wooden chairs have been haphazardly piled. There is a paradoxical tension between the disorder of the dense tangle and the way that it sits perfectly within the space, finishing flush with the face of the adjacent buildings. Similarly, the work has a spectacular, monumental, scale that sits alongside the haunting particularity of its components. The chair, a familiar domestic object, designed to be intimately shaped for the resting human body, here becomes a metaphor for bodily absence or loss. The installation, made for the 2003 Istanbul Biennial, evokes the mass graves and atrocities of the twentieth century. While Salcedo's work is rooted in her experience of political conflict in her native Colombia and often bears witness to specific acts of violence, it can be generalized to stand as a poetic memorial to all anonymous victims of war and forced migration. Although politically charged, its power lies in its visceral aesthetic and material qualities.

····⫶· Ataman, Boltanski, Serra

**Doris Salcedo. b** Bogotá, Columbia, 1958. **Istanbul Project**. 2003. 1,550 wooden chairs. Installation view, *8th International Istanbul Biennial*, Turkey, 2003

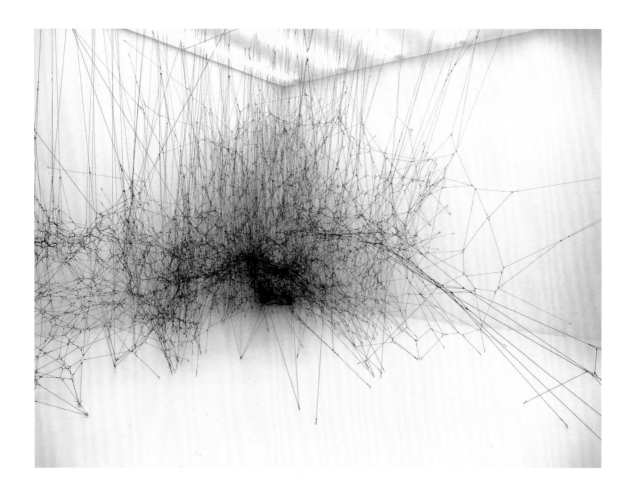

# Saraceno Tomás

## 14 Billions (Working Title), 2010

A giant spiderweb fills the gallery space. Created using black rope, this web is designed to entrap humans rather than insects but is based on the design of a real spider, the *Latrodectus mactans*, otherwise known as the Black Widow. Saraceno constructed *14 Billions* in consultation with a series of experts, including architects, arachnologists and astrophysicists. It is inspired by the use of spiderwebs in scientific study to map the structure and origin of the universe. Although Saraceno's work is based on scientific rigour his installations are also immersive and often invite participation from visitors; in other artworks he has investigated the possibility of human beings living in flying cities. *14 Billions* was two years in the making, and spans 400 cubic metres. It features over 8,000 black strings and over 23,000 individually tied knots, but despite its epic dimensions has been exhibited in galleries around the world.

····⫶ Hlobo, Lambie, Parker, Sze

**Tomás Saraceno. b** San Miguel de Tucumán, Argentina, 1973. **14 Billions (Working Title)**. 2010. Rope, elastic chords and hooks. Installation view, Bonniers Kunsthall, Stockholm, Sweden, 2010

# Šarčević Bojan

## She, 2010

This large work is formed out of a block of onyx. One face has been left in its rough, natural state, while the other has been carved with rigidly rectangular recesses and is highly polished. The austere nature of the geometry is undermined by the extravagant grain and colour variation in the stone. A sculptural tension arises out of the interplay between shape, texture and colour. A monolithic sense of weight and permanence is undermined by the removal of geometrical volume and substance. Its rational form and rectangular recesses suggest a semi-functional object, a hybrid of architecture and pure sculpture. As well

as monumental sculptures, Šarčević's practice includes architectural interventions, videos and collages. He often draws on the formal vocabularies of early Modernism, conjuring up an additional tension in his work: between the idea of the artwork as an autonomous object of contemplation and art as an engine of social change.

⋯⋰ Cragg, Horn, Sarah Lucas

**Bojan Šarčević. b** Belgrade, Serbia, 1974. **She**. 2010. Onyx. **h**184 x **w**124 x **d**40 cm. **h**72 1/2 x **w**48 7/8 x **d**15 3/4 in

# **Sasnal** Wilhelm

### Shoah (Forest), 2003

A dense forest, rendered as a swirling mass of green brushstrokes, towers over a small group of people. Against this dominating backdrop the figures seem weak and vulnerable. The image derives from a scene in *Shoah* (1985), Claude Lanzmann's epic documentary about the Holocaust, where the forest is in fact the site of a mass grave. While Sasnal's early work addressed representations of youth culture, the wartime history of his native Poland has since become a major theme. For Sasnal, whose great-grandmother was killed in Auschwitz, the events of the Second World War are not confined to documentaries or history books, but have a personal resonance. Source materials for his enigmatic paintings are gathered from newspapers, magazines, books and films. Working quickly, he distils images to their essentials elements, often completing works in a single day. While painting remains central to Sasnal's practice, he also produces drawings, photographs and films.

····⫶· Boltanski, Kiefer, Sosnowska

**Wilhelm Sasnal. b** Tarnów, Poland, 1972. **Shoah (Forest)**. 2003. Oil on canvas. **h**45 x **w**45 cm. **h**17 3/4 x **w**17 3/4 in

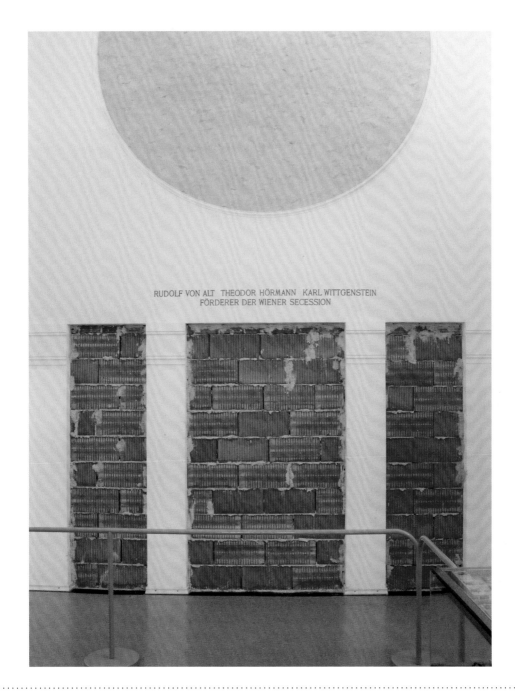

RUDOLF VON ALT  THEODOR HÖRMANN  KARL WITTGENSTEIN
FÖRDERER DER WIENER SECESSION

# Schabus Hans

## Astronaut (komme gleich), 2003

Finding the entrance to the Vienna Secession bricked up, museum visitors were forced to enter the main exhibition hall via the building's basement. After following a narrow, winding passageway, they were greeted with a life-sized replica of the artist's studio, constructed from cardboard and wood. The journey leading to Schabus's installation was as much a part of the work as his stage-set-like construction and was echoed by two accompanying videos, *Western* (2002) and *Astronaut* (2003). *Western* shows the artist sailing a boat through the Viennese sewer system, while in *Astronaut* he digs a tunnel in his studio, creating a large pile of earth on the floor. Standing as a metaphor for artistic labour, subterranean burrowing and pointless journeying are common motifs in the Austrian artist's work. Schabus's pieces – which include site-specific interventions, sculptures and performances – interact with their surroundings in surprising and innovative ways.

 Kounellis, Nelson, Schneider

**Hans Schabus. b** Watschig, Austria, 1970. **Astronaut (komme gleich)**. 2003. Bricks, mortar, wood, cast, paint. Two door-openings: **h**270 x **w**75 x **d**40. **h**106 1/4 x **w**29 1/2 x **d**15 1/4 in; one: **h**270 x **w**150 x **d**40 cm. **h**106 1/4 x **w**59 x **d**15 1/4 in. Installation view, Vienna Secession, Austria, 2003

# **Scheibitz** Thomas

## Il Maschine, 2010

While not exactly representational, this painting is strongly suggestive of an architectural arrangement of space. An opening in a vibrant orange wall leads out onto what might be read as a landscape. The opening is surrounded by stripes of artificial colour. Black horizontal and vertical lines form a strong, structural T-shape at the centre of the composition. A grey border defines two edges of the canvas, while the open sides allow the brilliance of the colour to resonate beyond its limits. Scheibitz's paintings and sculptures explore the boundaries between abstraction and figuration. He has evolved a pictorial language that takes inspiration from pop culture, film and advertising, as well as architecture and art history. His rich use of colour and carefully constructed formal arrangements of simple geometric shapes work as abstracts while never quite transcending their source.

 de Balincourt, Johanson, Shahbazi

**Thomas Scheibitz. b** Radeberg, Germany, 1968. **Il Maschine**. 2010. Oil, vinyl, pigment marker, lacquer on canvas. **h**250 x **w**170 cm. **h**98 1/8 x **w**66 7/8 in

# **Schneider** Gregor

## Totes Haus u r, 2001

An epic installation consisting of a series of rooms that visitors are invited to explore at will, *Totes Haus u r* – which translates as 'Dead House u r' – was first created for the German Pavilion at the 2001 Venice Biennale. The work is a continuation of *Haus u r*, Schneider's elaborate remodelling of his childhood home on Unterheydener Straße in Rheydt, a district of Mönchengladbach, which he began in 1985. Schneider has built new rooms within the original rooms of the house, some of which move, very slowly, or are accessible only by crawling. He shipped twenty-four rooms from the house to Venice to create the disorientating new installation, which featured dead ends and blocked-off spaces, producing a claustrophobic assault on the senses. Schneider has subsequently transported the installation to galleries around the world. The psychological discomfort induced by the piece is a recurring feature of all the artist's work.

 Büchel, Motti, Schabus, Suh

**Gregor Schneider. b** Rheydt, Germany, 1969. **Totes Haus u r**. 2001. Twenty-four rooms developed and reproduced from Haus u r (1985–present). **h**8.5 x **w**18.5 x **l**22m. h27 ft 10 5/8 in x **w**60 ft 8 3/8 in x l72 ft 2 1/8 in. Installation view, *49th Venice Biennale*, 2001

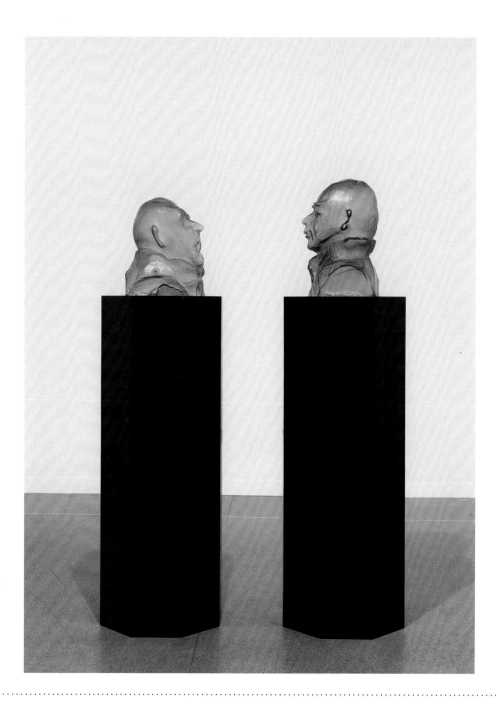

# Schütte Thomas

## Berengo Heads, 2011

Ranging across a variety of art forms – that has encompassed, minimalism, architectural maquettes, and even life-sized birdhouses – Schütte's subject is the human body. His drawings and paintings, sculptures and installations all relate, ultimately, to the frailty, absurdity and cruelty of contemporary society. Schütte is an artist of paradoxes and surprises. He belongs to a Conceptualist tradition (having studied under the intellectual heavyweights Gerhard Richter and Benjamin Buchloh) but he is alive to materiality and form. His *Berengo Heads* continue in the vein of the caricatured faces that he made from

modelling clay in his small sculptures *United Enemies* (1993–7). In that early series, furiously indignant characters were bound together with cloth and rope; by contrast, the *Berengo Heads* reside serenely, cast in limpid coloured glass. Other sculptures, such as his blobby chrome giants *Große Geister* (Big Spirits, 1995–2004), are just as funny, just as disconcerting, and just as humane.

⋯⋮⋯ Fischer, Horn, Rondinone

**Thomas Schütte. b** Oldenburg, Germany, 1954. **Berengo Heads.** 2011. Murano glass. **h**48.5 x **w**34 x **d**34 cm and **h**41.5 x **w**37 x **d**32 cm. **h**19 x **w**13 3/8 x **d**13 3/8 in and **h**16 3/8 x **w**14 1/2 x **d**12 5/8 in

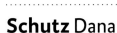

# Schutz Dana

### Frank as a Proboscis Monkey, 2002

In this painting a sullen, long-haired man emerges from a leafy jungle. His name is Frank and, according to Schutz, is the last man on earth. In reality, Frank does not exist but is a figment of the New York-based artist's furtive imagination. The work belongs to a series titled 'Frank From Observation', in which Schutz imagined herself as the last living painter and Frank as the last subject. The power dynamics between artist and subject are played out time and time again as the forlorn figure is depicted in different poses and settings. Whether on a beach, in a desert or, as here, in a jungle, the hapless Frank is subject to the artist's every whim. Characterized by vivacious brushwork, Schutz's figurative paintings brim with expressionistic energy. Combining fantasy, humour and the grotesque with a vibrant palette, they offer an offbeat commentary on the absurdities of contemporary life.

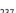 Baldessari, Dalwood, Nara

**Dana Schutz. b** Livonia, MI, USA, 1976. **Frank as a Proboscis Monkey**. 2002. Oil on canvas. **h**91.4 x **w**81.3 cm. **h**36 x **w**32 in

# Sehgal Tino

## This Objective of that Object, 2004

Sehgal allows no photography of any of his artworks. Instead, they are recorded only in the recollections of those who have experienced them. *This Objective of that Object*, like Sehgal's other work, is what he calls a 'constructed situation', in which interpreters (he rejects the term 'performers') enact a sequence of actions dictated in advance. A visitor enters the gallery and is immediately surrounded by five people. After repeating, in unison, 'The objective of the work is to become the object of discussion', the interpreters wait for the visitor to respond. If nothing is said, they slowly fall to the ground, but if the visitor speaks or moves, then that prompts an improvised discussion. Sehgal, who lives in Berlin, does not see his art as performance but as influenced by his training in dance, as well as early studies in political economics. He aims to create experiences that are valued as highly as objects.

⋯⫶ Abramović, Motti, Tiravanija

Tino Sehgal. b London, UK, 1976. **This Objective of that Object**. 2004

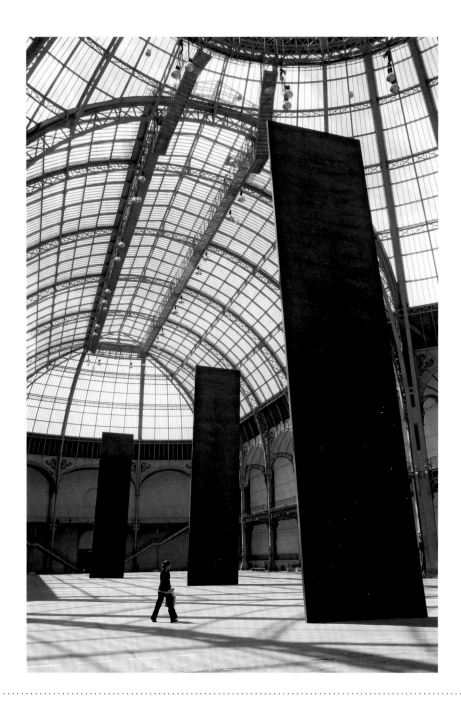

# Serra Richard

## Promenade, 2008

In Paris's Grand Palais, the largest uninterrupted glass and iron building in the world, Serra placed five vertical sheets of rolled Cor-Ten steel on end in a single line. The work, titled *Promenade*, was commissioned for the building's 'Monumenta' series of temporary sculptures. It commanded the whole of the space, the towering sheets – each one 17 metres (55 feet 9 1/4 inches) tall – casting dynamic shadows due to the fact that they were installed at subtly different angles and inclinations. In common with many of Serra's steel installations made since the 1970s, *Promenade* gave the impression that the heavy sheets might topple over at any moment. Building on the power of early sculptures such as *Prop* (1968), made from precariously balanced rolled lead, Serra disguises any necessary welds or structural supports in his work. Often, as with the curling walls of *Snake (Sugea)* (1994–7), he allows huge sheets of steel to stand unassisted.

⋯⫶ Boltanski, Gormley, Gowda, Kapoor

**Richard Serra. b** San Francisco, CA, USA, 1939. **Promenade**. 2008. Cor-Ten steel. Each sheet: **h**17 x **w**4 m. **h**55 ft 9 1/4 in x 13 ft 1 1/2 in. Installation view, Grand Palais, Paris, 2008

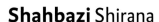

# **Shahbazi** Shirana

## Komposition-13-2011, 2011

A series of geometrically arranged planes float over and around each other, creating a dynamic confusion between depth and flatness. Shahbazi makes subtle use of colour, adding to the sense of spatial depth while making an abstract image in which all the planes resonate with each other. Surprisingly, this is a photographic image, constructed in the studio by overlaying exposures of painted and angled surfaces. Shahbazi works across a variety of photographic genres that include landscape, portrait and still life, as well as making abstract images. She has commissioned paintings of her photographs or had them translated into repeated patterns for carpets. Often showing the range of her work in unexpected combinations, she reveals the structural similarities between the observed world and imaginatively constructed space. Her concern is for the possibilities of photography beyond documenting reality, and in drawing attention to the artificial nature of all images, whether abstract or representational.

 Abts, Kelly, Marden, Odita

**Shirana Shahbazi. b** Tehran, Iran, 1974. **Komposition-13-2011**. 2011. C-print on aluminium. **h**150 x **w**120 cm. **h**59 x **w**47 1/4 in

# **Shaw** Raqib

## The Blossom Gatherer 1, 2009–11

The first impression created by *The Blossom Gatherer 1* is of opulence. An octagonal wooden panel is covered with extravagant detail, painted with luminous coloured enamel, encrusted with brilliantly coloured rhinestones and glitter. With a cast of animals and birds, and a humanoid figure swinging among vibrant flora, Shaw presents a sophisticated vision of paradise that is at the same time exquisitely beautiful, darkly hedonistic and potentially violent. Shaw left his native India in 1998 to study at art in London, where he continues to live. Firmly committed to painting, he experimented with materials before

developing his signature technique of manipulating pools of industrial paint with a porcupine quill. His fantastical paintings draw on both Eastern and Western myths and folklore. He has developed a distinctive visual language that evokes European traditions such as Old Master painters Hans Holbein and Hieronymus Bosch as well as Oriental textiles and Persian miniature painting.

⋯⋰ Ofili, Rojas, Ryden

**Raqib Shaw. b** Calcutta, India, 1974. **The Blossom Gatherer 1**. 2009–11. Oil, acrylic, glitter, enamel and rhinestones on birch wood. **h**243.8 x **w**243.8 cm. **h**96 x **w**96 in

# **Sherman** Cindy

## Untitled No. 466, 2008

As with nearly all the photographs that Sherman has made since she came to prominence in the mid-1970s, *Untitled No. 466* shows the artist, dressed as a fictional character. In this instance she appears as a wealthy and elegantly dressed middle-aged lady, posing confidently in the loggia of her Mediterranean villa. On closer inspection, the large-scale photograph begins to fall apart. Her face is caked in make-up, and her cheap shoes, thick stockings and costume jewellery indicate that the entire image is a fabrication. This impression is reinforced by the subtle mismatch between figure and background: Sherman photographed herself against a green screen and then superimposed it on another image. Whether in her *Untitled Film Stills* (1977–80) or her *History Portraits* (1988–90), Sherman exposes the entrenched stereotypes that continue to influence the way people – especially women – are represented, and choose to represent themselves.

⋯⋮ Barney, Ben-Tor, Opie

**Cindy Sherman. b** Glen Ridge, NJ, USA, 1954. **Untitled No. 466**. 2008. C-print. **h**246.1 x **w**162.6 cm. **h**96.7/8 x **w**64 in. MoMA, New York

# **Shonibare** Yinka

### Last Supper (after Leonardo), 2013

The British-Nigerian artist Shonibare has been poking fun at misguided notions of Britishness since his early installations such as *Gainsborough's Mr and Mrs Andrews Without Their Heads* (1998). In that work, Shonibare paid homage to Thomas Gainsborough's famous portrait, replacing the couple with headless mannequins and tailoring new outfits from colourful 'African-style' batik fabric purchased at London's Brixton market. (The artist is interested in the fact that the fabric is actually based on Indonesian designs and made in the Netherlands.) Shonibare's playful critique of post-colonial hybridity has continued through photographic tableaux, in which he himself poses as iconic literary and historic figures. *Last Supper (after Leonardo)* is one of his most ambitious installations to date, based on Leonardo da Vinci's fresco but with a goat-hoofed Bacchus – the Roman god of wine – in place of Christ. Around him, mannequins dressed in Shonibare's signature Afro-Victorian outfits indulge in gluttony and fornication.

····⦂· Chopra, Marshall, Kara Walker

**Yinka Shonibare. b** London, 1962. **Last Supper (after Leonardo)** (detail). 2013. Thirteen life-size mannequins, Dutch wax printed cotton, reproduction wood table and chairs, silver cutlery and vases, antique and reproduction glassware and tableware, fibreglass and resin food. **h**158 x **w**742 x**d**260cm. **h**62 1/4 x **w**292 1/8 x **d**102 1/2 in

I HATE BALLOONS

# Shrigley David

## Untitled, 2011

A crudely drawn male figure is preparing to fire an arrow into the air. The drawing is captioned with the words 'I hate balloons'. The caption combined with the image implies the presence of balloons beyond the frame. Shrigley's work is characterized by a mordant and absurdist sense of humour. The lack of sophistication in his graphic style, given further emphasis by the use of a ruler to underline the text, might be associated with amateur or Outsider Art, but Shrigley underwent a conventional art-school education and, rather, it reflects a self-conscious rejection of craft and a desire to create a sense of spontaneity. Best known for his drawings, Shrigley also produces photography, sculpture, animation and text. Despite their crude realization and their humorous intent, his work offers insightful and poetic commentary on the absurdities of the human condition.

⋯⋗ Banksy, Cattelan, Eloyan, Zhao

**David Shrigley. b** Macclesfield, UK, 1968. **Untitled**. 2011. Ink on paper. **h**29.7 x **w**21 cm. **h**11 3/4 x **w**8 1/4 in

# Sierra Santiago

## 10 Inch Line Shaved on the Heads of Two Junkies Who Received a Shot of Heroin As Payment, 2000

This work forms part of a highly provocative series by Sierra that explores the economic and social structures within capitalist societies. The artist paid two heroin addicts from a disadvantaged neighbourhood in Puerto Rico to take part in an artwork by each having a section of their head shaved, while the event was filmed and photographed. For other works, Sierra has hired a homeless man to clean shoes at an art opening, paid a group of people to have a line tattooed across their backs, and hired Iraqi immigrants to be sprayed with polyurethane foam to create a sculpture. Deliberately controversial, Sierra's art examines the impact of capitalism on those on the margins of society, such as immigrants, drug addicts and manual labourers. Usually invisible to those in power, they are brought into the spotlight in his work in challenging style, presented as objects to entertain – and outrage – art audiences.

·····⫶· Alÿs, Tiravanija, Zhang

Santiago Sierra. b Madrid, Spain, 1966. **10 Inch Line Shaved on the Heads of Two Junkies Who Received a Shot of Heroin As Payment**. 2000. DVD projection. **dur** 5 min

# Sietsema Paul

### Untitled figure ground study (Degas/Obama), 2011

Sietsema has painstakingly reproduced by hand two newspaper articles and carefully over-painted them with a perfect *trompe-l'oeil* image of a paint-covered notebook and paint stirrer. It is as if he has spread out some newspaper on a table in order to do some painting. Visually, there is a rich interplay between the flatness of the background and the *trompe-l'oeil* image with its illusion of three-dimensionality. But Sietsema is not interested in the craftsmanship of making such a facsimile *per se*. Rather, he uses exacting and complex making processes to explore what it is to make an artistic image today, when the digital production and reproduction of images are so readily available and when we are overloaded with visual information. He is also interested in specific bodies of knowledge, such as history, and how our understanding of the world is mediated by the way that images are made and presented.

⋯⋅⊹ Brown, Demand, McKenzie

**Paul Sietsema. b** Los Angeles, CA, USA, 1968. **Untitled figure ground study (Degas/Obama)**. 2011. Ink and enamel on paper. **h**139 x **w**168 cm. **h**54 3/4 x **w**66 in

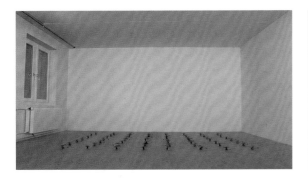
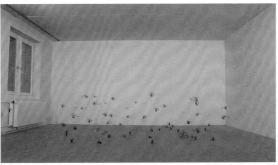
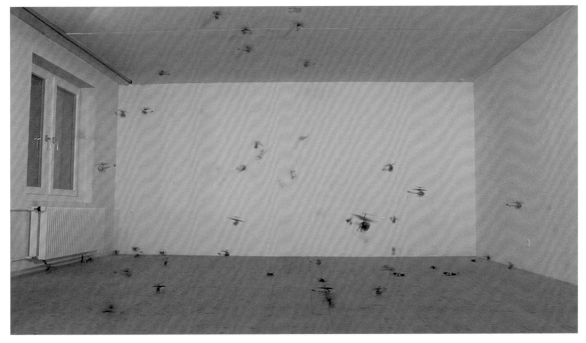

# **Signer** Roman

### 56 kleine Helikopter, 2008

Fifty-six remote-controlled helicopters sit, arranged in rows, on the floor of an empty room. In an instant they simultaneously rise into the air and begin to career around the space like madly swarming insects. One by one they crash into the ceiling, the walls or each other, and by the end of the short video all fifty-six helicopters lie expired on the floor. Since the 1970s Signer has made hundreds of such touching, funny and profound works. He terms them 'actions', and records many as videos, some as photographs, and others via sculptural remnants or live events. Many of his 'actions' take place in the Swiss countryside, where the grandeur of the landscape provides an added pathos to his modest experiments; in *Hat with Rocket* (1983), for instance, a firework was connected by string to Signer's woolly hat. When the rocket fired it whisked the hat from his head.

⋯⋮⋅ Bonvicini, Cai, Durham

**Roman Signer. b** Appenzell, Switzerland, 1938. **56 kleine Helicopter**. 2008. Video; colour, sound. Camera and editing: Aleksandra Signer. **dur** 3 min 10 sec

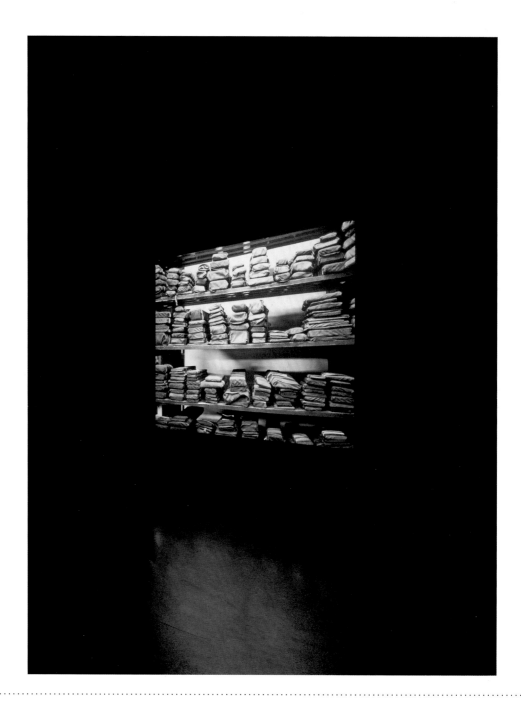

# **Singh** Dayanita

### Sea of Files, 2013

A black and white photograph shows a rack of shelves on which are piled stacks of files, tied up in parcels. The dim lighting suggests a basement storeroom, an atmosphere of dust and neglect. This is one of a series of images, projected as a visual essay. They come from Singh's own archive of images, collected over decades, of India's public offices before digitalization made such records redundant. She shows a world of dereliction – shelves sagging under the weight of decaying paper, claustrophobic spaces overcrowded by walls of forgotten and abandoned documents. Singh has experimented with different ways of presenting her work as visual poetry, in the form of projections, books or in portable 'museums', wooden structures that allow multiple images to be displayed in various configurations in order to create different narratives. She wants her photographs to be seen as interconnected bodies of work, rather than single images.

⋯⋮⋯ Chopra, Henrot, Quaytman

**Dayanita Singh. b** New Delhi, India, 1961. **Sea of Files**. 2013. Digital slide projection. Fifty-eight images. Dimensions variable

# Slominski Andreas

## Monkey Trap, 2004

Slominski's ongoing series of traps are set not for animals and birds – although, if triggered, they would reportedly function efficiently – but for the eyes and minds of humans. While sculptures such as *Monkey Trap* are metaphors for the way an artist ensnares a viewer's intellectual curiosity, they are also traps in the sense that they lure viewers into constructing interpretations, then snap shut – claiming only to be traps after all. *Monkey Trap* purportedly relies on the monkey's greed, which keeps him grasping a banana even though it is too large to extract from the cage. Can this be a genuine method for catching monkeys or is

it a shaggy dog story – another kind of trap for the gullible? In works such as *Imprint of the Nose Cone of a Glider* (2005), nothing more than a dented panel of foam, viewers once again have only Slominski's mischievous word to rely on.

⋯⋮⋅ Cattelan, Delvoye, Dion

**Andreas Slominski. b** Meppen, Germany, 1959. **Monkey Trap**. 2004. Wood, metal, paint, plastic and banana. **h**18.4 x **w**31.8 x **d**27.3 cm. **h**7 1/4 x **w**12 1/2 x **d**10 3/4 in

# **Song** Dong

## Waste Not, 2005

Thousands of everyday objects are displayed in the gallery space, ordered neatly in piles according to likeness. The items belonged to the artist's mother, Zhao Xiangyuan, who collected them over five decades. If our possessions tell the stories of our lives, this installation speaks of both thrift and obsession. Old pieces of soap are displayed alongside countless plastic bags, neatly folded, as well as more personal items such as shoes, toys and linen. Song began the work after the sudden death of his father in 2002, to try and cope with the family's grief and the installation features a neon sign displaying the message

'Dad, don't worry, Mum and all the family are well.' As well as exploring his relationship with his family, Song's art examines life in modern China: the installation reflects the changes the family experienced during his mother's lifetime, which included periods of extreme poverty. The work became a poignant memorial when the artist's mother died in 2008.

 Dion, Rhoades, Vo

**Song Dong. b** Beijing, China, 1966. **Waste Not**. 2005. Installation and event. Dimensions variable. Installation view, MoMA, New York, 2009

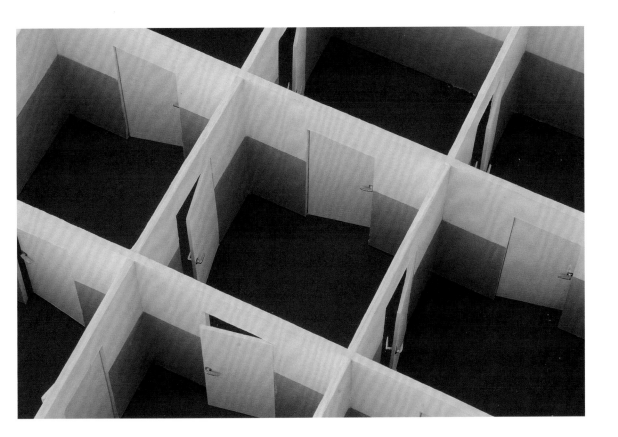

# Sosnowska Monika

### Untitled, 2002

Sosnowska's installations and sculptures reproduce the emotional and psychological effects of architecture, particularly the type of institutional buildings that the artist experienced growing up in 1970s and 80s communist Poland. *Untitled* was a succession of identical, life-sized (though each only around four square metres) rooms, installed as a site-specific, temporary installation. In every adjoining wall was an identical door, each of which led to an identical room with further identical doors. Viewers moving from one room to the next quickly became disoriented, even though there were only nine rooms in total. While the specific purpose of such claustrophobia-inducing architecture was never revealed, the dull green paint applied to the lower halves of the walls is common to hospitals and bureaucratic institutions the world over. In this work and in later, labyrinthine installations such as *Loop* (2007), Sosnowska recreates the kind of uncanny but banal in-between places that Franz Kafka famously evoked in his novels.

·····∴·

**Monika Sosnowska**. **b** Ryki, Poland, 1972. **Untitled**. 2002. Mixed media. Model for installation at *Manifesta 4*, Frankfurt am Main, Germany, 2002

# **Stark** Frances

## My Best Thing, 2011

In the 1990s, Stark became known for her confessional text-based collages, often typed by hand and combining scraps of material from all areas of her life. Writer's block and creative anxiety were the themes to which Stark returned. When she began, in 2010, to consort with men in online sex chat rooms, she soon realized that her communications with them were a valid form of writing, not just procrastination from work. *My Best Thing* documents, in eleven short episodes, Stark's often hilarious interactions with two men who appear as animated figures made with the free software Xtranormal. The work interweaves

Stark's usual preoccupations with conversations about literature, film, music, politics and, inevitably, sex. The project led to multimedia live performances, such as *Put a Song in Your Thing* (2011) in which Stark appeared on stage beside projected Xtranormal animations, as well as additional text-based video works such as *Nothing is Enough* (2012).

⋯⋯⋮ Bonvicini, Calle, Feng, Sun

**Frances Stark**. **b** Newport Beach, CA, USA, 1967. **My Best Thing**. 2011. Digital video. **dur** 99 min

# **Starling** Simon

## Autoxylopyrocycloboros, 2006

A set of thirty-eight slides are all that remain of this artwork, which began as a performance on 25 October 2006 when Starling took a small wooden steam-powered boat out onto Loch Long in Scotland. The boat, Dignity, had been salvaged from the bottom of Lake Windermere in Cumbria and restored to working order. In *Autoxylopyrocycloboros* it becomes fuel for an absurdist journey, with Starling slowly dismantling the wooden hull while motoring across the Loch and feeding it into the steam engine, until the boat inevitably sinks. The slides document this auto-destruction scene by scene. There is a

political angle to this work, Loch Long being home to both the Trident submarine base and the peace camp opposing it. At the same time the work is about process, a theme Starling regularly returns to. His art often involves dismantling and remaking objects into eccentric forms as he traces the narratives contained within them.

⋯⋰ Cidade, Durham, Slominski

**Simon Starling. b** Epsom, UK, 1967. **Autoxylopyrocycloboros**. 2006. Thirty-eight colour transparencies (**h**6 x **w**7 cm. **h**2 3/8 x **w**2 3/4 in), Götschmann slide projector, flight case. Dimensions variable

# **Stingel** Rudolf

### Untitled, 2003

For the 2013 Venice Biennale, Stingel was given the opportunity to exhibit his art throughout the 5,000 m² space of the Palazzo Grassi. He transformed the gallery's interior by covering the walls and floor with a synthetic carpet, featuring a digitally enlarged version of an Oriental pattern. This was a reference to Venice's past as a gateway to the Middle East but also to Sigmund Freud's study in Vienna, which was covered with similar rugs laid across both the floor and furniture. Over thirty paintings were exhibited on the carpeted walls, a mix of abstract works, such as the painting shown here, and photorealist paintings,

including a portrait of Stingel's recently deceased friend, the Austrian artist Franz West. Previous installations by Stingel have also used carpet, plus other materials, to resurface the interiors of exhibition spaces. The technique raises questions about the relationship between painting and architecture, as well as of how we view art.

····⫶ Ai Weiwei, Anatsui, Shonibare

**Rudolf Stingel. b** Merano, Italy, 1956. **Untitled**. 2003. Oil and enamel on canvas. Installation view, Palazzo Grassi, Venice, 2013

# Struth Thomas

## Pergamon Museum 1, Berlin, 2001

The Pergamon Altar was excavated and removed from Turkey in the late nineteenth century by the German archaeologist Carl Humann; today it is the centrepiece of the Pergamon Museum in Berlin. In Struth's photograph the altar is not in fact the subject of the image so much as the background against which museum visitors are caught in states of reflection, distraction or conversation. Struth's series of large-scale and sharply detailed photographs of museum interiors, begun in 1989, shares with his portraits, landscapes and cityscapes a deceptive sense of detached objectivity. The German artist's pictures are in fact packed with provocative information about the way society views its culture and environment. In *Pergamon Museum No. 1, Berlin*, for instance, Struth reveals how the altar continues to be a place of contemporary pilgrimage. Visitors relax on the altar's steps as if oblivious to the ancient edifice's incongruous new home inside a modern museum.

⋯⋮⋯ Fischer, Lawler, Nashat

**Thomas Struth. b** Geldern, Germany, 1954. **Pergamon Museum 1, Berlin**. 2001. C-print mounted on Plexiglas. **h**197.4 x **w**248.5 cm. **h**77 3/4 x **w**97 7/8 in

# **Sugimoto** Hiroshi

### Lightning Fields 128, 2008

A bolt of electricity pierces a pitch black background. For this image, one of a series, Sugimoto was inspired by Benjamin Franklin's and Michael Faraday's early experiments with electricity, as well as the work of the photographic pioneer William Henry Fox Talbot. Sugimoto used a Van de Graaff 400,000 volt generator, applying the electrical charge directly onto photographic dry plates, so that the artworks were created without the use of a camera. The finished photographs resemble lightning bolts, and reveal the branch-like forms of the electrical charge in high detail. Sugimoto is also renowned for his *Seascapes* series, taken all over the world, as well as his photographs of buildings and interiors, which are shot out of focus using a theoretical technique he calls 'Twice as Infinity', giving the images an eerie, surreal finish. What unites much of the artist's work is an interest in capturing on film the passing of time.

·····⫶ Assaël, Mirza, Tillmans

**Hiroshi Sugimoto. b** Tokyo, Japan, 1948. **Lightning Fields 128**. 2008. Gelatin silver print. **h** 58.4 x **w** 47 cm. **h** 23 x **w** 18 1/2 in

# Suh Do Ho

### 348 West 22nd Street, New York, NY 10011, USA-Apt. A, Corridors and Staircases (Kanazawa version), 2011–12

This towering installation comprises a life-sized replica of Suh's Manhattan apartment made with translucent nylon fabric. The diaphanous structure, formed from blue, green, red and pink material, not only recreates the artist's living space but also its surrounding corridors and staircases. Radiators, cupboards, a toilet and a sink with exposed plumbing have, along with many other domestic fixtures and fittings, all been meticulously sewn with exacting precision. In contrast to its subject the work appears light and flimsy, reflecting something of Suh's psychological relationship with the space, which is just one of many temporary bases occupied by the nomadic Korean artist. Living between Seoul, Paris, London, and New York, Suh has sought to deal with cultural and geographical displacement throughout his work since emerging in the late 1990s. The notion of home, the dynamics of public and private space, and the psychological effects of architecture have thus become integral themes.

⋯⋮ Halilaj, Schneider, Whiteread

**Do Ho Suh. b** Seoul, South Korea, 1962. **348 West 22nd Street, New York, NY 10011, USA-Apt. A, Corridors and Staircases (Kanazawa version)**. 2011–12. Polyester fabric, stainless steel. Apt. A: **h**690 x **w**430 x **d**245 cm. **h**271 5/8 x **w**169 1/4 x **d**96 1/2 in. Corridors and Staircases: **h**1328 x **w**179 x **d**1175 cm. **h**522 7/8 x **w**70 1/2 x **d**462 5/8 in

# **Sun** Xun

## Some Actions Which Haven't Been Defined Yet in the Revolution, 2011

After pulling an insect from between his teeth, the protagonist of this masterful animation proceeds to eat it alive. That is just one of the many unsettling scenes in this nightmarish journey through a familiar yet terrifying world where time collapses and reality starts to disintegrate. With its menacing animals, ominous nurses and attacking warplanes, the film portrays a paranoid vision of a world turned upside down by an unseen revolutionary force. Animated from thousands of individual woodblock prints, Sun employs a traditional Chinese technique that became an important medium for propaganda art during the Cultural Revolution of the 1960s and 70s. Taking over a year to complete, the work speaks to the revolutionary history of modern China and the threat of totalitarianism more generally. Sun, who has founded his own animation studio, is one of the few younger artists consciously producing politically engaged work in China.

⋯⋮ Kentridge, Tobias, Zeng

**Sun Xun. b** Fuxin, China, 1980. **Some Actions Which Haven't Been Defined Yet in the Revolution**. 2011. Video/single-channel animation. **dur** 12 min 22 sec

# Superflex

### Flooded McDonalds, 2008

In this film a full-scale recreation of the interior of a McDonald's burger bar slowly fills up with water until it becomes totally submerged. Furniture becomes adrift, while all the detritus of a fast-food restaurant floats about in the rising tide. As the water floods the space the electrics short-circuit and the lights go out. There is a chilling absence of human life in the scene. The work seems to be a powerful metaphor for both the ruthless power of corporations and the impotent vanity of those same corporations in the face of the implacable reality of climate change. Alongside the implied seriousness of intention, the film is lifted by an absurdist sense of humour. The Superflex collective blur the boundaries between art and social activism, often working outside conventional art contexts to collaborate with designers, engineers, businesses and marketers on projects that experiment with alternative economic and social models.

····┆· Chapman, Elmgreen & Dragset, Parreno

**Superflex.** Founded Copenhagen, Denmark, 1993. **Flooded McDonalds**. 2008. Film projection. **dur** 21 min

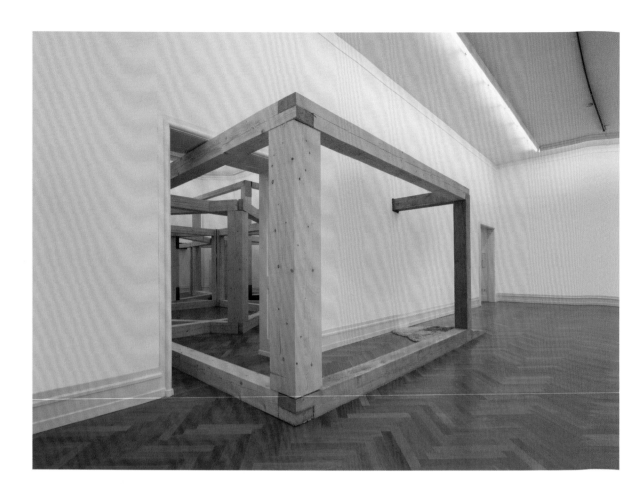

# **Tuazon** Oscar

### Untitled, 2010

In a white gallery space a large wooden construction spills out from one room into another, made up of repeated simple frames constructed from heavy, chain-sawn timber beams. The monumental scale, the simplicity of the structure and the crudity of the materials all give the work a strong physical presence that exists in tension with the purity of the space that it occupies. Despite the size of its components the work has a human scale and invites the viewer to enter and inhabit it. Tuazon's work clearly embodies traditional sculptural concerns of materiality, space, volume and mass, but it also reflects a long-standing interest in 'outlaw architecture', living off-grid and the associated impromptu, functional DIY constructions. His work also reflects the way that the built environment is inevitably redefined by human usage. After moving to Paris in 2007, Tuazon co-founded a gallery called castillo/corrales, a non-profit space for experimentation, discussion and learning.

⋯⋮⋯ Gowda, Halilaj, Jungen

**Oscar Tuazon. b** Seattle, WA, USA, 1975. **Untitled**. 2010. Pine, steel. Approx. **h**12 x **w**20 x **d**4.5 m. **h**39 ft 4 1/2 in x **w**65 ft 7 3/8 in x **d**14 ft 9 1/8 in. Installation view, 'Oscar Tuazon', Kunsthalle Bern, Switzerland, 2010

# Tuymans Luc

## The Valley, 2007

This portrait of an austere-looking boy is painted with an anaemic palette of yellow and green hues. If his impassive expression and piercing gaze have a sinister quality it is because the image is based on a still from the science-fiction horror film *Village of the Damned* (1960). It was selected by Tuymans because it evoked for him the strict moral and behavioural codes of the 1950s. The painting is part of a series addressing the influence of the Jesuit religious order on Western society. Such a tangled web of references epitomize Tuymans's approach. Rather than making his ideas explicit, he employs subtle allusions, inviting viewers to piece together disparate fragments in order to decode his work. Having contributed to the revival of figurative painting during the 1990s, Tuymans is one of the most influential painters working today. His distinctive, washed-out canvases, based on photographs and film stills, tackle themes of history, memory, religion and power.

⋯⋮⋯ Dumas, Peyton, Ruff

Luc Tuymans. b Mortsel, Belgium, 1958. **The Valley**. 2007. Oil on canvas. h106.5 x w109.5 cm. h41 7/8 x w43 1/8 in

# Uklański Piotr

## Untitled (Solidarność), 2007

Two large-scale images show an aerial view of a shipyard. In one we see the emblem of Solidarność (Solidarity), the Polish trade union that was formed in 1980 in the Gdańsk Shipyard, in defiance of the ruling Communist Party. In the second, the logo breaks up to become a loose crowd of individuals. Uklański celebrates Solidarność as representing, more than a trade union, a mass movement that was instrumental in driving political and social change in Poland. As well as the inherent symbolism, the work references the staging of photographs by the Soviet propaganda machine. Indeed his choice of subject has

frequently been polemical and provocative. Dividing his time between New York and Warsaw, Uklański came to prominence in the mid-1990s and works with a diverse range of media, including painting, sculpture, performance, photography and film. He released his first feature length film, *Summer Love: The First Polish Western*, in 2006.

····⫶· Deller, Gursky, Hayes

**Piotr Uklański. b** Warsaw, Poland, 1968. **Untitled (Solidarność)**. 2007. C-print in wood frame, diptych. Each panel: **h**300 x **w**472.4 cm. **h**118 x **w**186 in

# Vasconcelos Joana

## Lilicoptère, 2012

For this sculpture Vasconcelos adorned a Bell 47 helicopter with ostrich feathers and thousands of rhinestones. Its lavish interior is further bedecked with intricate woodwork, sumptuous gilding and embroidered upholstery. Inspired by the opulent surroundings of the Palace of Versailles, France, where it was first exhibited, Vasconcelos's work draws on the grand aesthetics of the Ancien Régime, speculating the type of motorized vehicle that Marie Antoinette might enjoy were she alive today. Such extravagant and witty projects are typical of the Lisbon-based artist, who de-contextualizes and subverts commonplace objects, investing them with new meanings. By delving into the past, Vasconcelos offers a critique of the present, exploring themes of gender, class and identity. Much of her work addresses feminist issues and often employs artisanal techniques and craft-related materials associated with female labour. Vasconcelos first attracted international attention at the 2005 Venice Biennale when she exhibited a giant chandelier made of tampons.

⋯∴ Bourgeois, Hlobo, Penone

**Joana Vasconcelos. b** Paris, France, 1971. **Lilicoptère**. 2012. Bell 47 helicopter, ostrich feathers, Swarovski crystals, gold leaf, industrial coating, dyed leather upholstery embossed with fine gold, Arraiolos rugs, walnut wood, wood grain painting, passementerie. **h**300 x **w**274 x **d**1265 cm. **h**118 1/8 x **w**107 7/8 x **d**498 in. Work produced in collaboration with Fundação Ricardo do Espírito Santo Silva, Lisbon, Portugal

# Villar Rojas Adrián

## Mi familia muerta, 2009

A gigantic sculpture of a whale lies stranded on the floor of a beech forest, among the fallen leaves, in the southern Argentinian city of Ushuaia. Although it seems entirely displaced, its surface is pockmarked with tree stumps as though it had lain there for decades. The whale presents a poetic image of grandeur and tragedy. Created for the *End of the World Biennial*, the wood and unfired clay sculpture will gradually break down and return to nature. *Mi familia muerta* (My dead family) dramatizes the uncertain future of the whale due to climate change, environmental degradation and predation by

man. Furthermore, it makes a wider commentary on a fragile and interdependent ecosystem, suggesting a parallel fate for human civilization – a point given elegiac expression in the work's title. Villar Rojas is best known for his large-scale site-specific and ephemeral sculptures made from materials such as unfired clay and mud, in which inevitable deterioration is a significant part of their meaning.

····⫶ Gelitin, Ondak, Orozco

**Adrián Villar Rojas. b** Rosario, Argentina, 1980. **Mi familia muerta**. 2009. Site-specific sculpture. Wood, rocks and clay (unfired). **h**300 x **w**2700 x **d**400 cm. **h**118 1/8 x **w**1063 x **d**157 1/2 in. Installation view, *End of The World Biennial 2nd Edition*, Ushuaia, Argentina, 2009

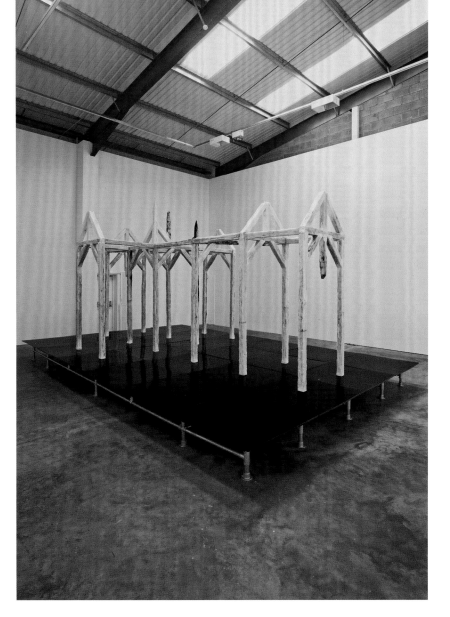

# **Violette** Banks

## Untitled (Church), 2005

The austere cruciform skeleton of a church stands atop a base of mirrored black panels, which gives it the appearance of floating. The structure at first appears to be made from charred and pitted wood, but is in fact constructed from salt, bonded with resin. Violette has made a 12-foot replica of a Norwegian church, referring to a series of sixty ritualistic arson attacks carried out by death metal fans that culminated in a fatal stabbing. The work includes a dark soundscape commissioned from Snorre Ruch, a musician implicated in the stabbing. The work immediately evokes a gothic, nihilistic romanticism that is consistent with Violette's source material. His work is heavily underscored by art history and theory, but he is personally steeped in the heavy metal subculture and is inspired by real-life events where over-identification with song lyrics have led to young men acting out fantasies of mayhem and violence.

⋯⋮⋯ Jankowski, Kelley, Trecartin

**Banks Violette. b** Ithaca, NY, USA, 1973. **Untitled (Church)**. 2005. Bonded salt, salt, polyurethane, polymer medium, ash, epoxy, wood, galvanized steel, steel hardware. **h**366 x **w**488 x **d**732 cm. **h**144 1/8 x **w**192 1/8 x **d**288 1/4 in

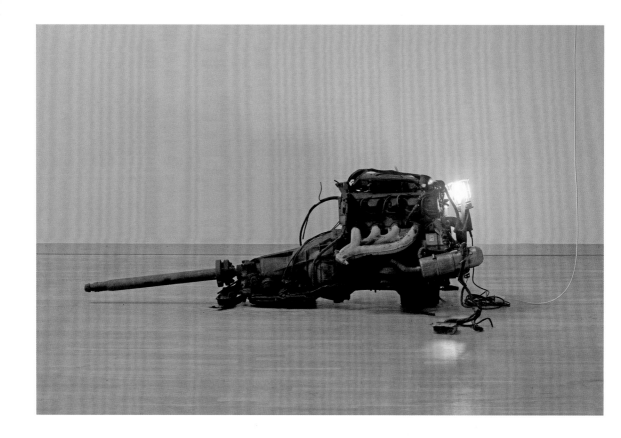

# **Vo** Danh

## Das Beste oder Nichts, 2010

Found objects and materials regularly appear in Vo's art, and are used by the artist as a means to express his life story. He was only four when he and his family left Vietnam by boat in an attempt to get to the USA. After becoming lost at sea they were rescued by a Danish commercial tanker and settled in Denmark instead. Vo's art investigates the impact the displacement from Vietnam had on their lives. In this piece he exhibits the engine of his father's Mercedes 190, which may look like an ordinary car engine, but is, for Vo, symbolic. The title, which translates as 'The Best or Nothing', is a Mercedes advertising tagline, but also represents his father's determination to succeed in the West. Vo has also exhibited other objects belonging to his family, particularly possessions of his father and grandmother, all of which are rich in personal history.

·····⫶ Cidade, Ortega, Song Dong

**Danh Vo. b** Ba Ria, Vietnam, 1975. **Das Beste oder Nichts**. 2010. The engine of the artist's father Phung Vo's Mercedes-Benz 190. **h**69 x **w**235 x **d**120 cm. **h**27 1/8 x **w**92 1/2 x **d**47 1/4 in. Installation view, Statens Museum for Kunst, Copenhagen, Denmark, 2010. Solomon R. Guggenheim Museum, New York

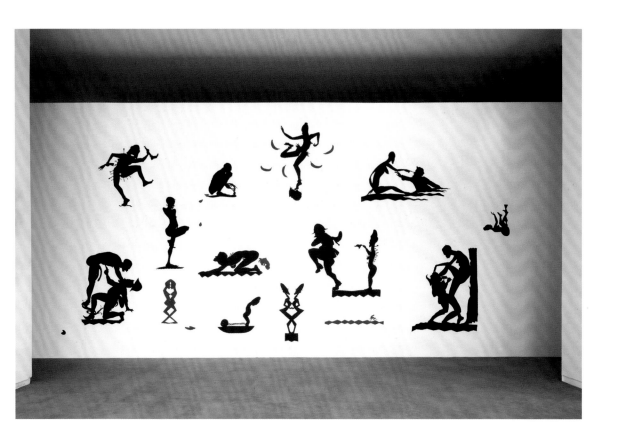

# Walker Kara

### Endless Conundrum, An African Anonymous Adventuress, 2001

A group of black silhouetted figures are shown leaping and cavorting, and engaging in lewd sexual acts. Walker has used black paper cut-outs, which are usually fixed directly onto the gallery walls, since the early 1990s. Silhouette art peaked in popularity in the seventeenth and eighteenth centuries, and Walker has reappropriated the style to create imagery that is often shocking and uncomfortable, addressing issues of race and gender, power and sexuality. This piece was originally commissioned by the Swiss museum Fondation Beyeler, and was created in response to its collection of African art. In it, Walker examines the influence of African tribal art on Modern artists, as well as looking at the wider appropriation of black creativity in Western art and culture. The piece includes Walker's recreations of works from the museum's collection, including Augustin Rodin's *Iris* (1895), while the title references the Constantin Brancusi sculpture *Endless Column* (1918).

⋯⋮ Gallagher, Marshall, Shonibare

**Kara Walker. b** Stockton, CA, USA, 1966. **Endless Conundrum, An African Anonymous Adventuress**. 2001. Cut paper on wall. Installation dimensions variable; approximately **h**485.1 x **w**1150.6 cm. **h**191 x **w**453 in. Installation view, 'Kara Walker: Mon Ennemi, Mon Frère, Mon Bourreau, Mon Amour', ARC/Musée d'Art Moderne de la Ville de Paris, France, 2007

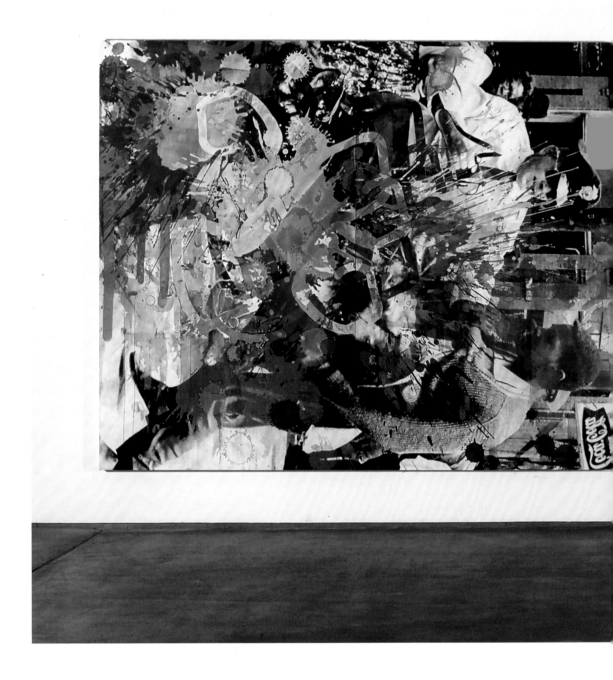

# Walker Kelley

## Black Star Press: Black Press, Black Star (rotated 90 degrees clockwise), 2006

A photograph is scanned and blown up to huge proportions before being digitally printed on canvas. With the image rotated 90 degrees, the artist then uses a silkscreen technique to place explosive splatters of milk, dark and white chocolate across the scene. The photograph that Walker uses is iconic and recognizable in the USA, taken during the 1963 Civil Rights demonstration in Birmingham, Alabama, and showing a protestor being attacked by a policeman and his dog. Walker is interested in the way we consume such images in popular culture, and regularly uses appropriated imagery in his work: as well as

political shots, he has also featured advertising images, and celebrity photographs of the notorious and infamous, such as Michael Jackson and Whitney Houston. This piece also references the silkscreen works of Robert Rauschenberg and Andy Warhol, in particular Warhol's series featuring images of the same race riots, emphasizing the continued relevance of this period in American history.

⋯⃯ Guyton, Marshall, Ofili

Kelley Walker. b Columbus, GA, USA, 1969. **Black Star Press: Black Press, Black Star (rotated 90 degrees clockwise)**, 2006. Digital print with silkscreened chocolate on canvas. Diptych, each: **h** 210.8 x **w** 264.32 cm. **h** 83 x **w** 104 in. Four panels total, each: **h** 210.8 x **w** 132.1 cm. **h** 83 x **w** 52 in

# Wall Jeff

## Siphoning fuel, 2008

On a piece of scrubby ground a middle-aged man in a Hawaiian shirt is kneeling as he siphons fuel from an old car, which is parked between two pickup trucks. All have seen better days. A bored-looking young girl squats nearby. We don't know what the relationship between the man and the girl is, but we sense that we are seeing a moment in an unfolding story. The scene has a cinematic quality and is rich with narrative possibility. The nonchalant, realism of the image suggests documentary photography, which belies the way that Wall carefully constructs his works, often restaging incidents that he has observed from everyday life. Wall works with a variety of photographic media, but he is best known for creating large-format transparencies mounted on wall-hung lightboxes. Originally trained as an art historian, Wall often creates meticulously staged scenes with allegorical or art-historical references.

⋯⋮ Abidi, Demand, Gursky, Sherman

**Jeff Wall. b** Vancouver, BC, Canada, 1946. **Siphoning fuel**. 2008. Colour photograph. **h**186 x **w**235 cm. **h**73 1/4 x **w**92 1/2 in

# Wallinger Mark

## State Britain, 2007

*State Britain* meticulously recreated campaigner Brian Haw's peace camp. Located opposite the Houses of Parliament in 2001, Haw's protest consisted of a 40-metre-long display of over 600 banners, photographs, peace flags and messages from supporters protesting against British military involvement in Iraq. The camp was drastically curtailed in 2006 following the passing of an Act of Parliament prohibiting unauthorized demonstrations within a 1-kilometre radius of Parliament Square. *State Britain*, installed in nearby Tate Britain, included a black line on the floor throughout the building, marking the exclusion zone, with Wallinger positioning the peace camp to bisect the line. The installation raised issues about freedom of expression, the right to protest and the erosion of civil liberties, not least through the work's title, in which the familiar and positive word 'Great' was replaced with the more menacing 'State'. Wallinger's art embraces a wide range of media, but is characterized by a commitment to accessibility and left-wing ideology.

····: Banksy, Cantor, Deller, Emin

**Mark Wallinger. b** Chigwell, UK, 1959. **State Britain**. 2007. Installation view, Duveen Galleries, Tate Britain, London, 2007. Tate, London

# **Warren** Rebecca

### Dark Passage, 2004

Working with raw clay since the mid-1990s, and more recently with painted bronze, Warren's art has included a substantial quotient of the female form, often perversely wrought with unexpected exaggerations and attenuations. In *Dark Passage*, the centre of gravity seems to want to shift around. There are extra feet of stone offset with a high kick, limbs either bulky or as token joiners between heavier elements of boots, buttocks and breasts. Its head is so diminished that it may only be another lock of hair, and any arms are entirely omitted. Often these fusions of magnified or missing parts relate to the sculptural

convolutions of past masters, notably Picasso, Degas and Rodin. Warren's lithe or overblown presences also borrow certain curves and attitudes from photographer Helmut Newton and cartoonist Robert Crumb, and movies and songs often figure in her titles. At the heart of this maelstrom of pop and high art renderings there is a pressured space where Warren's forms powerfully come into their own.

⸱⸱⸱⸳ Sarah Lucas, Rondinone, Wekua

**Rebecca Warren. b** London, UK, 1965. **Dark Passage**. 2004. Clay on MDF on wheels, **h** 195 x **w** 198 x **d** 45.5 cm. **h** 76 3/4 x **w** 78 x **d** 17 7/8 in

# Weber Klaus

## Veggieanatomy, 2011

Weber has constructed an anatomical model with cutaway sections revealing part of the skull and the interior of the torso. The internal organs are represented by vegetables: the brain is a cauliflower; the heart, a fennel bulb; the lungs, aubergines; and the intestines are potatoes. The work calls to mind the vegetable portraits by the sixteenth-century artist Giuseppe Arcimboldo. On one level Weber has made a visual pun illustrating the point that we are what we eat. He often uses humour in this way to convey a polemical message and sees a vital role for art in provoking thought and shifting consciousness.

Working across a wide range of media, he frequently uses complex technologies, elaborately organized production processes and quasi-scientific methodologies to explore power and social hierarchies, and to reflect on man's presumptive and precarious relationship to nature, which he regards as anarchic.

····⁑ Hirst, Koons, Mueck

Klaus Weber. b Sigmaringen, Germany, 1967. Veggieanatomy. 2011. Vegetables, Jesmonite, paint, wood. h182.9 x w25.4 x d38.7 cm. h72 x w10 x d15 1/4 in

# **Weischer** Matthias

### Fernsehturm, 2004

This large canvas shows an interior space, around which are arranged a collection of objects, including two paintings, a green flamingo and the trace of a chair. In the centre is a stack of screenless televisions from which the picture takes its title, *Fernsehturm* translating as 'television tower'. The naturalism of the scene is subverted everywhere: the view through the window bleeds beyond the window frame; despite the use of perspective and shadow the overall impression is of flatness; the disparate elements of the painting seem almost to be collaged together. The silhouette of a bust, which is like a void, adds to the

surreal air. Weischer constantly reminds us that his representation is an illusion. The work is full of references to artists and artistic movements of the twentieth century, which suggests that Weischer is engaged in a Post-Modern dialogue with art history as well as portraying a dysfunctional modernity.

⌁ de Balincourt, Dalwood, Pessoli, Rauch

**Matthias Weischer. b** Elte, Germany, 1973. **Fernsehturm**. 2004. Oil, charcoal, graphite and tape on canvas. Two parts, each: **h**200 x **w**145 cm. **h**78 3/4 x **w**57 1/8 in. Overall: **h**200 x **w**290 cm. **h**78 3/4 x **w**114 1/4 in

# Wekua Andro

## Sneakers 1, 2008

A spookily life-like wax figure of a dark-haired girl sits hunched, with her head buried in her knees. On her back is painted a harlequin pattern and on the crown of her head a theatrical mask smiles at the ceiling. But for a pair of purple sneakers, she is naked. She is placed on top of a makeshift table assembled from diverse parts, which stands on a pallet cast from aluminium. The pallet and table provide a functional plinth but their presence is so particular that they also serve as a device to further focus attention on the figure. Part of a series of cast-wax mannequins, in which the same sneakers play a recurring role, Wekua has staged an image of childhood solitude and indeed loneliness. In his sculpture, paintings and photography he draws on personal and shared iconographies to develop narratives through which he explores human experience at the intersections of individual and collective memory, identity and history.

⋯⋮ Bhabha, Manders, Mueck

Andro Wekua. b Sukhumi, Georgia, 1977. Sneakers 1. 2008. Wax figure, aluminium casted table and pallet, Akrystal board and ceramic shoes. h149.9 x w185.1 x d100 cm. h59 x w72 7/8 x d39 3/8 in. The Dakis Joannou Collection, Athens, Greece

# **West** Franz

## Lemur, 2009

A grotesque, head-like form is roughly modelled from papier mâché formed over a metal armature and mounted on a slender stand. Nose and chin are represented by crudely painted bulbous projections, a gaping hole for the mouth. seems comical at the same time as having a haunting, ghost-like presence. The lemur was a recurring motif in West's work, referring to its folkloric status as half human, half ape, and to Roman mythology, where lemurs were the restless spirits of the dead. West's art practice started in the 1970s as a reaction to the Viennese Actionism movement. Working typically with ordinary materials – plaster, wire, papier mâché and aluminium – he saw art as fundamentally participative and he sought to subvert the idea of the artist as sole author of their work. In his portable prop-like sculptures, called 'Adaptives', carrying or wearing the work is an essential element and their meaning is subject to continuous renegotiation depending on context and user.

⸱⸱⸱⸱⸱⸱⸱ Baghramian, Bhabha, Rondinone, Warren

**Franz West. b** Vienna, Austria, 1947. **d** Vienna, Austria, 2012. **Lemur**. 2009. Papier mâché, Styroform, metal, acrylic paint. **h**176 x **w**136 x **d**63 cm. **h**69 1/4 x **w**53 1/2 x **d**24 3/4 in

# White Pae

## Too much night, again, 2013

Thousands of coloured threads criss-cross from one wall to the other in this mesmerizing textile installation. Using 48 kilometres (30 miles) of yarn, the artist immerses visitors in a web of red, purple and black. The taut strands have been carefully arranged so that the ambiguous words 'TIGER TIME', and 'UNMATTERING' are spelt out along the gallery's walls, appearing and dissolving as one navigates the space. As alluded to in the title, this dream-like piece was conceived after a serious bout of insomnia. The coloured yarn refers to the cover of Black Sabbath's heavy metal album *Master of Reality* (1971), which terrified White so much as a child that she hid it under her bed so that she could sleep. This intermingling of personal, cultural and aesthetic references typifies her approach. Responding intuitively to each new situation, White's site-specific installations and commanding sculptural works are admired for their innovative use of objects and materials.

⋯⋮⋯ Friedman, Hashimoto, Sze

Pae White. b Pasadena, CA, USA, 1963. **Too much night, again**. 2013. Installation, mixed media. Dimensions variable

# **Whiteread** Rachel

## Holocaust Memorial, 2000

This site-specific memorial was created in remembrance of over 65,000 Austrian Jews killed by the Nazis during World War II. Installed in Vienna's Judenplatz, the city's historical Jewish centre, it represents an inverted library, where thousands of books line its walls, but each one faces inwards, therefore concealing its subject. In this way the monument speaks of the untold stories of Holocaust victims, poignantly marking their absence as well as referring to the additional loss of learning and knowledge through death and exile. On its base are listed the names of concentration camps at which Austrian Jews were killed. Renowned for her castings of interiors and negative spaces, Whiteread has turned objects, rooms and even entire buildings inside out to create haunting works that evoke absence and loss. Emerging in the late 1980s, she is one of Britain's most celebrated sculptors and became the first woman to win the Tate's Turner Prize in 1993.

 Balka, Bartana, Hiorns

**Rachel Whiteread. b** London, UK, 1963. **Holocaust Memorial**, 2000. Concrete. **h**3.8 x **w**7 x **d**10m. **h**12 ft 3 in x **w**23 x **d**32 ft 10 in. Judenplatz, Vienna, Austria

# **Woods** Clare

## Black Vomit, 2008

Nature is malevolent in this work, evocative of the dark forests of children's fairy tales. The colours are gloomy, oily, sickly, and the composition – centred on a brooding sky, darkly reflected in the water of a swampy hollow – is disorientating. The unpleasant title *Black Vomit* evokes a worrying symptom of numerous illnesses. The starting point for many of Woods's paintings are photographs, taken at night by pointing the camera into dense undergrowth and using a flashgun. There is an unsettling clarity in her surfaces, created using oil and enamel paints on an aluminium base. While there is nothing of the sublime or romantic that we usually associate with the British landscape tradition, there is a subtle duality to her work – as well as menace there is beauty, and decay sits alongside vivid fecundity. Woods frequently makes large-scale work, such as *Rack Alley* (2012) permanently installed in Worcester public library in the UK.

⋯⫶ Doig, von Heyl, Ofili

**Clare Woods. b** Southampton, UK, 1972. **Black Vomit**. 2008. Enamel and oil on aluminium. **h**200 x **w**280 cm. **h**78 3/4 x **w**110 1/4 in

# **Wool** Christopher

### Untitled, 2010

Fine black spray-painted lines have been partially swiped with a turpentine-soaked rag into grey washes and overlaid with horizontal and vertical white brushstrokes. The result is a dramatic, strongly expressive record of gesture and erasure. The action of the artist's hand as it makes marks and as it wipes them away can be clearly traced. Wool first came to prominence with his word paintings – white canvases with black, stencilled letters. In these works he was using the form of language while destabilizing its relation to meaning by removing punctuation, conventional spacing and even letters. Similarly, the marks in this later work also have a deceptively calligraphic quality, evocative of graffiti. However, Wool rejects propositional or conceptual content. His principal concern is with painting itself: he is calling attention to art-making as an exhilarating, physical process.

·····⫶· Guyton, Richter, Tillmans

**Christopher Wool. b** Chicago, IL, USA, 1955. **Untitled**. 2010. Enamel on linen. **h**243.8 x **w**198.1 cm. **h**96 x **w**78 in.

# Wyn Evans Cerith

### S=U=P=E=R=S=T=R=U=C=T=U=R=E ('Trace me back to some loud, shallow, chill, underlying motive's overspill…'), 2010

Wyn Evans first made his mark on the London art world as a filmmaker in the 1980s, working alongside figures such as Derek Jarman and the performance artist Leigh Bowery. However, in 1992 he made a neon sculpture titled *TIX3*, inspired by the backside of a cinema 'EXIT' sign, and from there began an investigation into the space between moving image and object, language and form. His installation *S=U=P=E=R=S=T=R=U=C=T=U=R=E ('Trace me back to some loud, shallow, chill, underlying motive's overspill…')* is, like TIX3 and many of his other works, made of light. Seven columns of tubular incandescent

lights rise from floor to ceiling, and slowly brighten and dim. Wyn Evans perceives the time-based sculpture as breathing. The heat of the lights also contrasts with the 'chill' of the title – taken from a poem by James Merrill in which the dead speak via a Ouija board.

⋯⁚ Creed, Hiorns, Holzer

Cerith Wyn Evans. b.1958, Llanelli, UK. **S=U=P=E=R=S=T=R=U=C=T=U=R=E** ('Trace me back to some loud, shallow, chill, underlying motive's overspill…'). 2010. Mixed media. Dimensions variable

# **Xu** Zhen

### 8848 Minus 1.86, 2005

As a politically provocative artist living in an authoritarian state, Xu has walked a careful path between humour and confrontation. One of his earliest works, *Shouting* (1998), was literally a cry for attention: in crowded places, Xu screamed as loudly as he could and videoed the sea of alarmed faces that turned towards him. In *8848 Minus 1.86* a video shows three men digging snow from the peak of a mountain. Accompanying information explains that Xu and his compatriots climbed Mount Everest and brought the sacred mountain's topmost 1.86 metres of ice back with them. Alongside the video Xu has exhibited a refrigerated vitrine containing a pile of ice, not quite convincing enough to corroborate his tall story that they had successfully reduced the height of the mountain. Since 2009, Xu has made art not under his own name but as CEO of 'MadeIn Company', the world's first art corporation. As always with Xu's work, the gesture is half comical, half deadly serious.

······∴· Ai, Althamer, Dean, Demand

**Xu Zhen. b** Shanghai, China, 1977. **8848 Minus 1.86.** 2005. Single-channel DVD video installation with sound. **dur** 8 min 11 sec

# Yang Haegue

## Dress Vehicle – Yin Yang, 2012

Venetian blinds are an elegantly functional means by which to modulate the amount of light entering and exiting a room. Liberating them from their usual position against a window, blinds have become Yang's signature motif: used in her sculptures and large-scale installations for both their decorative qualities and their associations with urban privacy and psychic interiority. Despite references to closure and withholding vision, Yang's installations are often colourful and structurally open, allowing viewers to walk and see through them. Many assemblages incorporate found domestic or craft objects, and

light bulbs dangling from lengths of cable. *Dress Vehicle – Yin Yang* is one of a series of works on castors. For a performance at Tate Modern, London, she enlisted performers to move them around a darkened space. Members of the audience were invited to play drums and sing or speak into a microphone, while lighting effects were projected in response to the sounds and movement.

⸱⸱⸱⸱⸱⸱ Allora & Calzadilla, Baghramian, Cidade

**Haegue Yang. b** Seoul, South Korea, 1971. **Dress Vehicle – Yin Yang**. 2012. Mobile performative sculpture, aluminium Venetian blinds, powder-coated aluminium frame, magnets, knitting wool, bells, rubber ropes, casters. **h** 318 x **w** 310 cm x **d** 310 cm. **h** 125 1/4 x **w** 122 x **d** 122 in

# Yang Fudong

## Seven Intellectuals in a Bamboo Forest, 2003–7

A five-part, black and white film shot over a five-year period, *Seven Intellectuals in a Bamboo Forest* is based on the legendary story of the Seven Sages, a group of third-century Chinese scholars who turned their back on the rigours of court and city life to move to the countryside and write poetry, drink heavily and reflect on the politics of the time. In Yang's work the seven characters are modern-day Chinese men and women, who are depicted in various situations, in both urban and rural environments. Like the Seven Sages before them, Yang's protagonists are questioning their roles within modern Chinese society. In keeping with much of his other film and photography work, this piece is ambiguous, with a dreamlike atmosphere. Yang typically uses black and white 35 mm film, and his work draws on influences from traditional Chinese painting to contemporary filmmakers, such as Jim Jarmusch.

····⫶· Ahtila, Gaillard, Tan

**Yang Fudong. b** Beijing, China, 1971. **Seven Intellectuals in a Bamboo Forest**. 2003–7. 35 mm film transferred to video. Black and white, sound. Five parts, durations vary from 29 min to 92 min

# Yin Xiuzhen

## Portable City Series, 2001

Suitcases hold portraits of cities, including Beijing, Berlin, Jia Ya Guan, Melbourne, Seattle and Vancouver. Made using old, discarded clothing, these 'portable cities' are contained within suitcases, which look ordinary when closed. Despite variations in their shape and size, there is uniformity to the places featured, a comment perhaps on the homogeneity that globalization has wrought on our urban centres. The rendering of the cities in cloth, all of which was obtained in the place in question, emphasizes an individual touch, and this mix of the personal and the political is a recurring theme in Yin's art. The sculptures reflect the artist's own travels around the globe, with the soft, malleable buildings evoking a childlike quality that stands at odds with the solid, gleaming structures they represent.

⋯⋮· Elmgreen & Dragset, Farmer, Leonard

**Yin Xiuzhen. b** Beijing, China, 1963. **Portable City Series**. 2001. Mixed media. Dimensions variable. Installation view, Kunsthall Düsseldorf, Germany, 2013

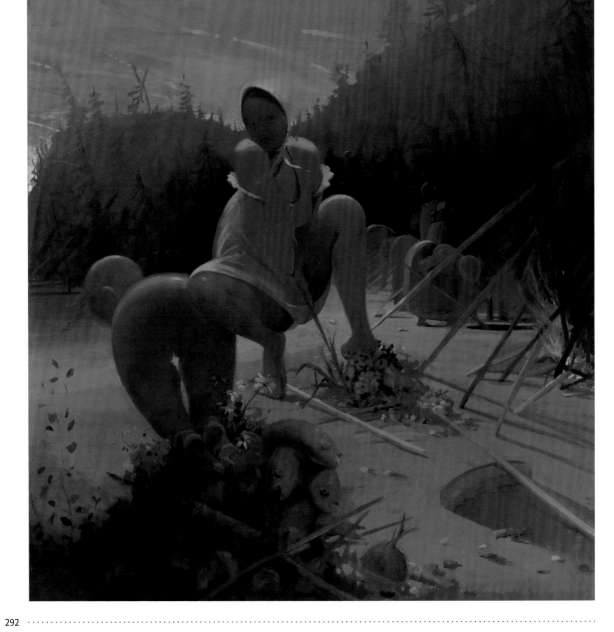

# Yuskavage Lisa

## No Man's Land, 2012

A cartoonishly voluptuous young woman squats over a tangle of twigs and flowers. She is wearing a bonnet and a pale blue dress, pulled up over her thighs. Her attitude is grotesquely licentious and coquettish. To her right, a naked female figure kneels on all fours, feet resting amid discarded fish and vegetables. The relative scale and perspective of the two figures is oddly out of kilter. To her left, a fire burns and beyond that, women are bent at work, tilling the ground. Their tools are held diagonally, a compositional device that echoes the bonfire. Behind them, other figures stand at the edge of a forest, indistinct in the gloom. A fiery sunset is visible beyond the trees and the whole scene is bathed in an eerie green twilight. Yuskavage's kitsch, child-like women in sexually-charged poses, often placed in surreal landscapes, confront and challenge our voyeuristic gaze.

⤳ Brown, Currin, Shaw

Lisa Yuskavage. b Philadelphia, PA, USA, 1962. No Man's Land. 2012. Oil on linen. h195.58 x w177.80 cm. h77 x w70 in

# Zaatari Akram

### End of Time, 2013

Set against a stark white background, two young men stand facing each other, engaged in a curious choreography. One takes off his T-shirt and tries to undress the other but is pushed to the floor. Later they appear to be dancing, or maybe kissing. These ambiguous, silent actions are repeated, with the actors swapping roles on each occasion. At the end of each segment both men are naked and their clothes lie on the floor. With its repeating cycle of seduction and indifference, Zaatari's film addresses the birth and death of human desire. It also offers an alternative view of relationships that is at odds with the prevailing attitude towards homosexual behaviour in Beirut, where the Lebanese artist lives. Investigating the history of Middle Eastern vernacular photography and its role in shaping aesthetics and social codes, through his work as artist, curator and co-founder of the Arab Image Foundation, Zaatari explores issues of representation, identity, sexuality and intimacy.

⋯⊹ Bonvicini, Jankowski, Stark

**Akram Zaatari. b** Saïda, Lebanon, 1966. **End of Time**. 2013. HD video with sound. **dur** 13 min

# **Zeng** Fanzhi

### Portrait, 2004

A man in a hooded red overcoat stares solemnly out of the painting. Disturbingly, the pupils of his eyes are represented by crosses. His well-defined lips are coloured by a vivid red smear. He stands next to a child's toy horse on wheels, against a uniform grey background. The figure is rendered in sharp detail, with expressive technique, but the overall impression is of flatness. The shadows of man and horse fall in opposite directions making their juxtaposition unnerving, uncanny. The painting is imbued with an underlying sense of psychological tension. The stillness of the figure, the hand in the pocket, the precisely directed and challenging gaze, all somehow imply the possibility of violence. Having grown up in the shadow of the Cultural Revolution, Zeng draws on Chinese history and traditions as well as his personal narrative to examine contemporary Chinese society and art as they establish new interactions with Western traditions and ideologies.

⋯⫶ Avery, Feng, Lassnig

**Zeng Fanzhi. b** Wuhan, China, 1964. **Portrait**. 2004. Oil on canvas. **h**200 x **w**150 cm. **h**78 3/4 x **w**59 in

# **Zhang** Huan

**My New York (Worker), 2002**

For this performance, made one year after the destruction of the World Trade Center, Zhang, covered in a white sheet, was carried out of the Whitney Museum of American Art in New York by a group of Chinese men. Once set down, he was revealed to be wearing a suit made out of raw meat, padded to look like over-developed muscles. He then led a procession through the city streets, releasing white doves and handing them out to passers-by. The juxtaposition of the muscle suit, possibly standing for the USA's role as a world power, with the white doves, a universal symbol for peace and compassion, suggests a commentary on

the War on Terror. Zhang often uses ritual in his performances, pushing his body to extremes in order to achieve a kind of transcendent state. As well as performance, he uses photography, installation, sculpture and painting in a politicized practice, addressing issues of identity, spiritualism and conflict.

 Abramović, Bock, Li Yongbin, Shonibare

**Zhang Huan. b** Anyang, China, 1965. **My New York (Worker)**. 2002. Performance, Whitney Museum of American Art, New York

May my situation be better
if I am in China?
如果是在中国，我的状况
会不会好些？

# Zhao Bandi

### May my situation be better if I am in China? 2003

The artist clutches a toy panda as he sits in a London street talking with a homeless man who asks: 'May my situation be better if I am in China?' The question, printed on the photograph in English and Chinese, is left unanswered, though Bandi's expression suggests an unfavourable response. The sardonic tone here is typical of the artist's photographs, which depict him and his panda in everyday scenarios. In some works comic book speech bubbles give voice to the toy, who discusses topical issues such as war, terrorism, pollution, and public health. Drawing from the visual language of advertising and public information campaigns, Bandi's witty and subversive works critique the absurd and often irrational aspects of government propaganda in his native China. While Bandi has exhibited in galleries internationally since the early 1990s, many of his works appear as public posters, allowing his political commentaries to reach a mass audience.

⋯⋰ Ai, Banksy, Xu, Zeng

**Zhao Bandi. b** Beijing, China, 1966. **May my situation be better if I am in China?** 2003. Photograph. **h**98 x **w**120 cm. **h**39 x **w**47 in

# Żmijewski Artur

## Them, 2007

In this reality-TV-style documentary, four distinct groups of adults – left-wing social activists, Polish nationalists, Catholic women and a Jewish youth group – take part in a social experiment. Each opposing faction is asked to design a banner promoting their beliefs. Żmijewski then instructs the gathered groups to modify each other's work as they see fit. Discussion soon turns to aggression, and after much cutting, ripping, scrawling and erasing, the participants turn against each other, each group seeing their counterparts as an adversary, the 'Them' of the work's title. Finally the banners are burned and hurled out of the

window. The video highlights the powerful role that visual language plays in political expression and the tensions arising from opposing ideologies. Having witnessed the collapse of Soviet communism during the late 1980s, the Polish-born artist became fascinated with the subsequent influx of competing philosophies. His provocative films and photographs reflect on complex moral issues and the seamy underbelly of human nature.

⸱⸱⸱⸱⸱⸽ Althamer, Hayes, Jamie

Artur Żmijewski. b Warsaw, Poland, 1966. Them. 2007. Single-channel video, projection or monitor. Polish with English and German subtitles. dur 26 min 30 sec

**Abstract Art/Abstraction**

A composition of form, colour and line that is not concerned with representing the world. Abstraction can be seen across many cultures and all times, and includes abstract art, which, strictly applied, is a term relating to Western painting and sculpture from the late-nineteenth century onwards that rejects any relationship to the external world.

**Abstract Expressionism**

American painting movement with roots in Europe that flourished in the 1940s and 1950s. Although their styles varied, Abstract Expressionist artists all used **Abstraction** to externalize emotions, allowing the subconscious to express itself on the canvas. Gesturalism, sometimes called Action Painting, was one technique used by these painters.

**Aesthetic**

Relating to the visual qualities of an object, often concerned with the characterization and appreciation of beauty.

**Animation**

The sequential arrangement of slightly altered still images or objects to create the appearance of movement. Animation can be recorded by film and video, or be computer-generated.

**Anime**

Abbreviation of 'animation', which relates specifically to hand-drawn or computer-generated animation originating from Japan. While incorporating a wide range of genres and art styles, Anime productions are known for their fantastical themes and locations populated by characters with wide, exaggerated eyes. See also **Manga.**

**Appropriation**

The artistic practice of intentionally recycling or borrowing imagery from another context for inclusion in new work.

**Arte Povera**

A twentieth-century artistic movement particularly prevalent in Italy, which literally means 'Poor Art'. It celebrated simple and cheap materials, such as mud, twigs, paper, cloth and cement fusing nature and culture in its reflection of contemporary life.

**Assemblage Art**

Form of sculpture produced by arranging often disparate found objects and materials.

**Avant-garde**

A term used to describe a movement or work that is experimental, innovative or that challenges the current predominant style. It comes from the French phrase meaning 'advance guard' and was first used in relation to art in 1825. Many artists have aligned themselves with the avant-garde movement and continue to do so today.

**Biennial**

A large-scale international exhibition held every two years, usually linked to a specific city or location.

**Body Art**

The use of the body itself as the raw material for art. This prime means of expression became widespread during the 1960s and 1970s and became one of the most direct ways of exploring issues of gender, sexuality and identity. Often it has tested the limits of human endurance. Alongside **Performance**, **Land** and **Conceptual Art**, it has

taken art beyond the confines of the gallery and raised questions of ownership and permanence.

**C-print/C-type**

The C-type (Chromogenic colour print) process was introduced in the 1950s for printing from colour negatives. C-type paper is coated with three emulsion layers sensitized to primary colours and protected by filters. The images are made from cyan, magenta and yellow dyes. C-type prints are also known as dye coupler prints.

**Chiaroscuro**

Term used in drawing and painting to describe the utilization of light and dark shades of a colour to produce an illusion of depth. Literally translated as 'light-dark', the technique was developed during the Renaissance, and Italian and Dutch masters of the seventeenth and eighteenth centuries famously used it to create works full of exaggerated light and shadow.

**Collage**

Term for the technique, and the resulting work, where materials such as pieces of paper or cloth are pasted onto a flat surface. It comes from the French world *coller* (to stick). **Photomontage** applies the same principles to photographs.

**Conceptual Art**

Term applied to art in which an artist eliminates or radically reduces emphasis on the aesthetic or material concerns – in favour of the idea behind the art work. The history of Conceptual Art often finds its origins in the **Ready-mades** of Marcel Duchamp.

**Constructivism**

An **Abstract Art** movement with its roots in early 1900s Russia, based

on the belief that art should imitate the forms and processes of modern technology. Internationally, Constructivism's aims and ideals defined a wider mood in Western art, rejecting traditional approaches. Sculpture that uses industrial materials and construction techniques is a clear example.

**Cubism**

Artistic movement based in France from the late 1900s to the early 1920s, developed by Georges Braque and Pablo Picasso. The style is characterized by the fracturing of images, the simplification of form to its essential elements, and the use of unnatural and multiple perspectives.

**Digital Art**

A broad term used to describe both art created or presented using digital technologies, often computer-generated.

**Diptych**

Any two-part art object or painting, intended to be displayed as a pair and traditionally joined by a hinge.

**Expressionist**

An artist that prioritizes the expression of their subjective emotions – in contrast to the accurate depiction of objective reality – in the creation of an artwork. See **Abstract Expressionism.**

**Feminist Art**

Emerged in the 1960s, but with roots in women artists' fight for increased visibility since the early twentieth century. As a move away from male dominated traditions of painting, they utilized crafts, film, video, performance, installation and text-based art.

# Glossary

### Figurative Art

Art that clearly depicts the world around us, whether with truthful accuracy or deliberate distortion. Figurative art is typically associated with paintings and sculptures of the human or animal form, although it can be used in a more general sense where art is derived from real object sources. The term Representational Art is used synonymously with Figurative Art.

### Fluxus

An international collective, named in 1961 who reacted against traditional art forms, the term described a condition of perpetual activity and change. Many **Avant-garde** artists took part in Fluxus, and it paved the way for **Performance** and **Conceptual Art**.

### Found Materials / Found Objects

Originating from the French *objet trouvé*, the term describes art created from undisguised, but often modified, objects or products that are not normally considered art, often because they already have a non-art function.

### Futurism

Italian-centred art movement that was launched in 1908 by Filippo Tommaso Marinetti and continued until the late 1920s. Futurism glorified the dynamism of the newly mechanized world and rejected the veneration of past art, particularly the weighty tradition of Italian art.

### Graffiti Art

The term has its origins in the Greek *graphein* (to write) and the Italian *sgraffito* (scratched drawings). Ancient examples have been found at such sites as Pompeii and Hadrian's Villa at Tivoli. Today, the term is most typically associated with urban **Street Art**, born from the American graffiti movement of the 1960s and 1970s.

### Hard-Edge Painting

Painting style characterized by clean and clear abstract shapes in block colours and with sharp edges. The term was coined by the Californian art critic Jules Langsner in 1958, and the style became extremely widespread in the 1960s.

### Installation Art

Often occupying an entire room or gallery space, through which the spectator has to move in order to engage fully, installation art describes works comprising individual elements within a defined space to be viewed as a single work. Often **Site-specific**, they may be designed for a particular gallery and cannot be reconstructed elsewhere.

### Impasto

Term for paint that is thickly applied so that it stands in relief and retains the marks of the brush or palette knife. The technique was only really explored when oil paint was introduced.

### Kitsch

A term that refers to tasteless, garish or sentimental art. It is the German word for trash.

### Land Art, Earth Art

Arising in the mid-1960s as a reaction against the growing commercialization of art, and the traditional context of the gallery or museum, Land Art (also known as Earth Art) entered into a direct dialogue with the environment. Some artists brought nature into the gallery, while others worked outside in the landscape. Often large-scale and situated in remote places, Land Art is frequently impermanent and subject to the erosive forces of nature. It therefore relies on photography as a means of documentation.

### Lightbox

A translucent glass-faced box containing an internal light source. Used to illuminate photographs from behind whilst displayed.

### Manga

Illustrated comics published in Japan. Although like **Anime**, Manga is stylistically distinct, it incorporates a wide range of themes and genres aimed at all age groups.

### Minimalism

Art movement that flourished in the 1960s, characterized by simple geometric forms and industrial materials. Minimalist art has an impersonal austerity, and is predominantly driven by perfection of form and the exploration of space and time. It can be seen as an extreme form of **Abstract Art**.

### Modernism

More of an attitude than a specific style, Modernism was a celebration of the new and a rejection of the past. It encompassed an array of **Avant-garde** movements in art, design and architecture from the mid-nineteenth to the mid-twentieth century, with artists seeking a visual equivalent to contemporary life and thought.

### Montage

The assembly of a collection of elements – physical objects, images or sounds – to form a single work. See also **Photomontage**.

### Moving image

A general term for many durational media, including animation, film, video and digital art.

### New British Sculpture

A group of sculptors particularly associated with the Lisson Gallery in London in the early 1980s. There is no specific characteristic style that links them together and yet they all worked with ordinary and conventional materials. What also defined these artists was a return to the production of individual, autonomous objects, after the innovations of **Conceptual** and **Performance Art**, which had dominated the previous decade.

### New Leipzig School

Movement in German painting that came to prominence during the country's post-reunification period (since 1989). Paintings often merge figurative and abstract elements, while retaining a narrative basis. Importance is placed on traditional painting skills and draughtsmanship. Many of those associated with the movement studied at Leipzig's *Hochschule für Grafik und Buchkunst* (Academy of Visual Arts).

### Œuvre

A French word used to describe the body of work produced over the course of an artist's career.

### Outsider Art

Used to describe work produced outside the established art scene by the untutored, such as children, the mentally ill and criminals. It is often considered to be a more authentic, spontaneous form of expression than the official art that is exhibited in museums and galleries.

**Palette**
A rigid, flat surface on which a painter arranges and mixes paint, the word has also come to mean the range of colours that are used by an artist generally or in a specific work.

**Papier-mâché**
A technique for creating three-dimensional objects or reliefs using pulped paper and glue. In French it literally means 'chewed-up paper'.

**Participatory Art**
A form of art in which the audience / viewer is directly involved in the creative process. A factor in the development of **Performance Art** and types of **Digital Art**, it is seen as a challenge to the view that an artwork is created by an individual professional artist.

**Performance Art**
Term used to describe live presentations by artists, where the medium is either the artist's own body or the bodies of other people. It is often documented for later presentation or collection in film, video or photography.

**Photomontage**
The process and the result of making a composite by cutting and joining two or more photographs. Since the birth of digital photography, photomontages can also be made using a computer rather than physical photographic prints.

**Pop Art**
Abbreviation for 'popular art', term used to describe a movement that began in the late 1950s and flourished until the 1970s, independently but simultaneously, in Europe and the USA. It included artists working in a variety of different styles whose subject matter embraced and celebrated popular commercial culture, including advertising, photography, comics and the entertainment industry.

**Post-colonial Art**
Art reproduced in response to the consequences and legacies of colonial rule. Issues relating to race, ethnicity, and cultural and national identity are central themes.

**Postmodernism**
Late twentieth-century movement in art and architecture that was a reaction against the principles of Modernism. As well as pushing some Modernist aspects to the very extreme, postmodernism also saw the return of elements of classical and traditional styles. Characteristics include a refusal to recognize any single definition of art, a blurring of the boundaries between high art and popular culture and frequent use of appropriation.

**Prints/Printmaking**
A design or image impressed onto a surface, such as paper or fabric and reproduced in duplicate. Techniques include woodblock and woodcut; engraving and etching; silkscreen and screenprint and lithography.

**Queer Aesthetics**
Art concerned with lesbian or homosexual imagery and identity.

**Ready-made**
A term coined by Marcel Duchamp to describe a found object selected by the artist and placed on its own in an art context. His intention was to challenge the viewer's preconceptions about what created 'value' in art. He implied that it was not the object itself which carried artistic content, but the context in which the object was displayed.

**Relief**
Primarily used in sculpture and architecture, this term – from the Italian *rilevare* (to raise) – describes work where three-dimensional elements of the design protrude from a flat surface.

**Site-specific**
Art created for a particular location or environment, often taking the form of **Installation Art** or **Land Art**. The meaning of the work is often closely linked with the place in which it is situated, taking into consideration political, social or geographical aspects, and so framing the viewer's experience and interpretation. In some cases, the intention of this approach has been an explicit rejection of the traditional context of the museum and other institutional spaces.

**Socialist Realism**
Term used to describe a style of painting and sculpture in which the dictatorship of the proletariate is idealized and celebrated. It was made the official style of the USSR in 1934; artists who worked in other styles risked imprisonment until the death of Stalin in 1953. It later became the officially sanctioned style in China under Mao.

**Street Art**
Art that is displayed, often illegally, in urban public spaces. Although related to **Graffiti Art**, street artists create works in a wide range of materials including, fly-posting, stenciling, stickers, sculpture and video projection.

**Surrealism**
Artistic and literary movement prominent from the 1920s until World War II, which sought to explore the unconscious mind to find a deeper truth; Surrealists produced fantastical, disturbing and sometimes amusing works of art.

**Trompe-l'œil**
French term ('trick the eye') describing a painting technique designed to create the illusion that depicted objects actually exist in three dimensions, rather than being merely two-dimensional representations.

**Video Art**
Art created through televisual and video processes. Video Art was developed in the 1960s and 1970s, and includes visual recordings broadcast in galleries; installations incorporating television sets displaying images and sound; and performances that include video.

**Western Art**
Largely describes the art of western Europe, but is also used as a general category for forms of art that are more geographically widespread, particularly in the USA, but that have their roots in Europe.

**Young British Artists (YBA)**
A diverse group of London based British artists active in the 1980s and 1990s. A number of those involved studied at Goldsmiths' College. They received notable patronage from the collector Charles Saatchi, whose collection was the basis for the controversial *Sensation!* exhibition at the Royal Academy of Arts in 1997.

# Glossary

## January

**India Art Fair**
New Delhi, India
January, annual
www.indiaartfair.in
Art Fair

## February

**Art Rotterdam**
Rotterdam, Netherlands
February, annual
www.artrotterdam.com
Art Fair

**Feria Internacional de Arte
Contemporáneo (ARCO) Madrid**
Madrid, Spain
February, annual
www.ifema.es/arcomadrid_06
Art Fair

**Marrakech Biennale**
Marrakech, Morocco
February to March, every two years
www.marrakechbiennale.org
International Exhibition

## March

**Whitney Biennial**
New York, USA
March to May, every two years
whitney.org
International Exhibition

**The Armory Show**
New York, USA
March, annual
www.thearmoryshow.com
Art Fair

**Art Basel Hong Kong**
Hong Kong, China
March, annual
www.artbasel.com/en/Hong-Kong
Art Fair

**Sharjah Biennial**
Sharjah, United Arab Emirates
March to May, every two years
www.sharjahart.org
International Exhibition

**Art Dubai**
Madinat Jumeriah, Dubai
March, annual
artdubai.ae
Art Fair

**Biennale of Sydney**
Sydney, Australia
March to June, every two years
www.biennaleofsydney.com.au
International Exhibition

**International Biennial of Cuenca**
Cuenca, Ecuador
March to June, every two years
www.bienaldecuenca.org
International Exhibition

## April

**Glasgow International**
Glasgow, UK
April, every two years
www.glasgowinternational.org
International Festival

**Art Cologne**
Cologne, Germany
April, annual
www.artcologne.com
Art Fair

**Art Brussels**
Brussels, Belgium
April, annual
www.artbrussels.com
Art Fair

## May

**Manif d'art.
The Quebec City Biennial**
Quebec, Canada
May to June, every two years
www.manifdart.org
International Exhibition

**Venice Biennale**
Venice, Italy
May to November, every two years
www.labiennale.org
International Exhibition

**Frieze New York**
New York, USA
May, annual
friezenewyork.com
Art Fair

**The Dak'Art Biennial
of Contemporary African Art**
Dakar, Senegal
May to June, every two years
www.dakart.org
International Exhibition

**Havana Biennial**
Havana, Cuba
May to June, every two years
www.bienalhabana.cult.cu
International Exhibition

**Berlin Biennale
for Contemporary Art**
Berlin, Germany
May to August, every two years
www.berlinbiennale.de
International Exhibition

## June

**Documenta**
Kassel, German
June to September, every five years
www.documenta.de
International Exhibition

**Skulptur Projekte Münster**
Münster, Germany
Summer, every ten years
www.skulptur-projekte.de
International Exhibition of Sculpture

**Art Basel**
Basel, Switzerland
June, annual
www.artbasel.com
Art Fair

**Manifesta, the European Biennial
of Contemporary Art**
New location each edition
Every two years
www.manifesta.org
International Exhibition

301

# Calendar of International Contemporary
# Visual Art Events

## July

**Liverpool Biennial**
Liverpool, UK
July to October, every two years
www.biennial.com
International Exhibition

## August

**Yokohama Triennale**
Yokohama, Japan
August to November,
every three years
www.yokohamatriennale.jp
International Exhibition

**Baltic Triennial**
Vilnius, Lithunaia
August to September,
every three years
www.cac.lt
International Exhibition

**Folkestone Triennial**
Folkestone, UK
August to November,
every three years
www.folkestonetriennial.org.uk
International Exhibition

## September

**The São Paulo Biennial**
São Paulo, Brazil
September to December,
every two years
www.bienal.org.br
International Exhibition

**Gwangju Biennale**
Gwangju, South Korea
September to November,
every two years
www.gb.or.kr
International Exhibition

**Guangzhou Triennial**
Guangzhou, China
September to November,
every three years
www.gztriennial.org/home/en
International Exhibition

**Lyon Biennale
of Contemporary Art**
Lyon, France
September to December,
ever two years
www.labiennaledelyon.com
International Exhibition

**Istanbul Biennial**
Istanbul, Turkey
September to November,
every two years
www.iksv.org
International Exhibition

**BolognaFiere Shanghai
International Contemporary Art
Exhibition (ShContemporary)**
Shanghai, China
September, annual
www.shcontemporary.info/en/
Art Fair

## October

**Moscow Biennale**
Moscow, Russia
September to October,
every two years
www.moscowbiennale.ru
International Exhibition

**Taipei Biennial**
Taipei, Taiwan
September to January,
every two years
www.taipeibiennial.org
International Exhibition

### October

**Shanghai Biennale**
Shanghai, China
October to March, every two years
www.shanghaibiennale.org
International Exhibition

**Carnegie International**
Pittsburgh, USA
October to March,
every three to four years
www.cmoa.org
International Exhibition

**Frieze Art Fair**
London, UK
October, annual
friezelondon.com
Art Fair

**FIAC (Foire Internationale
d'Art Contemporain)**
Paris, France
October, annual
www.fiac.com
Art Fair

**Singapore Biennale**
Singapore
October to February,
every two years
www.singaporebiennale.org
International Exhibition

## November

**Performa**
New York, USA
November, every two years
www.performa-arts.org
International Exhibition
of Performance Art

**Artissima**
Turin, Italy
November, annual
www.artissima.it
Art Fair

## December

**Art Basel Miami Beach**
Miami, USA
December, annual
www.artbasel.com/en/miami-beach
Art Fair

The scheduling of international art
events may vary year on year.
Refer to websites for the most
up-to-date information.

302

# Calendar of International Contemporary
# Visual Art Events

We would like to thank all those who gave their kind permission to reproduce the listed material. Every effort has been made to secure all reprint permissions prior to publication. However, in a small number of instances this has not been possible. The editors and publisher apologize for any inadvertent errors or omissions. If notified, the publisher will endeavour to correct these at the earliest opportunity.

All works are © the artist.

303

# Picture Credits

# Picture Credits

**Abdessemed** Adel
**Abidi** Bani
**Abramović** Marina
**Abts** Tomma
**Ahtila** Eija-Liisa
**Ai** Weiwei
**Aitken** Doug
**Allora & Calzadilla**
**Almond** Darren
**Althamer** Pawel
**Altmejd** David
**Alÿs** Francis
**Anatsui** El
**Andersson** Mamma
**Aranberri** Ibon
**Assaël** Micol
**Ataman** Kutluğ
**Avery** Charles

**Baghramian** Nairy
**Baldessari** John
**de Balincourt** Jules
**Balka** Miroslaw
**Banksy**
**Barba** Rosa
**Barlow** Phyllida
**Barney** Matthew
**Barrada** Yto
**Bartana** Yael
**Bas** Hernan
**Belmore** Rebecca
**Ben-Tor** Tamy
**Bhabha** Huma
**Black** Karla
**Bock** John
**Boltanski** Christian
**Bonvicini** Monica
**Bourgeois** Louise
**Bove** Carol
**Brown** Glenn
**Büchel** Christoph

**Cai** Guo-Qiang
**Calle** Sophie
**Cantor** Mircea
**Cao** Fei
**Cattelan** Maurizio
**Celmins** Vija
**Chan** Paul
**Chapman** Jake & Dinos
**Chopra** Nikhil
**Cidade** Marcelo
**Cragg** Tony

**Creed** Martin
**Cuoghi** Roberto
**Currin** John

**Dalwood** Dexter
**Deacon** Richard
**Dean** Tacita
**Deller** Jeremy
**Delvoye** Wim
**Demand** Thomas
**Dijkstra** Rineke
**Dion** Mark
**Djurberg** Nathalie
  **& Berg** Hans
**Doig** Peter
**Dubossarsky** Vladimir
  **& Vinogradov** Alexander
**Dumas** Marlene
**Durham** Jimmie
**Dzama** Marcel

**Eliasson** Olafur
**Elmgreen & Dragset**
**Eloyan** Armen
**Emin** Tracey

**Farmer** Geoffrey
**Farocki** Harun
**Fast** Omer
**Feldmann** Hans-Peter
**Feng** Mengbo
**Finch** Spencer
**Fischer** Urs
**Fischli** Peter
  **& Weiss** David
**Floyer** Ceal
**Friedman** Tom
**Fritsch** Katharina

**Gaillard** Cyprien
**Gallagher** Ellen
**Gates** Theaster
**Gelitin**
**Genzken** Isa
**Ghenie** Adrian
**Gober** Robert
**Gonzalez-Foerster** Dominique
**Gordon** Douglas
**Gormley** Antony
**Gowda** Sheela
**Graham** Rodney
**Grotjahn** Mark
**Gupta** Subodh

**Gursky** Andreas
**Gusmão** João Maria
  **& Paiva** Pedro
**Guyton** Wade

**Halilaj** Petrit
**Harrison** Rachel
**Hashimoto** Jacob
**Hatoum** Mona
**Hayes** Sharon
**Hein** Jeppe
**Henrot** Camille
**von Heyl** Charline
**Hiorns** Roger
**Hirschhorn** Thomas
**Hirst** Damien
**Hlobo** Nicholas
**Hockney** David
**Höller** Carsten
**Holzer** Jenny
**Horn** Roni
**Huang** Yong Ping
**Huyghe** Pierre

**Jaar** Alfredo
**Jacir** Emily
**Jamie** Cameron
**Jankowski** Christian
**Johanson** Chris
**JR**
**Julien** Isaac
**Jungen** Brian

**Kabakov** Ilya & Emilia
**Kapoor** Anish
**Kawara** On
**Kelley** Mike
**Kelly** Ellsworth
**Kentridge** William
**Kiefer** Anselm
**Koons** Jeff
**Kounellis** Jannis
**Kuri** Gabriel

**Lambie** Jim
**Lambri** Luisa
**Landy** Michael
**Lassnig** Maria
**Lawler** Louise
**Leckey** Mark
**Leonard** Zoe
**Li** Songsong
**Li** Yongbin